THE
ENCYCLOPEDIA
OF
OIL PAINTING
TECHNIQUES

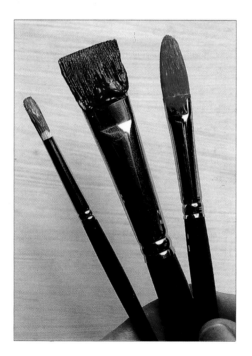

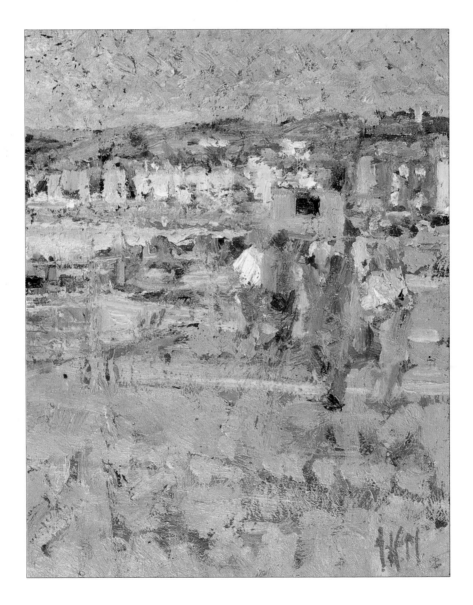

ARTHUR MADERSON
"Weston, Evening Study"

THE
ENCYCLOPEDIA
OF
OIL PAINTING
TECHNIQUES

JEREMY GALTON

SEARCH PRESS

A QUARTO BOOK

Published in paperback 2001 by
Search Press Ltd
Wellwood
North Farm Road
Tunbridge Wells
Kent TN2 3DR

Reprinted 2002, 2003, 2004, 2005, 2006, 2007

ISBN-10: 0 85532 960 2
ISBN-13: 978 0 85532 960 0

British Library Cataloguing in Publication Data
The Encyclopedia of oil painting techniques
1. Oil paintings. Techniques
1. Galton, Jeremy
751.45

This book was designed and produced by
Quarto Publishing plc
The Old Brewery
6 Blundell Street
London N7 9BH

Senior Editor Hazel Harrison
Art Editor Philip Gilderdale
Designer Andrew Shoolbred
Photographers Ian Howes, Paul Forrester
Picture Manager Sarah Risley
Picture Researcher Sheila Geraghty
Art Director Moira Clinch
Publishing Director Janet Slingsby

Typeset by En-to-En, Tunbridge Wells
Manufactured in Singapore by Chroma Graphics (Overseas) Pte. Ltd.
Printed in Singapore by Star Standard Industries Pte. Ltd.

CONTENTS

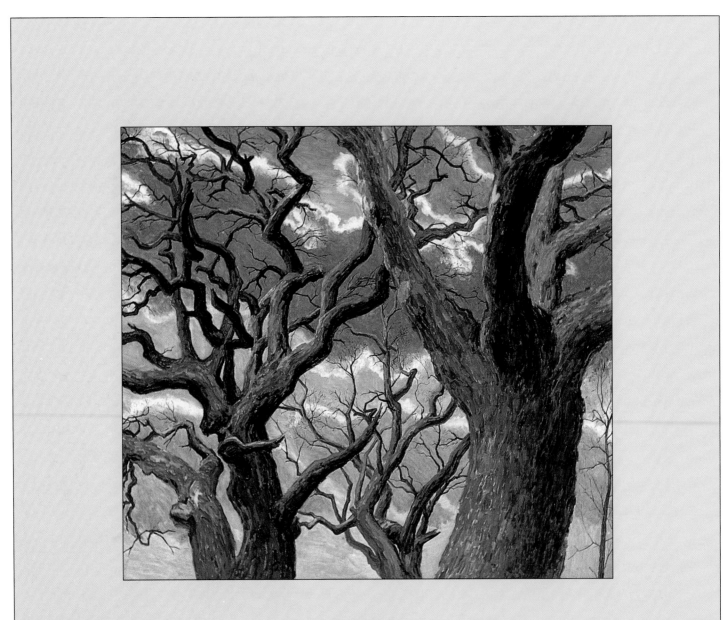

ROBERT BERLIND
"Winter Oaks"

INTRODUCTION

Oil paint is probably the most popular of all the painting media, both with amateurs and professionals. When it was first introduced, artists had to go through the laborious process of grinding their own pigments, but since the 19th century a succession of technical advances has been made, and a huge range of high-quality colours in convenient and portable tubes is now available to everyone.

The Impressionists benefited greatly from these tube colours which we now take for granted, as they were able to take their paintboxes and easels outside to paint directly from their landscape subjects. Oils are still among the best of all mediums for this rapid, spontaneous work, but their versatility is such that they are equally well-suited to large, ambitious studio paintings. It is this amazing versatility that forms the central theme of this book, because in a way it causes its own problems. Today's artists use their paints in such varied ways that it is often hard to believe that the same medium has been used. Some apply paint thickly with a knife, building it up on the surface of the canvas until it resembles a piece of relief sculpture. Others apply it in thin, transparent washes, almost like watercolour. How, then, is the inexperienced artist to know how to proceed, or which technique to decide on?

One can learn a lot by trial and error, but it saves time and frustration to know the "language" of painting. This is what the book sets out to teach, with series of articles and demonstrations outlining the main oil painting techniques, both traditional and modern. Ultimately, each artist must find his or her own means of expression through paint, but a knowledge of what is possible in terms of technique makes the task much easier.

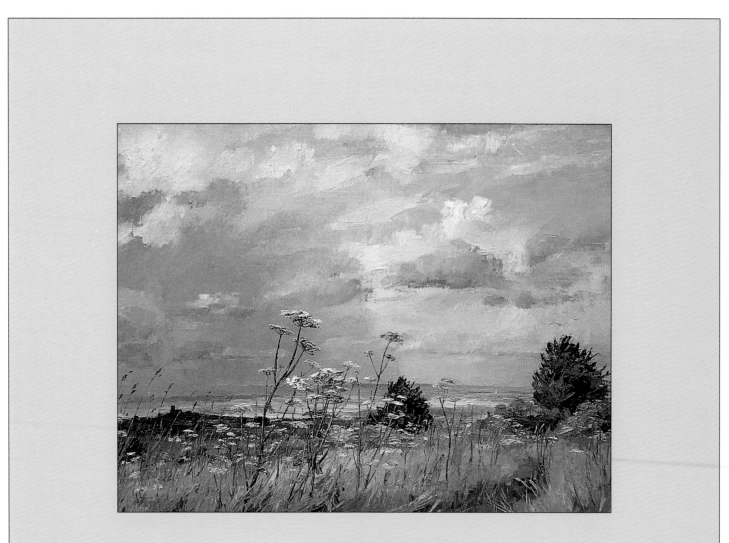

BRIAN BENNETT
"Hogweed Over Edlesborough"

PART ONE
TECHNIQUES

The aim of this first section of the book is to show you what you can and cannot do with oil paints. Although nowadays there are relatively few rigid rules about how paint should be applied, there are certain guidelines you should adhere to if you want to avoid your paintings cracking or yellowing with time. Such basic principles as working "fat over lean" and choosing the best surface to work on are explained here, but there is also a wealth of creative and stimulating ideas and unusual techniques.
The section is arranged alphabetically for easy reference, but I suggest looking through all the techniques initially to gain an idea of all the possibilities. A perfect command of one technique alone is seldom enough to make a good painting, and you will certainly need to experiment before you can develop your own artistic language. Painting involves seeing as well as doing: it is your personal vision that is to be translated into marks on canvas, and the wider your technical range the better.

This is an Italian term meaning "at first", and it describes paintings completed in one session. This necessarily involves working WET INTO WET rather than allowing a first layer to dry before others are added. The essential characteristic of alla prima is that there is no initial UNDERPAINTING as such, although artists often make a rapid underdrawing in pencil or charcoal to establish the main lines.

After the introduction of tubed paint in the mid-19th century, artists were able to work out of doors more easily. This *plein air* painting, as it is called, first undertaken by painters such as Constable (1776-1837), Corot (1796-1875) and later the Impressionists, established the rapid and direct alla prima approach as an acceptable technique. Hitherto oil painting had been largely a studio activity as pigment had to be ground by hand, and paintings were built up slowly in a series of layers.

The direct method creates a lively and free effect that is seldom seen in more deliberate studio paintings. This is certainly true of Constable, whose small landscape sketches done on the spot have much more immediacy and vigour than his larger works such as *The Haywain*.

Working alla prima requires some confidence, as each patch of colour is laid down more or less as it will appear in the finished picture. Any modifications and reworking must be kept to a minimum so that the fresh effect is not destroyed.

It is a good idea to use a limited PALETTE, as too wide a choice of colours may tempt you to put in too much detail – there is no room for inessentials in alla prima painting. It is usually easiest to leave the lightest and darkest passages to the end so that the brushstrokes used for these lie undisturbed on top of adjacent colours without mixing and muddying.

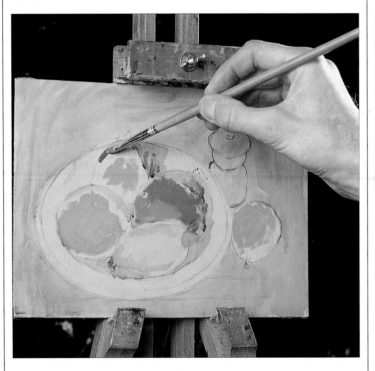

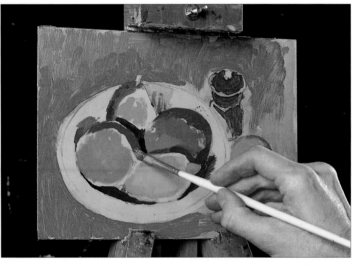

2 The tablecloth has been loosely painted, and now the darker tones of the fruit are developed. The bold brushstrokes give a three-dimensional appearance.

3 The red stripe around the bowl is crucial to the composition, so it is painted next, in a mixture of cadmium red and alizarin crimson. A higher proportion of crimson is used towards the far side.

1 Because it is difficult to get ellipses right, these were first drawn with pencil. The next stage was to block in some of the shaded areas with cobalt blue and the tablecloth with ochre, which helped to establish the feel of the composition. This photograph shows some of the basic colours being laid in with rather thicker paint. The colours are those that will appear in the finished painting, though minor modifications can be made as the work progresses.

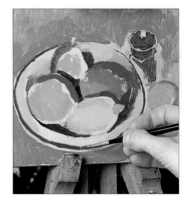

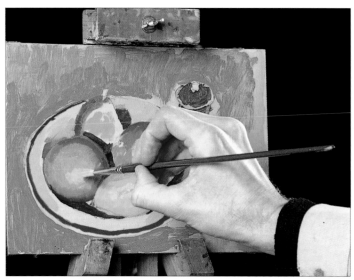

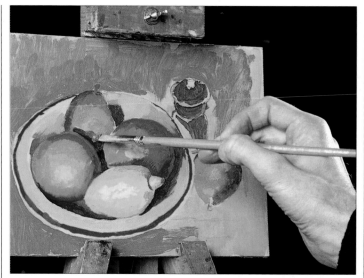

4 On the fruit, intermediate colours have been introduced between the darks and the lights without blending their boundaries. The final highlight has now been scumbled onto the orange, using a round bristle brush. This will not be touched again.

5 The other pieces of fruit are treated in a similar way, taking care that the intermediate colours successfully link the dark with the light areas. Here the addition of a patch of greenish brown contributes to the final brushwork of the pear.

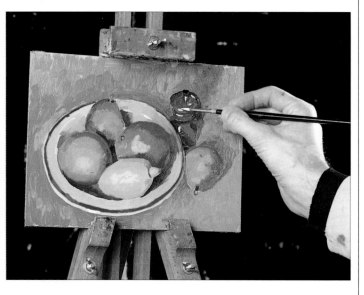

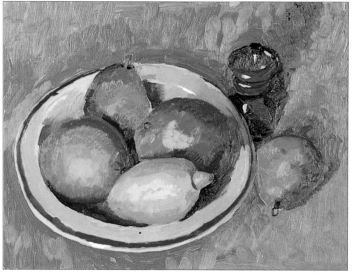

6 The tablecloth has been completed, and the shadows of the bowl, pepperpot and pear added. A fine sable is used for laying small highlights on the pepperpot in thick, undiluted paint.

7 After approximately two hours' work, the painting is complete. Although certain areas have been modified by painting WET INTO WET, the majority of the paintwork remains exactly as it was first applied.

Blending is the process of merging one colour or tone into another so that no sharp boundary is formed. It is used when soft effects are needed; for example, the gradation of a rich blue sky from deep colour to pale; clouds; subtle light and shade effects in a portrait and so on.

One of the best "implements" to use for such effects is the fingers (see FINGER PAINTING). Leonardo da Vinci (1452-1519) was one of the great exponents of a technique called *sfumato* (from the Italian word for smoke), rubbing with his fingers to achieve the impression of colours and tones melting into one another.

Whether to blend colours or not and the degree to which you should take the blending depends on the way you use BRUSHWORK and on the particular passage being dealt with. An artist who favours highly finished, detailed work may create imperceptibly smooth gradations across large areas of his canvas. At the other extreme, one who paints in loose brushstrokes may restrict blending to the placing of one colour up to and beyond the boundary with the next one (see DETAILS AND EDGES).

In most cases the colours to be blended will be closely related, as they will represent contiguous areas of a single form, and will mix to give a true blend of intermediate colours. Colours which mix to create a completely new colour cannot be blended satisfactorily; for example, blue cannot be blended with yellow since a band of green appears where the two colours overlap.

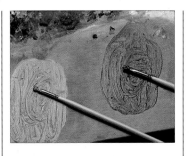

▲ The sea towards the horizon is to be painted a dark blue-grey, but the area closer to the shore is to be much paler. Here these two colours are being mixed carefully, using separate brushes.

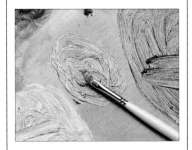

▲ A third brush is used to make an intermediate colour consisting of a mixture of the two original ones. Approximately equal amounts of the two paints are used for this.

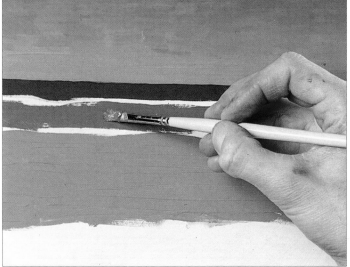

▲ The three colours are applied to the painting, but are not yet allowed to touch one another. This ensures that no mixing or streaking of the paint occurs.

▲ The bands of colour are now widened to meet each other prior to blending. The sky has already been completed, and blended to achieve soft gradations of colour and tone.

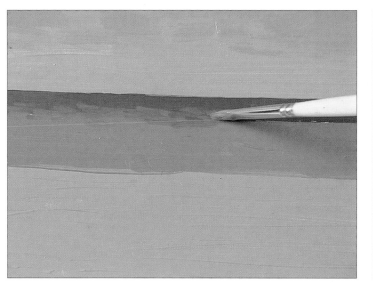

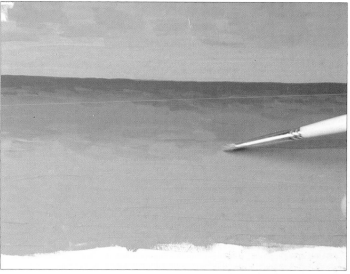

▲ A clean brush is dabbed in a zig-zag motion up into one layer and down into the next (above). Paint from one layer is carried into the adjacent one and vice versa, forming a zone of dappled and crudely blended colour. The middle and foreground areas of the sea are treated in the same way (above right). The larger the brush, the cruder the blending, so if desired a finer brush can be used to produce a smoother effect.

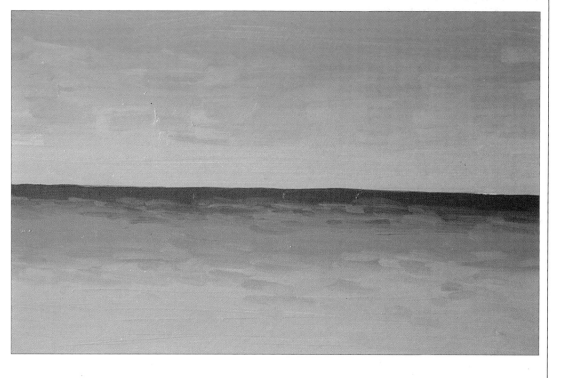

▶ Some darker patches of paint have been "pulled" further down into the foreground to give the impression of ripples. These echo the deliberately rough blending in the sky, which helps to unify the whole. In this case the boundary between sea and sky has been left unblended, but on a hazy day this area might also need blending.

This, put at its simplest, means colour which is not applied flat and is not blended. In most oil paintings, at any rate those in which BRUSHWORK forms a feature, the colour is to some extent broken, but it can be done in a more planned and deliberate way.

Optical mixing

The English landscape painter John Constable (1776-1837) was one of the first to realize that colours, particularly greens, appeared more vivid if they were applied as small strokes of varied hues placed side by side. The Impressionists took the idea further, often juxtaposing small dabs of blue, green and violet in shadow areas. When viewed from the correct distance they fused together to read as one colour while retaining a lively, flickering brilliance that could not be achieved by flat colour. Like Constable, they worked directly from nature, and the method, because it cut down on pre-mixing time, allowed them to complete paintings very rapidly before the light changed.

Georges Seurat (1859-91), who was influenced by scientific discoveries about light and colour, further refined the theory of optical mixing in his technique of POINTILLISM.

Modifications

The essence of optical mixing is to keep all the colours relatively bright and pure and the brushstrokes as small as possible, but this is not the only way to "break" colour. A painting consisting mainly of muted hues, such as a townscape or winter landscape, can be enlivened by an adaptation of the same approach. This is best done with a square-ended brush, and involves placing larger brushstrokes of several separate but related hues side by side with no blending, giving a mosaic-like effect. This is a good method for flat surfaces such as walls that might otherwise run the risk of drabness, and the square brushstrokes can also give a texture impression.

Working methods

Both broken-colour methods take some practice, as very careful mixing and assessment of colour are needed. In optical mixing, for instance, the introduction of a pale yellow or a bright red into a mid-toned blue/green/brown colour area would immediately destroy the effect, as the difference in tone would be too great.

The same applies to the related method – the colours must be close in tone and chosen so that they have a definite relationship to one another. It can be helpful to work on a COLOURED GROUND, because any small areas left uncovered between brushstrokes will help to unify the picture – patches of white have exactly the opposite effect unless all the applied colours are very pale.

The paint must be fairly thick so that it does not run and allows the brushstrokes to retain their shape. Brushes must be carefully washed between each stroke or group of strokes, or the new colour will be sullied by traces of the earlier one left on the brush.

Broken-colour effects can also be created by DRY BRUSH, GLAZING and SCUMBLING, all of which are ways of working WET ON DRY to modify existing colours.

▲ CHRISTOPHER BAKER "Haymaker's Field" (detail) Patches of bright scarcely mixed paint are built up into a mosaic of colour. At a distance the colours merge together to create a scintillating, light-filled image. The complete painting is reproduced on page 130.

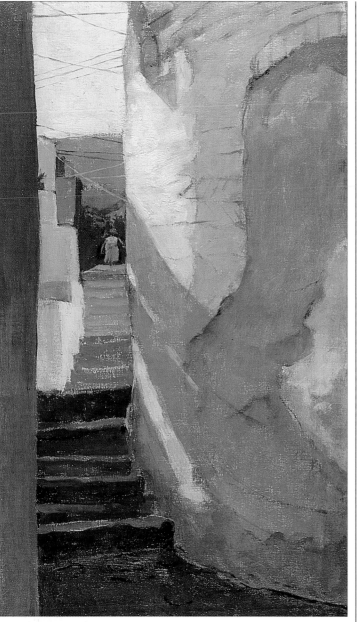

▲ JAMES HORTON
"Pyrenees – St Laurent de Cerdans"
The abstract qualities of this landscape are emphasized by the way the individual patches of colour are kept apart from each other. Each patch is given greater importance by the patches of pinkish-brown ground showing through.

▲ PAUL MILLICHIP
"Blue Steps, Symi"
The walls of this street, taking up the greater part of the picture surface, are painted in streaks and patches of blues and yellows. An overall greenish hue results, with a much more convincing effect than if the colours had been previously mixed.

▲ JULIETTE PALMER
"On High Ground"
There is some slurring of paint WET INTO WET here, but on the whole each brushmark retains its own identity. The patches of colour are relatively large, so optical colour mixing does not occur, but the effect is livelier than flat colour.

Because oil paint has a thick, buttery consistency (if not too diluted) it is the perfect medium with which to exploit the marks of the brush. Since the paint does not change as it hardens and dries, brushstrokes remain exactly as they were when first applied, with every bristle mark clearly visible, providing a visual history of the painter's manner of working.

Paint can be applied rapidly or slowly and methodically; the brushmarks can all run in the same direction; they can be used directionally to describe a shape or form; or they can swirl around the picture, as in Van Gogh's paintings. Whatever form it takes, brushwork provides the texture on the painted surface which is an integral part of the picture – indeed in many cases a painting almost *is* its brushwork.

Obviously there is a direct relationship between the marks and the brushes chosen. These are available in a variety of shapes, as shown here, and it is worth spending time experimenting with all of them to discover their possibilities. Try them with different paint consistencies and on different supports. Make rapid swept strokes and then slower ones; dab them lightly, at different angles and vertically; experiment with holding a brush in different ways or twirling it during its stroke. It may take some time to discover your painting "handwriting", but remember that brushwork is not just an exercise or a way of embellishing a picture, it is a means to express yourself and your personal perception of the subject.

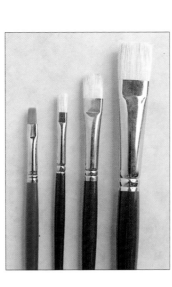

▲ A selection of short flats, one soft-haired (synthetic) and three bristle. Long-haired flats are also available.

▲ Flats make distinctive square or rectangular marks, much exploited by the Impressionists.

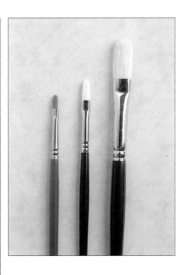

▲ These are filbert brushes, one soft-haired (synthetic) and two bristle. The hairs are quite long, arranged as a flat head and tapered to a rounded tip.

▲ Filberts are extremely versatile brushes. They can leave rounded dabs of paint or be twisted during a stroke to create marks of varying thickness.

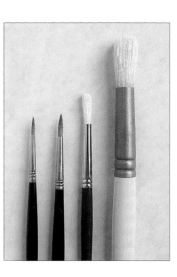

▲ Rounds: two sable and two bristle. Sable rounds taper to a fine point, and are useful for details in the final stages of a painting.

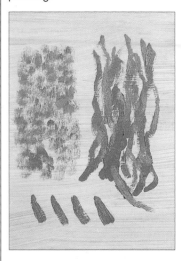

▲ Rounds, when held vertically, are ideal for stippling. They can also deliver long, continuous strokes.

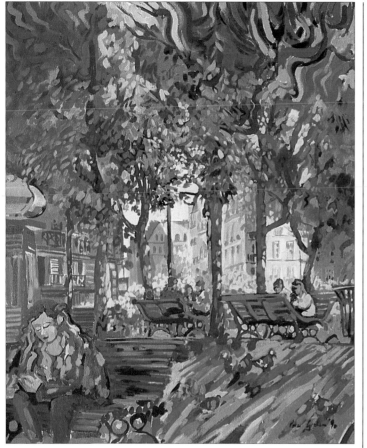

▲ PETER GRAHAM
"Rue Viviani"
The artist began by making linear strokes with medium-sized synthetic flats and hog filberts. Large areas were then rapidly blocked in with large flat bristle brushes, and the subsequent free-flowing brushmarks were made with large rounds and filberts. The latter were also used for the more intricate work, and the dappling of sunlight on the tree trunks and figures (left) was added with round sable and synthetic brushes. The effect is one of lively spontaneity.

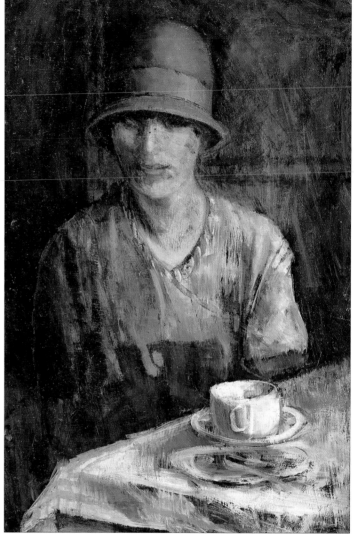

▲ NAOMI ALEXANDER
"Mother-in-Law in Blue Hat"
The brushwork here makes an obvious contribution to the character of the painting, with individual bristle marks clearly visible, criss-crossing over each other. The whole picture has been built up from very thin layers of paint streaked or scumbled over previously dried layers. The contrast between this and Peter Graham's painting is striking, each conveying a different visual message.

Although the process of building a painting is to some extent an individual matter, there are some general guidelines which can help the beginner avoid a discouraging mess of churned-up paint. The most important of these is to work FAT OVER LEAN, which simply means reserving the thick, juicy paint for the later stages so that it is not disturbed by subsequent brushstrokes.

Some artists like to begin with an UNDERPAINTING in thin, diluted paint, which dries very quickly. This allows them to establish the main blocks of tone and colour, which are then modified through the course of the painting.

Whether or not you follow this practice, it is always best to begin with the broad masses, using paint diluted with turpentine or white spirit (see MEDIUMS), and concentrating on the main areas of shape and colour. If you are painting a portrait, for example, resist the temptation to begin by "drawing" lips and eyes with a small brush – these details should be added only when the main planes of the face have been established.

If the subject is at all complex, it is wise to make an UNDERDRAWING on the canvas or board first. The lines will act as a guide to the first application of paint and cut down the risk of extensive corrections later on. Even when you are working rapidly on location it is helpful to make a few marks with brush or pencil to plan the position of the horizon or the shapes of important features such as mountains or clumps of trees.

Theoretically, since oil paint

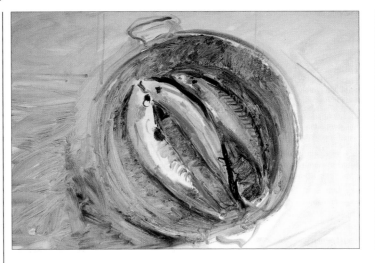

▲ The basic shapes are rapidly but carefully established with loose brushstrokes in well-thinned paint: cobalt blue, Payne's gray, raw sienna and cobalt violet. The white ground glows through this transparent paint. A few strokes of more opaque blue mixed with white can be seen in the photograph above.

is opaque, colours can be laid dark over light as easily as light over dark, but this is not always true in practice. Opacity is relative, and light colours, formed by the addition of white, have more covering power than dark ones. It is usually easiest to work up from the dark tones, and to apply the highlights last with really thick paint. This is particularly important when working WET INTO WET, as dark colours applied over light ones will mix with them and thus lose their character.

Also, dark areas such as shadows are more convincing when the paint is kept thin, perhaps with the grain of the canvas or a COLOURED GROUND showing through in places. In Rembrandt's paintings the light-struck areas of figures or faces, thickly built up, emerge from the merest skin of dark underpainting.

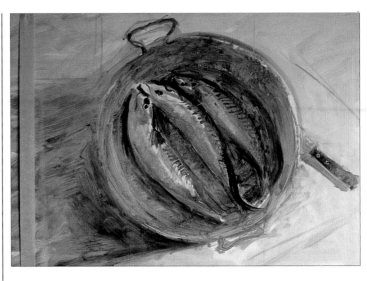

▲ Having laid the foundations of the composition, the artist begins to develop the fish by building up with more opaque paint (mainly blues, greys and ochres with white). Notice how he works all over the picture at the same time rather than treating each area in isolation. This ensures that all the elements – the fish, the bowl and the tabletop – are related to one another. More details are defined at this stage, such as the pot handles, markings on the backs and eyes of the fish.

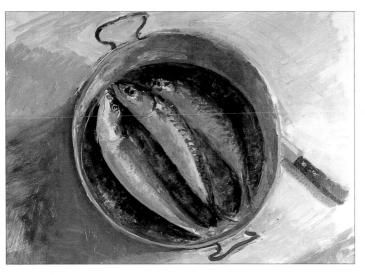

◄ Further definition is given to the heads, and applications of thicker paint give more body to the dark and light areas. In places this obscures the original UNDERPAINTING. Other details, such as the rim and handles of the pot, are clarified.

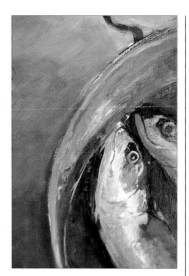

▶ The transparency and wetness of the eyes is skilfully conveyed through additions of thicker, opaque paint, the colours carefully matched to the subject.

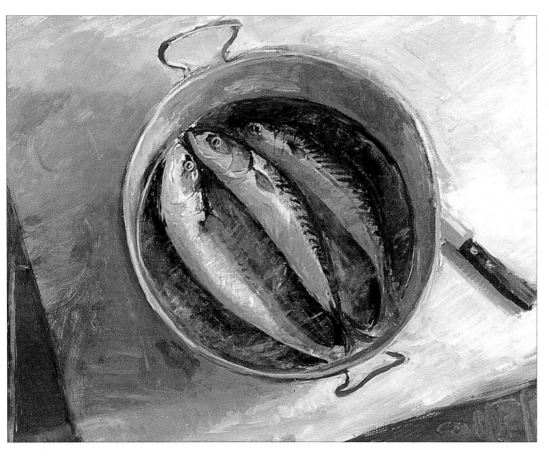

◄ Following the principle of FAT OVER LEAN, each new layer of paint contains an increasing oil content. The artist might have chosen to continue with the painting – it is not always easy to know when to stop – but by this stage the fresh firmness of the fish were so beautifully captured that further work could have destroyed the spontaneity and liveliness of the picture.

The first time collage was used in oil painting was in 1912 when Picasso (1881-1973) stuck a piece of oil-cloth onto his canvas to represent a caned chair seat. The Cubist painters, notably Braque (1882-1963), continued to exploit this new concept, adding pieces of newspaper, stamped envelopes, theatre tickets and wallpaper to their paintings. The purpose of sticking real objects to the picture surface was to emphasize the existence of the picture as an object in its own right as opposed to an illusion of reality.

"Found" objects can either be fastened with glue to the virgin canvas or board, or pressed into thick, wet oil paint, which serves as a good adhesive. Sand, pebbles, bits of wood, in fact almost anything can be added to the paint to create special textures, although for any but purely experimental work it is important to consider the permanence of the additions. Paper, for instance, tends to yellow quickly, and certain organic materials can rot or crumble in time.

Collage can also be used as a stage in painting rather than an end in itself; the artist will sometimes decide on his next step by painting new areas on paper and temporarily sticking them to the canvas. This is a helpful method for working out the exact placing of figures in a landscape, for example. The collaged figures can be moved around, changed in colour, size or posture until the artist has found what he or she wants. The collage is then removed and the painting proceeds as usual.

▲ ◄ BARBARA RAE
"Vines and Olives"
Rae's work is semi-abstract, but its content is always closely derived from observation of the real world. She is particularly interested in the way humanity has shaped its natural environment, and finds collage an ideal medium through which to express her ideas. Her paintings are multi-layered, often beginning with rice paper attached to the canvas support with PVA glue. She is fond of using silver and gold foil, as in this picture, but in the detail (left) you can see how acrylic and oil paint provides the brightest colours.

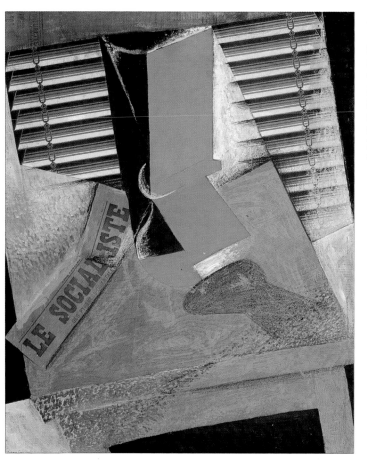

◄ JUAN GRIS
"The Sunblind" (1914)
Several of the Cubist painters experimented with collage, as they were interested in the relationship of image (or illusion) to object, and the use of real objects such as pieces of wallpaper, theatre programmes and tickets emphasized this.

▼ BARBARA RAE
"Capiliera Rooftops"
Overlapping planes of smooth and wrinkled paper are dominant in this richly coloured composition. Rae will use almost any materials to construct her collages provided they are not prone to deterioration.

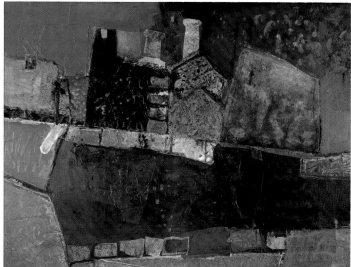

◄ JUAN GRIS
"The Sunblind" (detail)
This detail shows newspaper and wallpaper combined with oil paint. Some textures have been built up by stippling and spattering.

◄ BARBARA RAE
"Capiliera Rooftops" (detail)
The shapes of the chimneys are cut out of paper, forming sharp contours which contrast with other, softer edges. Not all paper is suitable for collage; the colours of tissue paper, for example, fade very quickly.

Many artists like to paint on a pure white surface, as the light reflected back through the paint gives a quality of luminosity to the work. The Impressionists favoured white grounds for this reason, but they can be inhibiting, particularly for beginners. It is difficult to assess colours against white, and there is a tendency to paint in too light a key, as almost any colour looks too dark by contrast. Another drawback is that when working out of doors the white surface can be dazzling, which can cause an over-hasty rush to obliterate all white areas.

A coloured ground will be closer to the average tone of the final picture, making it easier to judge both colours and lights and darks from the outset. Mid-tones are the easiest to work on as you can paint towards light or dark with equal ease. If you paint over a very dark ground (called a bole) it follows that you will continually be adding lighter tones, culminating in highlights of thick, opaque paint.

Colouring a ground, whether canvas or board, is easily done by laying a thin layer of paint, diluted with white spirit, over the white priming. Acrylic can also be used, in this case diluted with water. The ground can be any colour, but the most-used are subdued hues – browns, ochres, blue-greys, greens or even reds. The choice of colour is important as it acts as a background for applied colours to play against and thus effects the colour-key of the finished picture. Some artists like a ground that contrasts or is complementary to the dominant colour, for instance, a warm red-brown shows up green foliage while an ochre could enhance the brilliance of blue in a seascape. Others prefer a matching or harmonizing ground – blue-grey for a seascape, or brown for a figure painting. Rubens (1577-1640) always painted his figure compositions on a yellow-brown ground, leaving areas unpainted to stand as the mid-tones. Allowing the ground colour to show through in this way is still common practice, whether the colour is contrasting or harmonizing. This helps to unify the picture, as small areas of the same colour recur throughout.

1 The artist has chosen a mid-tone ochre ground as a basis for working towards both light and dark. He has begun the painting with the deep shadow areas.

2 One advantage of a coloured ground is that the painting never looks too "unfinished", even in the early stages. This is especially helpful to the beginner, as it avoids the discouragement of large areas of unpainted white canvas.

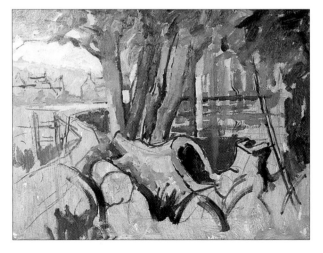

3 Patches of lighter paint have now been introduced. The artist will leave unpainted those areas approximating to the ground in tone and colour. At this stage it is possible to decide which they are to be.

4 This detail shows how the loose brushwork follows the directions of the forms. Some areas of the ground are still to be painted over, but those on the fallen tree, representing flakes of bark, will be left as they are.

5 Small areas of the ground remain exposed throughout the picture, their golden colour helping to unify the composition and contrasting with the cool greens and greys. These might otherwise have become over-dominant.

Learning to mix colours is the first step towards achieving a successful painting. Initially it is certain to involve some trial and error, but there are some general guidelines to bear in mind.

Any flat, non-absorbent surface can be used as the palette, but whether it is a conventional kidney-shaped one or simply a piece of glass it must always be large enough to enable you to arrange the tube colours around the edges while allowing plenty of room in the centre for mixing.

The tube colours should be arranged in some sort of order so that you can always find the one you are looking for (the dark colours in their pure form look very similar). Some artists arrange colours from light to dark, with white and black as opposite poles. Others prefer to group all the warm colours (reds, yellows, browns etc) together at one end and all the cool ones (blues, greens and acid yellows) at the other. You are more likely to mix warm with warm and cool with cool than to combine both in one mixture.

Light and dark mixtures
It is usually best to restrict mixtures to no more than three colours, as this reduces the risk of muddying. Care has to be taken when mixing any colour with white, as although this lightens the tone, it does so in unpredictable ways, and sometimes also changes the hue. The reds, for example, become pink as soon as white is added. The tinting power of pigments varies considerably. Raw umber becomes very pale when mixed with white, even in small quantities, as does

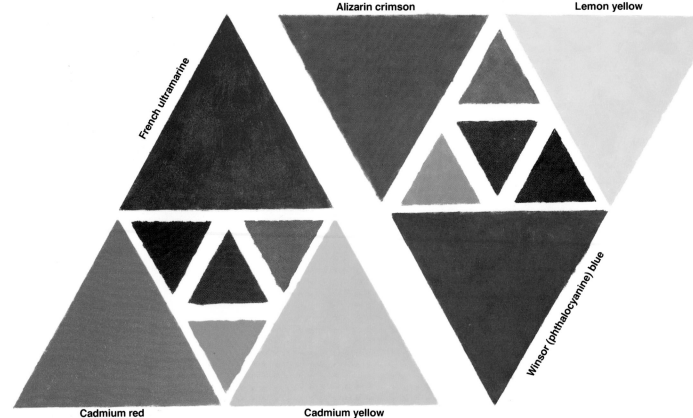

▲ Everyone knows that the three primary colours are red, blue and yellow. However, there are many different versions of the primaries, so those new to painting will have to find out the different kind of mixtures each will produce. This triangle shows the "warmer" primaries, with the secondary colours made from them in the inner triangles and a mixture of all three secondaries in the centre.

▲ Here the "cooler" primaries are used as a basis for a different set of mixtures. Painting colour triangles is a good way of learning about mixtures. You can vary the primaries further by using a blue such as cerulean instead of the ones shown here, or a different yellow or red.

erre verte, a deep green when unmixed. Colours such as these are best used neat, or mixed with other dark colours or shadow areas. Alizarin crimson and Prussian blue, on the other hand, only have to be added to white in small quantities to produce quite vivid colours, so for pale tints, always start with the white and add colour little by little.

The addition of black to any colour will darken the tone, but in some cases can lead to muddying, so it can be more satisfactory to darken with brown, green or blue. However, black is a most useful colour on the palette, and mixing it with a strong yellow, such as cadmium or Indian yellow, produces a wonderfully rich olive green.

Complete and partial mixing
Colours can be mixed with a palette knife or a bristle brush, the former being more suitable for thick IMPASTO work. Mixing with a brush can wear down the bristles; it is a good idea to keep old brushes specifically for this purpose rather than using painting brushes.

As a general rule, colours should be mixed thoroughly or the brushstrokes will be streaky. However, this is an effect that can be exploited deliberately; for example, streaks of pure green appearing in a brown-green mixture for a tree trunk or wooden building can be more descriptive than flat colour. Some artists take this method further by using two or even three separate colour mixtures, taking up a little of each on the brush so that they remain separate within the brushstroke.

This partial mixing gives an effect very much like working WET INTO WET, where the colours blend on the picture surface. There are also other methods of mixing colour on the support itself, such as DRY BRUSH, GLAZING and SCUMBLING, all of which can be used to modify a colour by adding further layers.

◀ Partial mixing is sometimes an accidental result of not having cleaned brushes thoroughly between one colour and the next, but it can be exploited deliberately. Mix up two or more colours separately and then pick up a little of each so that the same brushstroke incorporates more than one colour.

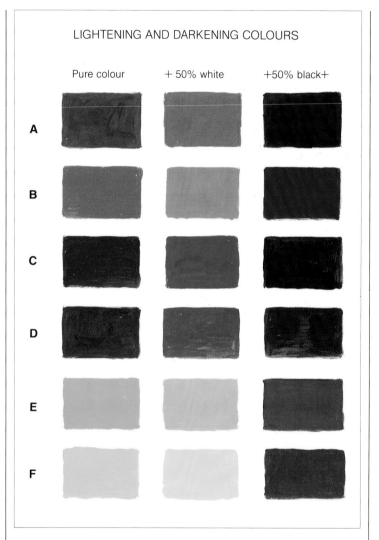

LIGHTENING AND DARKENING COLOURS

Pure colour + 50% white +50% black+

▲ KEY TO CHART
Colours:
A Alizarin crimson
B Cadmium red
C French ultramarine
D Winsor (phthalocyanine) blue
E Cadmium yellow
F Lemon yellow

▲ This chart shows how some colours behave when they are mixed with first white and then black. As you will see, reds change their character in both cases, so it is often more satisfactory to lighten them with another colour such as yellow and darken with blue or another red.

One of the advantages of working in oils is that corrections can be made easily either to the whole painting or to small passages.

When painting ALLA PRIMA, wet paint can simply be scraped off with a palette knife. This may leave a ghost of the previous image, which can either be retained to act as a guide for the fresh attempt or removed with white spirit on a rag. If a painting becomes unworkable because it is overloaded with paint, the top layer can be lifted off with absorbent paper (see TONKING).

In the case of a painting which is to be built up of a number of layers, you can facilitate later corrections by rubbing a little linseed oil (or whatever medium is being used) into the previous dry layer before adding more colour. This is called "oiling out", and it not only assists the application of wet paint, but also makes it easier to remove if you need to.

Thick IMPASTO takes several weeks at least to dry, so within this period it can still be scraped off if necessary. However, this becomes increasingly difficult as it begins to dry, and may necessitate using sharp knives or razor blades. It is always best to paint thin layers first with as little oil as possible (see FAT OVER LEAN), leaving thick impasto to the very end when it is less likely to need alteration.

An area of thin, dried paint that requires correction can simply be overpainted, but existing paintwork can be very distracting if small modifications are being attempted. It may be better to either sandpaper down the offending area, which will remove at least some of the paint, or paint a new ground over this patch and start again.

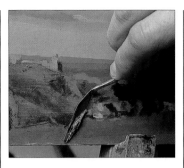

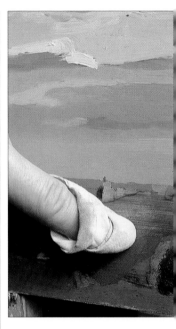

2 Scraping back leaves a ghost of the original image which can often form a helpful base on which to rework.

3 In this case, however, scraped-back paint is completely removed with a rag dipped in white spirit.

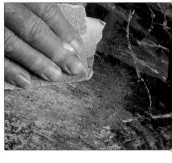

5 Dry paint can be removed with sandpaper as long as it is not too thick.

1 Much of the paintwork at the lower left is unsatisfactory and has become thick and unworkable. It is thus removed, initially by scraping off with a small painting knife.

4 The area is now reworked. Corrections such as these are easy to make when the paint is still wet.

DABBING

This is a technique by which paint is applied with a sponge, cloth or even crumpled paper. Depending on the material chosen, this leaves a more rugged texture than a brush, and can be a useful way to cover large flat areas. A sponge is probably the most useful implement, although it is worth experimenting with others. Natural sponges give an interesting open pattern, although they will not last long under these conditions. Paint applied with a synthetic sponge has a finer, closer texture, which could be ideal for the rendering of clouds, foliage or foaming water. Any of these can also be used to lift paint off the surface.

Whatever kind of dabber is chosen it should be turned and struck from different angles to give the texture some variety and prevent a monotonous repetition of the imprint. A fine misty covering of paint can be achieved by using a fine-textured dabber lightly loaded with paint. By superimposing two or more layers you can create optical colour mixtures in a technique slightly like SCRAPING BACK, although in this case paint is added to the canvas rather than being removed. BROKEN COLOUR effects can also be obtained by using rather drier paint (see also SCUMBLING).

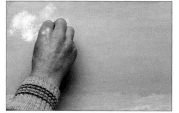 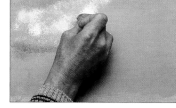

1 White paint is dabbed onto toned primed card with a synthetic sponge. The texture of the paint is open and diffuse.

2 The sponge is now used to apply blue and grey paint, which smoothly blends in without sharp boundaries.

4 5 Dabbing onto canvas or canvas board leaves the troughs of the weave largely untouched. Some mixing of the paint and some optical mixing can be seen here.

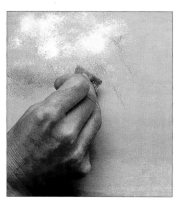 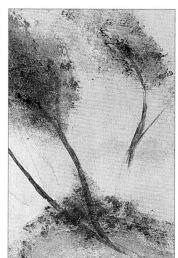

3 The ground still shows through the new veil-like covering of paint.

Clearly defined edges or contours where there are sharp boundaries between colours and tones can be very difficult to portray convincingly. It is a dual problem; firstly it is hard to paint crisp lines with thick paint and clumsy bristle brushes, and secondly, sharp-edged boundaries do not always sit easily in a painting. If the brushwork is generally rather free and loose, lines drawn with a small brush look out of place or even unrealistic. In such cases a degree of blurring is needed.

Soft edges

In WET INTO WET methods the details and edges will always be soft and slightly ragged because each brushstroke will overlap the one next to it, and this will cause some mixing of colour. Even in a studio painting done over a number of sessions, this technique can be used for specific areas of a painting, with the rest worked WET ON DRY.

But there are several other tricks for softening edges, one of which is to allow parts of the UNDERPAINTING (an earlier, dry layer of paint) to remain exposed here and there along and to either side of the contour or line. Another is to continue painting beyond the edge of a form into the adjacent area, but increasingly "starving" the brush of paint, as in the DRY BRUSH technique. This method is most effective on canvas, as the paint will tend to lie on top of the weave, with small flecks of the underlying layer showing through. Indeed, working on a heavily textured surface will in itself soften contours by breaking up the painted stroke.

In portraits it is helpful to keep the edges of eyes and lips softly defined. The painting of a head should evolve by the gradual build-up of the various planes, and a good likeness can be achieved with few or no hard edges. These can in fact work against the portrait; over-definition of any feature placed even slightly awry will destroy the likeness.

Definition

However, there are times when a boundary, or at least parts of it, does need to be relatively sharp, for example, the division between the light and dark side of a building or the curved prow of a boat catching the light. Beginners often try to add hard, dark or pale lines with a tiny sable brush as a final stage, but this seldom works. It is usually out of keeping with the rest of the painting, added to which the paint will probably be built up too thickly to allow an accurate line.

Defining details needs preplanning. Do not use a heavily textured canvas – for the reasons explained above – and avoid too much build-up of paint around the outlines by keeping the paint thin in the early stages (see BUILDING UP). Leave these first layers to dry before applying thicker paint (paint diluted with turpentine only dries very quickly) and try to keep overpainting to a minimum. If you need to make alterations, it is best to scrape down to the underpainting (see CORRECTIONS) and begin again.

There are also some "mechanical aids" which can be helpful in this context. One is a mahlstick, used by artists for time immemorial to support their painting hand. The traditional mahlstick is made of bamboo and has one padded end which rests on the canvas, with the stick supporting your hand. You can simplify this by using a piece of stick which you rest on the edge of the canvas or board.

For straight lines, you can either use MASKING tape or use a ruler as a temporary mask, holding it on the support and painting over it. But whatever method you use, remember that achieving perfect edges does not necessarily make for a better picture.

▲ ARTHUR MADERSON
"Verlayne"
The pose is beautifully captured with almost no detail, the contours of the head and shoulders merging unobtrusively with the background. The face is defined more sharply with later additions of pale impasto to the background.

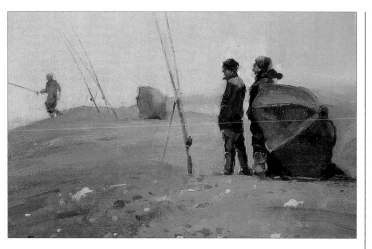

◀▲ RAYMOND LEECH
"The Last Cast"
Notice how none of the edges
or details has been "cleaned
up". The paler umbrella has
been very loosely painted
around the darker one. The sky
has been painted after the
figures, leaving a ragged border
of toned ground around them.

▼▶ OLWEN TARRANT
"La Calle Cruces"
Unlike the picture above, this is
made up of patches of paint,
each precisely laid in an almost
mosaic-like technique, with the
edges of each patch fairly
sharp.

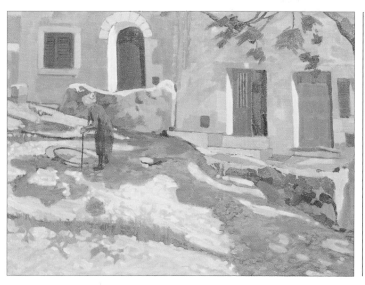

▲ CHRISTOPHER BAKER
"Vase of Flowers"
The clear, crisp edges of some
of the petals and leaves are a
vital element in this painting.
They have been defined with a
narrow sable brush in thin,
graphic lines, while other edges
have been left deliberately
rough in contrast, with patches
of ground exposed here and
there.

DRY BRUSH

The dry brush technique is a method of applying colour lightly so that it only partially covers a dry layer of colour below. The minimum of paint should be used on the brush, and the brushstrokes should be made quickly and with confidence – overworking destroys the effect. Dry brush is most successful when there is already some existing texture, either that of the canvas or that provided by previous BRUSHSTROKES.

It is a useful method of suggesting texture, for instance, that of weathered rock or long grass, but like all "special" techniques, should never be overdone or treated as a short cut.

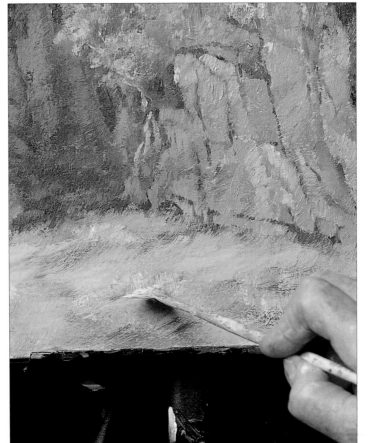

1 The artist uses a fan brush to lay a scant overpainting of thick, undiluted paint. The bristles of this type of brush are well splayed and deposit paint in a light covering of fine separate lines.

3 Dry brush is most effective when used light over dark. Here you can see how a succession of mostly paler layers are added one over the other.

2 The same technique has been used for the intricate pattern made by the branches of the small tree.

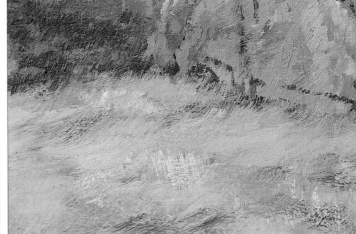

4 Again using a fan brush, these trees are given a soft, feathery appearance, with each thin spray of foliage being represented as one brush-stroke.

5 Brushstrokes must be decisive and not overworked, since the essential character of drybrush is the ability to see between the bristlemarks to the layers below.

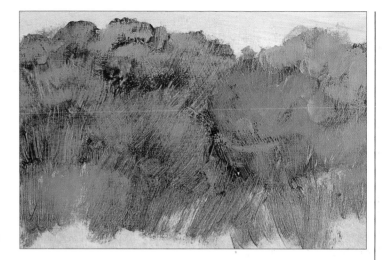

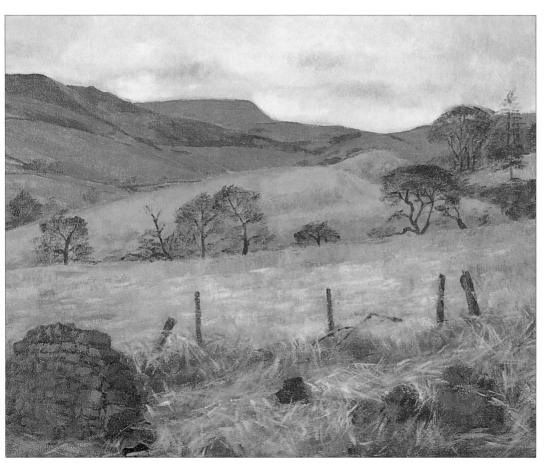

◄ HAZEL HARRISON "Winter, Derbyshire" Foregrounds are often tricky, but here the problem has been elegantly solved by the assertive painting of the weatherbeaten hay. It has been applied swiftly with relatively dry paint on a thin round brush.

Paint which has a high percentage of oil (see MEDIUMS) is described as "fat", and may be straight from the tube or mixed with extra oil. "Lean" paint is that which has been thinned with turpentine or white spirit only.

The golden rule in oil painting is to paint fat over lean, and there are good reasons for this. The drying oils used both in the manufacture of paint and as a medium do not evaporate. They simply dry and harden on exposure to air, but this takes a long time (six months to a year to become completely dry). During this process the paint surface shrinks a little. If lean paint has been applied over oily paint the top layer will dry before the lower one has finished shrinking, and this can cause the hardened lean paint to crack and even flake off.

So for any painting built up of several layers (see BUILDING UP) the oil content should progressively increase. Any initial UNDERPAINTING should be done with thinned paints, preferably the low oil ones such as cobalt blue, terre verte, lemon yellow and flake white. Some tube colours, such as burnt umber and Payne's gray are exceptionally rich in oil and remain fat even when diluted. The next layer can be mixed with a little linseed oil or other medium, while the final ones can be as thick as you like.

▶ The blue paint on the left is lean, as it has been well diluted with turpentine. The red paint, straight from the tube, has a much more substantial texture.

▲ Some preliminary underpainting in thin, lean paint provides a basis for the application of subsequent layers of oilier paint.

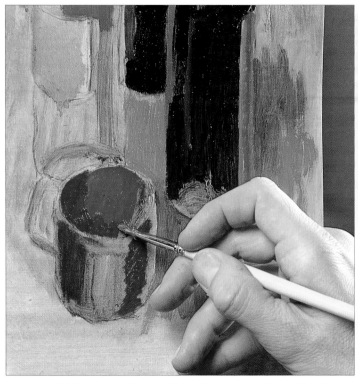

▶ The images are built up using slightly thicker paint, but this is less oily than that which will be used later.

► Apart from the danger of paint cracking as it dries, another reason for painting fat over lean is that it is difficult to add lean paint to a very oily layer. It does not adhere properly, so your brush tends to lift it off again.

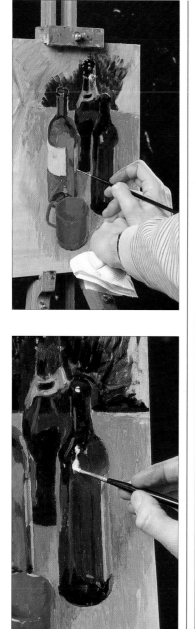

► Fat white paint, straight from the tube, is applied for the highlights. This must be done last, as it would be impossible to paint further over these oil-rich patches with the paint still wet.

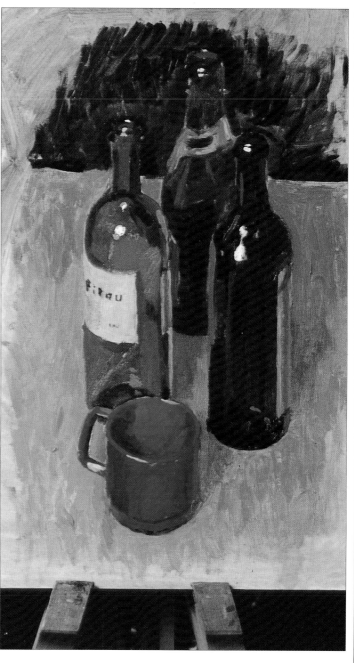

▲ The now complete painting shows a mixture of different paint thicknesses. The blue tabletop consists of quite lean paint while parts of the bottles have been built up with increasingly oily paint.

This is perhaps the most natural, and certainly the most direct method of applying paints, and although it has slight connotations of "child art" it has a definite place in serious painting. The fingers are sensitive tools, and are often superior to either brush or palette knife for subtle effects and fine control of paint thickness. Many painters have used the technique, among them Leonardo da Vinci (1452-1519), Titian (c.1487/90-1576), Goya (1746-1828) and Turner (1775-1851). It is said of Titian that he would soften outlines, dab in highlights, accents and other final touches by using his fingers more than his brush.

The fingers and hand are particularly useful for the rapid application of undiluted paint over large areas, as it can be rubbed well into the canvas fibres to give a greater degree of adherence. Paint can also be smeared off by hand until it is at its desired thickness. When modelling rounded forms, as in portraiture or figure painting, this technique can be invaluable, as it allows you to obtain very smooth gradations of colour and tone in which the underlying layer shows through as much or as little as you want it to.

It should be borne in mind, however, that many pigments are toxic, so always clean your hands thoroughly at the end of a painting session. You can also avoid direct contact with the paint altogether by working with a rag wrapped around your fingers or bundled into a suitably shaped wad.

▲ A combination of fingers and brushes was used for this painting. Having blocked in the basic features in slightly diluted paint the artist blends them with her finger and then adds further thin layers. She is careful to keep the colours very close in tone so as not to lose the misty atmosphere.

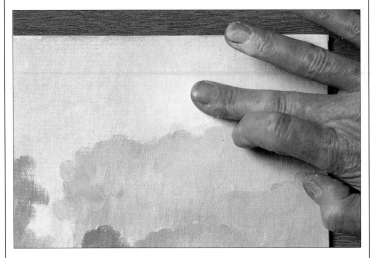

▲ Layer upon layer of pale colours are rubbed into one another in the sky area to produce an indefinable and luminous quality. The trees, in contrast are blended to a lesser degree to retain their pale but distinct outlines.

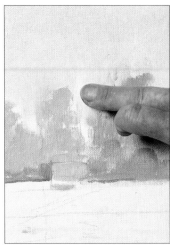

▲ The contours of the distant trees are smudged into the sky so that they appear to recede from the viewer.

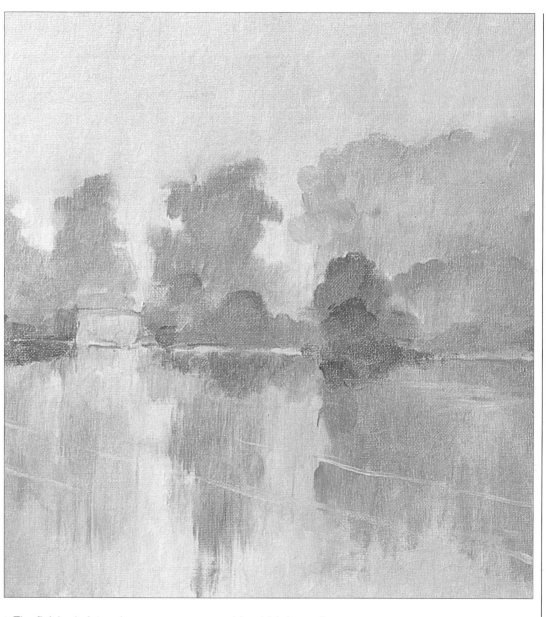

▲ The water, like the sky, is built up of many thin layers of paint. The thickness of the paint can be very precisely controlled by the finger method, and in this case it becomes both thicker and darker towards the bottom of the picture.

▲ The finished picture has a wonderfully atmospheric effect. Handling the paint with the fingers has helped to ensure the ethereal quality of the scene is maintained throughout. The picture has been painted in a limited colour range and in a high key – that is, only pale colour mixtures have been used.

A glaze is a thin layer of transparent paint laid over a dry layer which can be either thick or thin. Since the lower layer is visible through the glaze, the effect is quite different to anything that can be achieved with opaque paint.

The Renaissance painters achieved wonderfully luminous reds and blues by building up successive layers of ever-richer colour, using little or no opaque paint, but glazing over IMPASTO is equally effective. Rembrandt (1606-69) built up the light areas of his portraits with thick flake white modified by a series of glazes, and Turner created his distant luminous skies by the same method. Rembrandt always used transparent paint for shadow areas, which gave the dark passages a rich glow and an effect of insubstantiality — the eye is unable to judge exactly where the light is coming from.

Since a glaze alters the colour of an underlying layer it can serve as a method of COLOUR MIXING. For example, a transparent ultramarine blue glaze over yellow produces a green, while a glaze of alizarin crimson over blue will make purple.

Before a glaze is applied the previous layer of paint must be dry to the touch. If glazing is to be put on directly over an UNDERPAINTING, the latter can be done in acrylic paint (which dries in some cases within minutes). Oil glazes, or indeed any oil paint, will lie perfectly well over acrylic, but acrylic cannot be laid over oil.

The best MEDIUMS to use for glazing are the modern synthetic ones sold specially for the purpose; ask your art supplier if you are not certain what to buy. Linseed oil is not suitable. Because a high proportion of oil is needed to make the paint transparent, it will simply run down the support or merge with adjacent glazes.

1 Glazing medium straight from the tube (top) and mixed with paint (bottom).

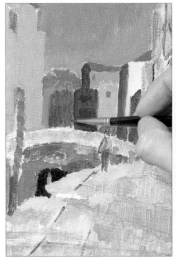

3 Shadows cast across other distant buildings are glazed. Details can be added later within the glazed layers.

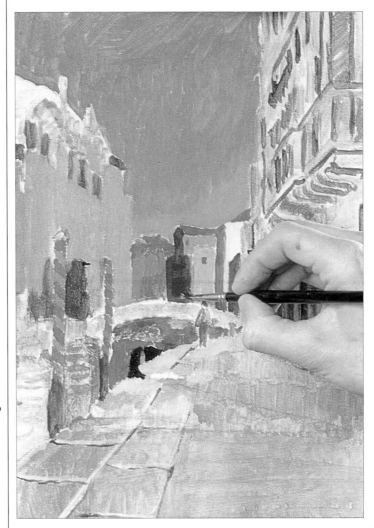

2 The underpainting has been left quite pale so that it can be built up by glazing. Here the distant red house is being glazed with alizarin crimson.

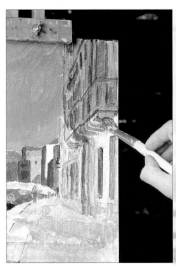

4 The detail already painted remains visible through the purple glaze.

5 The purple glaze is continued over the whole right-hand wall. Further glazes can be added at a later stage.

6 The glaze used here is a mixture of ultramarine, alizarin crimson and Payne's gray.

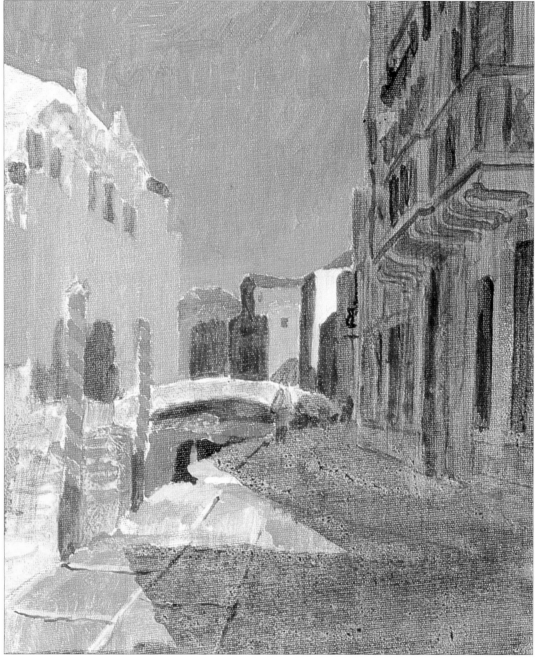

7 The large, bold shadows of the foreground and to the right of the picture demonstrate the usefulness of glazing as a technique. Previously painted detail is not obscured, and the colour of the underpainting glowing through the glaze gives a particularly rich effect.

GROUNDS

Commercially prepared canvases and painting boards are always sold ready primed, that is, they are treated with a layer of paint known as a ground. This not only provides a good surface to paint on, it also acts as a sealant to separate the paint from the support. Without it, oil will be sucked from the paint by the absorbent surface, leaving a rather powdery, matt finish. Some artists like this effect, and choose to paint on unprimed surfaces, but it is not in general a sound practice as there is a tendency for the paint to crack, and the canvas may rot in time.

Grounds are sometimes prepared by artists according to individual recipes, and these vary so widely that it is not possible to describe them. However, for those who prefer to prepare their own canvases or boards (see SUPPORTS) there is a good selection of primers on the market which are adequate for most needs. The modern acrylic primers, for instance, can simply be applied to canvas, hardboard or paper in two or three coats and you are ready to paint in a few hours. Ready mixed oil primers are also available, but in this case a coat or two of size must be applied first to seal the support. Household paint can be used in emergencies, but in general it is wisest to stick to the products sold specifically for the job.

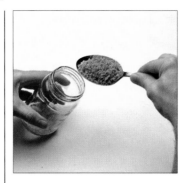

1 Canvases and boards which are to be given an oil ground must be sized first. Use rabbitskin size (sold in most good art shops) not builders' size, as the latter contains a fungicide which could damage your painting. Put one rounded tablespoon of crystalline or granular skin size into a 450g jam jar.

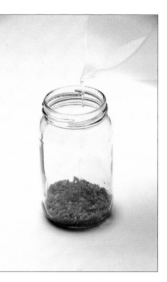

2 Add just enough water to cover the size and allow it to soak for about 20 minutes. It will swell during this time.

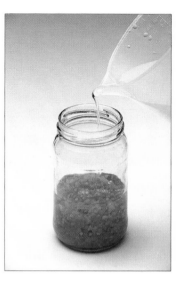

3 Add more water until the jam jar is three-quarters full.

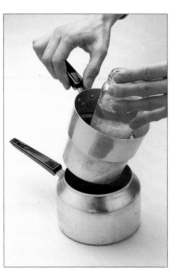

4 The size must now be heated, but not allowed to boil. Place the jam jar in a double saucepan or rest it on a saucer or trivet in an ordinary saucepan.

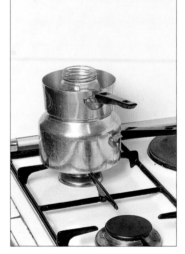

5 Let it warm gently for about half an hour.

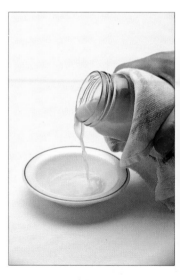

6 To test that the size is of the right consistency, pour a small sample into a saucer and allow it to set.

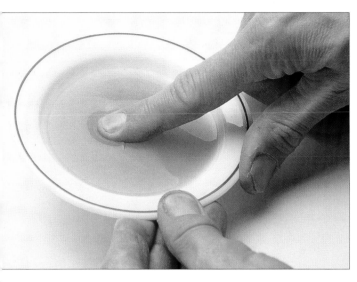

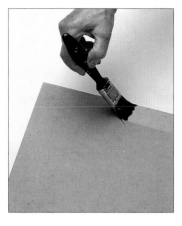

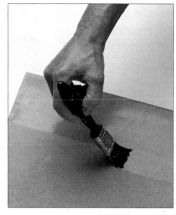

8 Before applying the size to sanded hardboard (as shown here) or canvas re-dissolve it by warming gently. Use a well-loaded 25mm or 38mm brush and stroke it in one direction only across the surface, starting from one edge. Once dry, repeat in the opposite direction.

If using hardboard or cardboard a coat of size on the reverse side prevents warping. Leave to dry thoroughly for 12 hours and then sand lightly. The surface is now ready for priming.

7 It should be rubbery yet soft enough for you to be just able to break it with your finger. If it is too thin reheat with more size; if too solid add more water. The size will take a few hours to set in the jam jar. Freshly prepared size remains usable for two or three days or up to a week in a refrigerator.

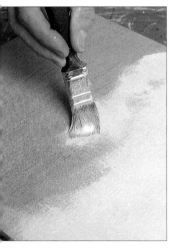

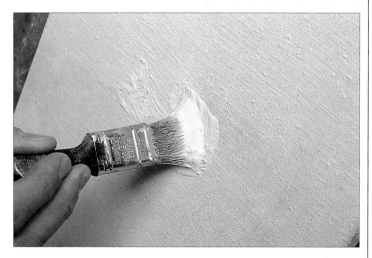

9 If an acrylic primer is used, no sizing is necessary, as these are designed to adhere to untreated surfaces. Using a household brush, apply the primer with a scrubbing motion and work it across the canvas in one direction only.

10 Once the first coat of primer is dry, lightly sand it down if the surface is grainy.

11 If you want to accentuate the brushmarks, apply a second coat of primer in the same direction as before. Alternatively, brush at right angles to give a more even surface. Finally, sand it again very lightly unless you prefer a rougher texture to paint on. If a toned ground is required acrylic primer can easily be tinted by mixing in acrylic colours (see also COLOURED GROUNDS).

This term describes paint that has been applied thickly enough to retain the marks and ridges left by the brush or painting knife. The ability to build up oil paint is for many people one of its main attractions. The picture surface can acquire a three-dimensional quality which can be used to model form and even mimic the texture of the subject. Turner (1775-1851) built up layers of paint in the pale areas of his paintings, such as clouds and sun, and some of Rembrandt's portraits are almost like relief sculptures.

Thickly applied paint is often used in conjunction with GLAZING. A dark glaze over a light-coloured impasto will cling to the grooves and pits, emphasizing the BRUSHWORK. This can be an effective way of depicting texture; for example, rough stone or wood.

The paint can be applied with a brush or painting knife for impasto work, or it can even be squeezed out straight from the tube. Some makes of paint are particularly oily, in which case excess oil should be absorbed by blotting paper or the brushmarks may become blurred. If the paint is too thick a little linseed oil can be added. There are also MEDIUMS specially made for impasto work, which act as extenders, bulking out the paint. For anyone working on large scale these are very helpful, as they can halve your paint costs. They also help the paint to retain the marks of the brush and speed the drying process, which is an important consideration when more layers of paint are to be added.

1 So far only fairly thin paint has been used. The brushwork is rather monotonous and the picture lacks vitality, so the artist decides to introduce some eye-catching accents.

2 Thick, unmixed white paint is dabbed in place to represent foaming breakers.

3 Some yellow ochre "pushed" into the white suggests churned-up sand, while the grey provides shadows below the tops of the breakers. Finally a thin sable brush was used to lay cadmium red impasto as a foreground accent.

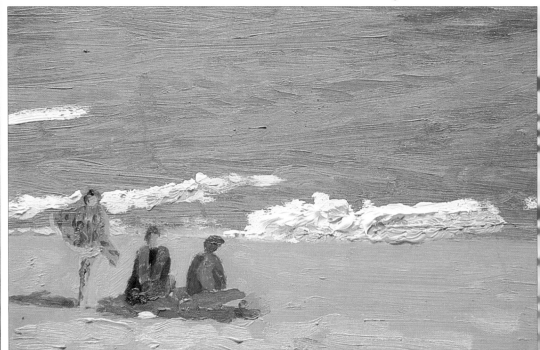

4 The whipped cream quality of the impasto is clearly seen in this photograph. It will not change as it dries – one of the unique characteristics of oil paint.

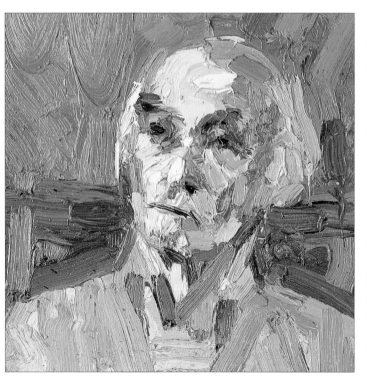

▲ ARTHUR MADERSON
"Towards Evening, Weymouth"
The entire painting is composed of impasto brushmarks in a stunning mosaic of colour. Much of it has been scumbled and added WET INTO WET, giving rise to streaking and mixing of colour. As is obvious from the detail (above), the artist loves the sensual feel of thick oil paint, and the rich texture he creates is as important as the colours or the subject matter.

◄ GEORGE ROWLETT
"The Artist's Father"
This artist also likes thick paint, and often applies it with knives and his fingers as well as brushes. In this powerful yet sensitive portrait he has allowed the thick, juicy colour to dribble down the canvas in places, and has used it throughout in an inventive and expressive way.

Sometimes you may find that the paint texture provided by brushes or painting knives falls short of your expressive needs. Or you may simply want to experiment with other methods. The slow-drying nature of oil paint, together with its plasticity, enables it to be re-textured on the support itself by pressing a variety of materials or objects into it and then removing them to leave imprints. Almost anything can be used for this method — objects with holes (slotted spoons), grooves (forks), serrated edges (saw blades) or any open structures tend to leave the most satisfactory marks. The thickness of the paint, the pressure you apply and other factors will affect the texture and quality of the imprint, so try out different effects. Experimentation is essential before committing yourself to part of an actual painting.

This technique is perhaps most relevant to non-representational painting, but it has been used successfully by a number of contemporary artists to create exciting textures where the surface quality of the paint is of paramount importance.

◄ Pink IMPASTO has been imprinted with the base of a film can. Here and there the pink paint has come away to reveal the red ground.

► Here green paint has been dabbed with crumpled foil so that a faint image of yellow ground shows through. The streaks are made by the SGRAFFITO technique.

▼ This pitted and veined pattern has been formed by pressing a teaspoon into wet paint and slightly twisting it.

◄ The ribbed texture was made by the blot-off method, a similar principle to imprinting. In this case a piece of non-absorbent paper was placed on wet paint and then pulled away. The brick design is the imprint of the end of a matchbox.

► This pattern was made with a fork, which has removed the upper layer of dark paint to reveal the red underlayer.

KNIFE PAINTING

Applying thick paint (see IMPASTO) with knives gives a quite different effect to applying similarly thick paint with brushes. The knife squeezes the paint onto the surface, leaving a series of flat, smooth planes often bordered by ridges or lines where each stroke ends. It is a versatile and expressive method, although initially somewhat trickier than brush painting. The marks can be varied by the direction of the knife, the amount of paint loaded onto it, the degree of pressure applied, and of course the knives themselves.

Painting knives are not the same as palette knives, which are intended only for mixing paint on the palette and for cleaning up. Unlike the latter, they have cranked handles and extremely flexible blades of forged steel. They are made in a wide variety of shapes and sizes from large straight ones to tiny pear-shapes ideal for flicking paint onto the surface.

Knife painting is ideal for the artist who enjoys the sensuous, "hands-on" aspect of mixing and applying thick, creamy paint. However, care must be taken not to build up the paint too thickly; it may crack if it is more than about half a centimetre thick at its maximum.

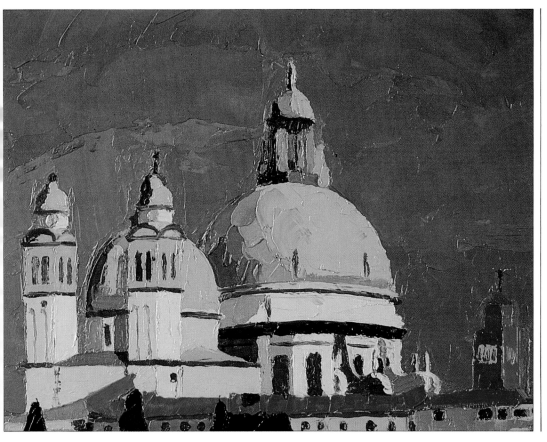

▲ Knife painting needs to be done with confidence and no hesitation, so it is wise to practise before trying out the method on a painting. The effect is quite different to that of brushstrokes; notice how the paint is squashed out in ridges at the edges. When one colour is laid over another there will be some mixing and streaking of the paint, which can be very effective.

◄ JEREMY GALTON
"San Giorgio Maggiore, Venice" (detail)
Knives are often used only for certain parts of a painting, such as final highlights in thick impasto, but in this case the whole picture was built up with knife strokes, giving a lively surface texture. It is a technique well-suited to architectural subjects, as considerable precision can be achieved.

1 Thick paint is smeared onto the surface in a sideways sweep of the knife. Impasto is applied right from the start in this still life.

3 A narrow-bladed knife drags paint onto the surface in a long, thin stroke.

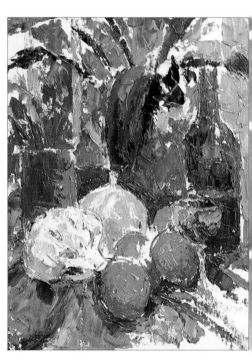

4 The side of the knife can be useful to make fine, linear marks, as shown here. You can also make dabbed marks the exact shape of the blade if desired.

2 The picture is built up over a rapid drawing done in thinned paint. UNDERPAINTING would be pointless, as it would be completely obscured by the IMPASTO.

5 The picture is built up gradually, rather in the manner of a jigsaw. Each new colour is well mixed before application.

6 The texture of the paint gives a satisfying three dimensional quality to the fruit.

7 Each separate patch of colour joins with its neighbours to form a near-continuous covering of paint. The final texture of smeared and ridged paint has a lively, sparkling quality.

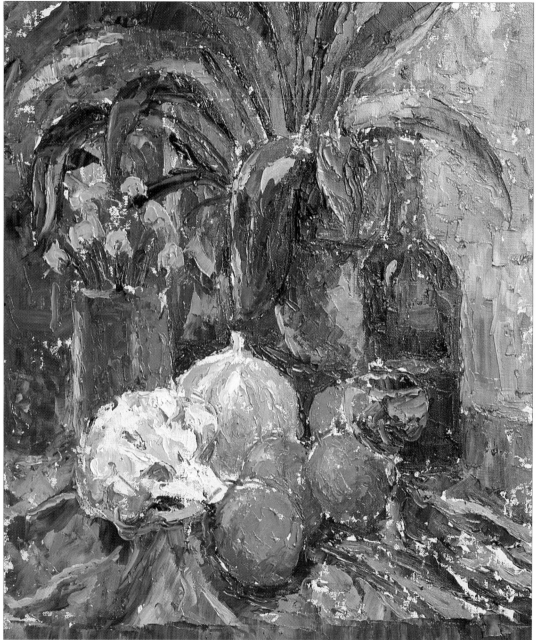

MASKING

This simply means covering up parts of the picture surface with card or tape so that they remain untouched by paint being applied to adjacent areas. The use of masking tape is invaluable for any paintings that rely on hard-edged, ultra-straight boundaries between colours and tones, while cut-out pieces of card or adhesive film can be used to achieve crisp, curved contours. Masking is not recommended for the freer, more impressionistic type of painting, as such hard edges would look incongruous (see DEFINING EDGES).

The mask must be applied to virgin canvas or a thoroughly dry underpainting, and the paint should be fairly thick to prevent it running underneath. It should be left to become dry or at least semi-dry before the mask is removed. If the adhesive has hardened, as it may after a period of time, it can usually be dissolved with lighter fuel or white spirit.

A variation on masking is stencilling, which involves cutting a shape out of stencil paper, acetate film or some other tough material and dabbing or brushing paint through it. This enables you to repeat a motif over the picture surface.

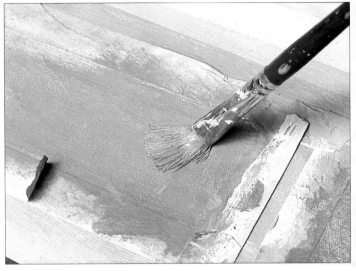

▲ Paint thinned with an oil and turpentine mixture was applied quite freely over the tape.

▼ The paint was allowed to dry and the tape was lifted, giving clean, precise edges.

▲ This artist likes a crisp, sharp-edged effect, and uses his paint quite thinly. He began by making a careful UNDERDRAWING with a pencil and ruler and then placed masking tape over all the edges.

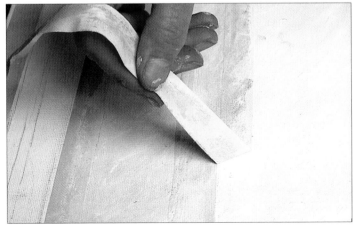

▲ The dark paint for the floor area was applied in the same way.

▲ The area around the broom was to be spattered, so the rest of the painting was protected with newspaper and more masking tape.

▶The effect of the spattering can be seen in the finished painting, contrasting with the clean straight edges.

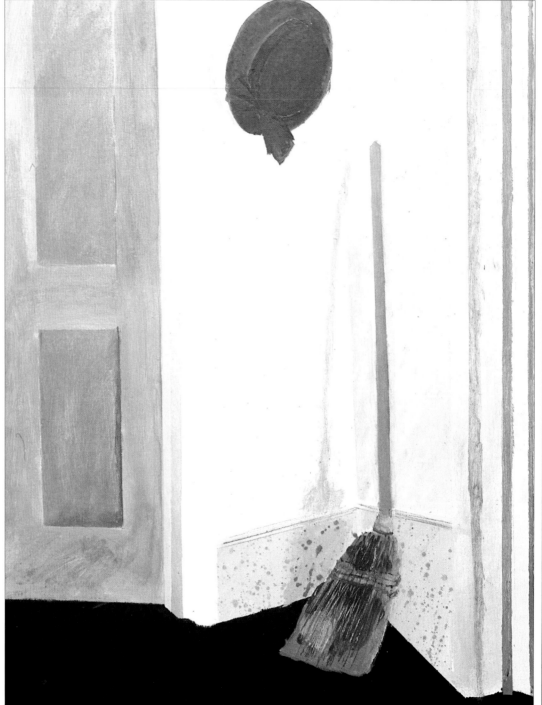

This word embraces all the different fluids used both in painting and the manufacture of paint. They fall into four main categories.

Binders are the drying oils which are mixed with pigment particles in the manufacture of paints to form a thick paste. They are usually linseed oil and, for the paler pigments, poppy oil, and they are called drying oils because they dry on exposure to air.

Mediums (a more specific use of the word) are oils or synthetic "oils" used in the course of painting. Their purpose is to change or enhance various properties of paint, such as consistency, drying time and glossiness. Linseed and poppy oil are also used in this context.

▲ From top to bottom: paint thinned with white spirit; paint mixed with linseed oil; paint mixed with an impasto medium, causing it to retain the marks of the brush.

Diluents are liquids which may or may not act as solvents, used to dilute and thin down paints to aid their application. They evaporate once exposed to the air, leaving paint of the original composition. Turpentine and white spirit are the most-used diluents.

Varnishes are liquids designed to cover a finished painting in order to protect it and to provide the desired matt or glossy finish.

The binders, mediums and varnishes are all mixtures of one or more of the following: drying oils, resins, waxes, diluents and siccatives. All of these may either be natural or synthetic. The resins, such as damar, mastic and copal, contribute towards a hard protective film in varnishes and add gloss to paint mediums. Waxes such as beeswax are used in GLAZING mediums and also in those designed to improve the IMPASTO effect of paint. Siccatives are drying agents, usually containing lead, manganese or cobalt, sometimes added to the medium. (Some paints also contain these, and will accordingly be quick driers.) An art shop is usually stocked with a daunting array of bottles, but actually the beginner need purchase nothing more elaborate than one bottle of distilled turpentine with which to thin paints for the initial layers of UNDERPAINTING, and one bottle of refined linseed oil. The latter, diluted with at least twice its volume of turpentine, gives a fatter, glossier texture to the final layer of paint (see FAT OVER LEAN). You will also need white spirit for washing brushes, but this is usually more cheaply obtained from hardware and DIY stores. It is a cheap mineral turpentine substitute which can also be used as a diluent and is useful for those who are allergic to turpentine.

If in time you find that the basic linseed oil-turpentine mixtures do not suit your needs, the only course is to experiment with other mediums until you find one or more that you are happy with. All manufacturers provide information on their products, so it is wise to consult these before making your choice. You may decide to dispense with a medium altogether; there is no reason why paint should not be applied neat, particularly for impasto areas such as highlights, laid towards the end of a painting.

▲ Synthetic painting mediums can help to reduce the drying time and change the consistency of the paint.

▲ From left to right: gloss varnish, retouching varnish and matt varnish.

▲ Drying oils and solvents. A large variety of products is available from manufacturers, but most artists start with refined linseed oil and distilled turpentine only, extending their range when specific needs arise.

MIXED MEDIA

This term is most often found in the context of "works on paper", which may be mixtures of watercolour with gouache, pastel, pencils, wax crayons and so on, but other media can also be used in combination with oil paints. It can be very liberating not to be bound by one medium, and is sometimes a way to save a less than successful painting.

As is explained in the FAT OVER LEAN article, oily pigments can be applied over less oily ones. Thus UNDERPAINTING in watercolour, gouache and particularly acrylic forms a very good base for overpainting in oil.

The mix of textures provided by the use of different media can be highly expressive. Fast-drying acrylic paints can be applied both thinly like watercolour or thickly like oils, and are frequently used nowadays to lay the first few stages of a painting.

You cannot paint with acrylic over oil, as the paint does not adhere, but oil, once dry, can be worked over with both soft pastel and oil pastel, and drawn into and over with pencils. Such techniques can produce intriguing broken textures, rather like DRY BRUSH painting, and also provide a means of sharpening up and redefining edges and small details. If pastels are used, the picture should be mounted under glass for protection, so if you plan a mixed-media approach it may be best to use a paper support (see SUPPORTS).

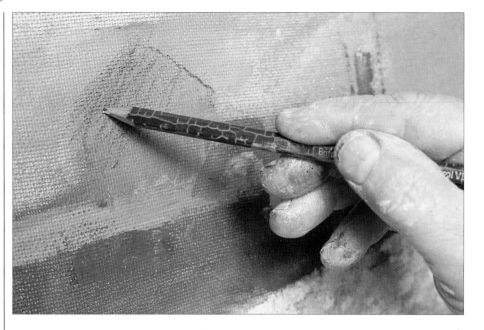

1 Pencil combines well with oil paint, and here the artist is using one to redefine forms and to provide a variety of textures. Much of the pencilling will remain visible in the final picture.

2 Oil pastel can be dabbed and stippled over oil paint, and in this case is ideal for describing the dancing light on the water.

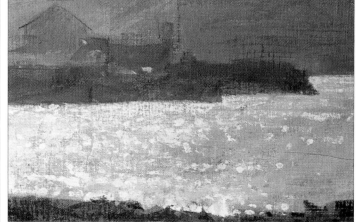

3 The graphic quality of the pencil, the heavy texture of the canvas, the large swathes of oil paint and the dabs of oil pastel complement one another beautifully. It is worth mentioning that this exciting painting was derived from a rather dull photograph; the inventive use of media minimizes the temptation of direct copying and encourages the artist towards a personal means of expression.

MONOPRINTING

This is a fascinating and enjoyable technique which is a kind of cross between painting and printmaking. It was widely used by Degas (1834-1919), and has been extensively exploited by artists ever since. There are two basic methods. In the first, a painting is done on a sheet of glass or other non-absorbent surface, and a piece of paper is laid over it and gently rubbed with a roller, or simply your hand. The paper is then carefully removed, and you will see a "printed" version of the original painting.

This can be left just as it is, if satisfactory, or allowed to dry and then worked into with more paint or with oil pastels (which combine very well with paint). Some experiment will be needed to find the right consistency of colours for the painting; it needs to be fairly juicy but not so thick that it will smudge and smear. Experiment, however, is part of the excitement of the method, which is always to some extent unpredictable.

The second method involves covering the whole of the glass slab with an even layer of paint, leaving it to become slightly tacky and then placing paper on top as before. The design in this case is made by drawing on the back (top) of the paper so that selective pressure is applied; only the drawn lines will print. There is a trial and error factor here also, since if the paint is too wet it will simply come off all over the paper.

You can achieve a wide range of different effects in this way, varying the kind of line you use, and creating textures by pressing objects onto the paper. You can also print in two or more colours, simply by inking up the glass with a different one for each printing. This does take more time, though, because you must allow the first colour to dry before printing another over it.

▼ INGUNN HARKETT
"Figure 1"
One of the beauties of the monoprinting technique is that it is very quick and direct. Oil paint or printing ink can be used, but the examples shown here have all been done with paint. The image was painted on a glass slab with thick but not oily paint (too much oil makes it difficult to control) and a print was taken by simply rubbing with the hand.

▶ INGUNN HARKETT
"Figure 2"
The same method was used for this print, in which the bold, sweeping brushstrokes are very much a feature of the finished image. The white outlines were achieved by drawing into the paint with a piece of cardboard - any tool that comes to hand can be used.

▲ INGUNN HARKETT
"Still Life in Spring"
As before, the picture was painted on glass and then printed, but the printing paper itself was given a thin coat of pink and blue acrylic first. Firm pressure was applied with a hand roller as a clear image was needed. The print was then worked into with more oil paint to add an extra dimension of texture and BRUSHWORK.

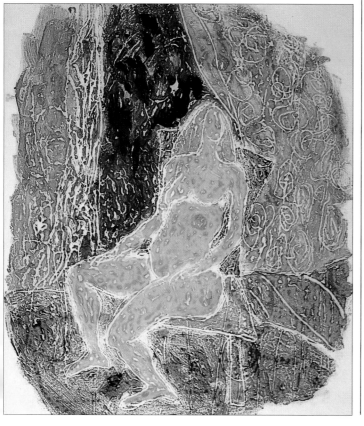

◀ INGUNN HARKETT
"Seated Nude"
This more elaborate picture was the result of several stages of printing, with further colours and textures added to the original painting on glass each time. This creates intriguing effects, as the paint builds up on the glass to give different textures to the print. The white lines were again produced by drawing into the paint, in this case with a brush handle.

There are two meanings of the word palette, one referring to the object on which paint is mixed, and the other to the actual colours selected as a basis for all mixtures. This article deals with the second and wider meaning, the other being discussed under COLOUR MIXING.

Choosing a range of colours for a painting depends very much on individual interests and the subject being depicted. For example, Van Gogh (1853-90) used mainly heavy, dark colours — earthy browns and black — for his early works showing the misery and poverty of peasant life in his native Holland. When he moved to the South of France and the sun became one of his major themes, he abandoned these and switched to bright, pure colours with a preponderance of yellow.

A starter palette

However, those relatively new to painting will not have established this kind of specific colour requirement, so the initial choice has to be made on a more practical basis. The essential colours are the three primaries: red, blue and yellow. These cannot be made from mixtures of any other colours. There are, of course, many different versions of the primaries, but a good choice to begin with would be, for the reds, cadmium red and alizarin crimson; for the blues, French ultramarine and Prussian blue or phthalocyanine blue; and for the yellows, cadmium yellow and lemon yellow.

These will produce a wide range of secondary colours, the term used for a mixture of two primaries, while if these are in turn mixed with each other or with primaries an almost unlimited range of neutral hues can be obtained.

You will also need white, of course, to lighten the tone of colours (see COLOUR MIXING), and one or two greens and browns. Theoretically these can be made from the primaries, but mixing every single colour is a laborious process and not always productive. Viridian and cadmium (or chrome or sap) green, raw umber, burnt umber and burnt sienna are found on most artists' palettes, as is yellow ochre, a particularly useful colour. Black is not strictly essential, but many artists find it valuable for mixtures — indeed Renoir (1841-1919) described it as "the queen of colours".

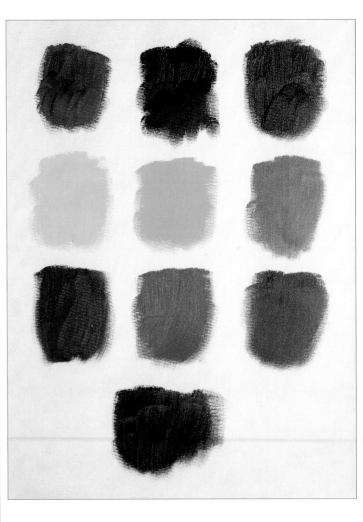

► The arrangement of paints on your palette is purely personal, but be consistent so that you can always quickly find the colour you want. The dark colours all look rather similar, so knowing their positions will prevent you from picking the wrong one and ruining a mixture. With experience you will get to know the relative quantities to squeeze out of the tubes so that wastage is kept to a minimum. The colours on this palette are, from right to left: titanium white, French ultramarine, cobalt blue, viridian, lemon yellow, cadmium yellow, yellow ochre, burnt umber, cadmium red, alizarin crimson and Payne's grey. The same colours, minus the white, are shown in the upper photograph (read from left to right).

Working with a limited palette

It is advisable to start with a small palette such as this so that you get to know the mixtures you can — and cannot — achieve. Other colours can be purchased later if needed.

In any case too wide a colour range can diminish a painting. Both Turner (1775-1851) and Monet (1840-1926) created subtle harmonies by using a range of blues and blue-greys with occasional touches of yellow for contrast. This bias towards one dominating hue is called a colour key, and can be identified in the majority of paintings.

You can learn a great deal by deliberately restricting your palette, so if a subject strikes you as being predominantly green, blue or brown, try to stay within that range of colours. This will impose a natural harmony on your work as you will be using the same colours again and again in different mixtures.

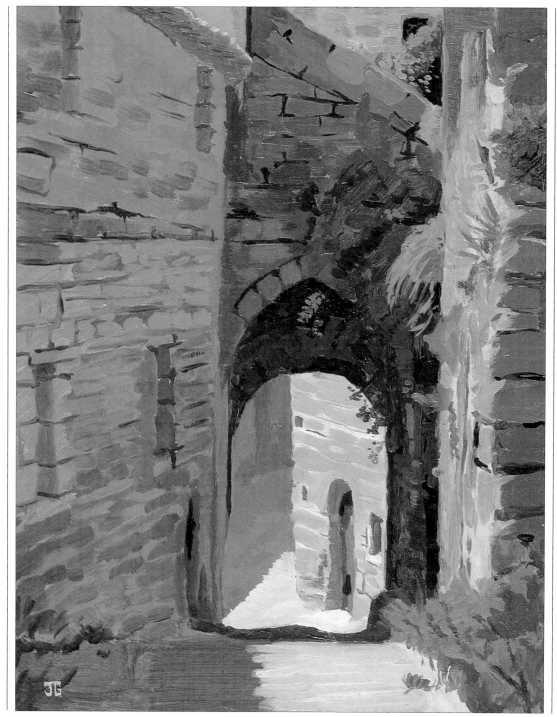

▶ JEREMY GALTON
"Provencal Archway, Lacoste"
This was painted with only six colours plus white: French ultramarine, raw sienna, burnt umber, cadmium yellow, Winsor violet and ivory black. To some extent the choice of colours depends on the subject. For a flower piece, for example, you would certainly need some reds and perhaps purples, but most amateurs buy far more colours than they need.

PEINTURE A L'ESSENCE

This was a technique invented by Degas (1834-1917), and also used by Toulouse-Lautrec (1864-1901), which involved draining the paint of oil and mixing it with turpentine to give it a matt, gouache-like consistency. Degas disliked thick, oily paint, and sometimes scraped it off the canvas when wet (see SCRAPING BACK) to achieve the soft, fresco-like effects he admired.

He often painted on unprimed cardboard or paper mounted on canvas, which absorbed any residue of oil. The thinned paint removed any surface texture and allowed him to use areas of flat colour. Because it dried quickly, he found it ideal for preparatory studies, though he did occasionally use it for finished paintings also.

Lautrec followed Degas' lead, also painting on cardboard. His approach was primarily linear, and he used the thinned pigment very much as a drawing medium. Some of his paintings on board have rather the appearance of pastels.

The term *peinture a l'essence* is not much used today, but the method itself is often employed by artists who share Degas' antipathy to oily paint. Much of the oil can be drained off by laying out the colours on an absorbent surface such as thick paper or untreated cardboard instead of the conventional palette. Although this "oil-free" oil paint looks similar to gouache, it is more versatile and easier to use, as it allows for overpainting without disturbing earlier layers. It is well worth experimenting with, particularly for quick sketches.

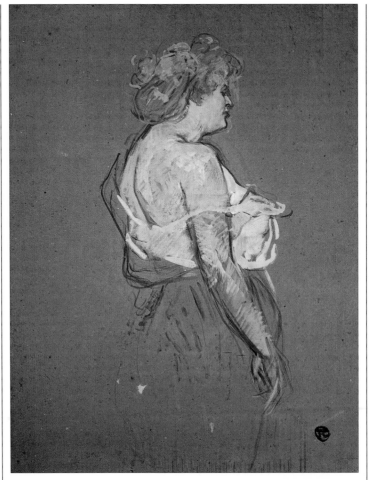

▲ EDGAR DEGAS
"Two Laundresses Ironing" (detail)
Degas had a deep antipathy to oily paint, and in this case has worked on an unprimed canvas, which absorbed the excess oil. Like Lautrec's, the picture has a pastel-like quality – Degas worked extensively in pastel, particularly towards the end of his career.

▲ ▶ HENRI DE TOULOUSE-LAUTREC
"Lucie Bellanger"
The combination of thinned paint and the absorbent cardboard support allowed Lautrec to literally draw with his brush, an approach which suited his highly graphic style. The effect is rather similar to a pastel.

POINTILLISM

This is the technique of covering the whole canvas with tiny dabs or points of colour laid side by side but not overlapping so that when viewed from a distance they merge together to create effects of colour and tone. Evolving from the Impressionists' use of BROKEN COLOUR, the technique was pioneered by Georges Seurat (1859-91), who preferred to use the term divisionism. Seurat was fascinated by colour theory, and much influenced by the new scientific discoveries about the properties of light and colour made by Chevreul and Rood, who had shown that different colours when lying next to each other will mix in the eye of the viewer. The principle of optical mixing is made use of in both colour television and colour printing: an entire picture is composed of countless dots of three primary colours.

Seurat not only created secondary and tertiary colours in this way but also believed he could enhance the apparent brightness of one colour by placing its complementary next to it and vice-versa – another of Chevreul's theories.

Wonderful as many of Seurat's paintings are, pointillism in its pure form is a very limited painting technique, as several other artists who took up the idea quickly discovered. Paul Signac (1863-1935), Camille Pissarro (1830-1903) and Henri-Edmond Cross (1856-1910) were all enthusiastic about it, but soon began to modify it by enlarging the dabs of paint so that they would contribute towards the composition rather than merging into a single image.

▲ GEORGES SEURAT
"The Can-can"
In this painting the separate dots of pure colour have resulted in an overall subdued tint. This may be at least in part because of fading; Seurat's contemporaries began to notice a dulling of the colours soon after his pictures were finished. The minute size of each brushstroke gives a good idea of how slow and laborious the method must have been. It is hardly surprising that later artists modified it, but Pointillism has nevertheless been extremely influential.

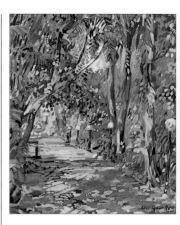

◄ JAMES HORTON
"Venice from San Marco"
Large dabs of juxtaposed colours are particularly striking here. The patches of blue in the water are approximately complementary to the orange reflections of the sun, and they thus enhance the latter's brilliance.

▲ PETER GRAHAM
"Courtyard"
This dazzling painting demonstrates a highly successful adaptation of Pointillism. The bold patches of pure, unmixed colour are so large that little optical mixing occurs, but at a distance the reds and blues do combine to give an overall purple effect.

◄▼ ARTHUR MADERSON
"Ely Cathedral"
The major part of the overpainting (left) is made up of stabs of relatively dry paint dragged onto the surface, allowing the previous statement to show through. The artist has used fairly pure colours which mix optically when viewed at a distance, and parts of the painting are very close to Seurat's own Pointillism, as can be seen in the detail below.

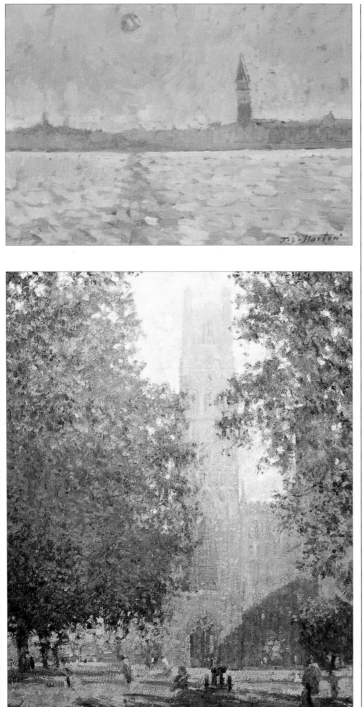

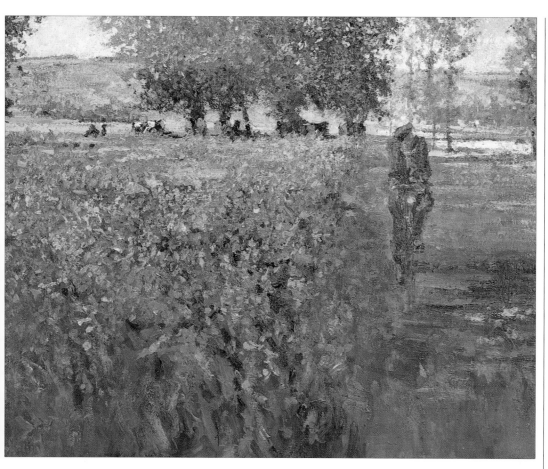

◄ ARTHUR MADERSON
"Point of Sunset, Dordogne"
Fine stippling in the distance
varying in size through to rich,
slurred gestures in the
foreground form the basis of
this essentially Impressionist
painting. A bright red ground
can be seen at intervals
between the brushmarks,
enhancing the vibrant effect.
The artist has consistently
avoided any dark browns, greys
or blacks, constructing the
shadows from violets, blues
and greens.

◄ This detail shows the artist's
working method very clearly.
Over the red ground there is
UNDERPAINTING consisting of a
network of mainly dark greens.
On top of this, a multitude of
paler dabs of IMPASTO build up a
shimmering web of colour.

Removing paint from the canvas or board with the flat edge of a painting knife is not only a way of making CORRECTIONS, it is a valuable painting technique in its own right. Scraping off paint will leave a vaguely defined ghost image formed by the remaining thin layer of colour, so it follows that deliberate scraping back allows you to build a painting in a series of such layers without using diluents and without leaving brushmarks.

On canvas the knife removes most paint from the raised fibres, leaving that between the weave more or less untouched, while on a smooth panel scraping back produces a very flat, almost texture-free layer of paint.

Whatever support you use the effect of repeated scraped-down applications of paint (allowing each to dry in succession) is quite different to anything that can be achieved by conventional methods. The technique was quite unintentionally pioneered by James Whistler (1834-1903), who often scraped down his portraits at the end of a session, preferring to begin again rather than overworking. Having done this with a painting of a girl in a white dress, he suddenly found he had just the gauzy, transparent look he wanted for the fine, delicate fabric.

Over a white ground scraped-back paint receives illumination from underneath in the manner of a glaze, while over a coloured underpainting it can act as a means of subtly modifying colour.

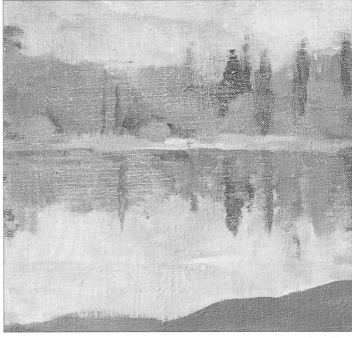

2 This detail illustrates how the scraped paint is removed from the crests of the canvas weave but remains in the troughs. The scraping action sometimes gives a streaked effect, as here.

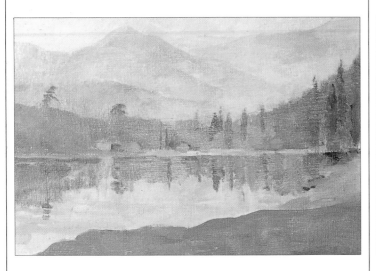

1 The technique of scraping back lends itself well to a hazy, atmospheric scene such as this. The picture has already been scraped back once, hence the rather washed-out image.

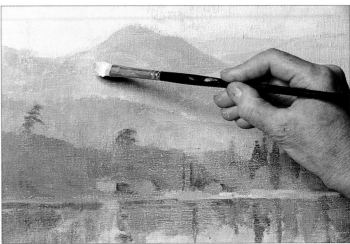

3 More paint of a different colour and tone is now added. This will eventually be scraped back to leave some of the old paint together with some of the new in a somewhat random manner. The colours will, in effect, mix optically.

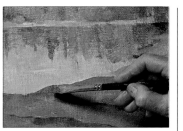

4 Layers of bluish and then greenish paint are being applied and then scraped down with a palette knife.

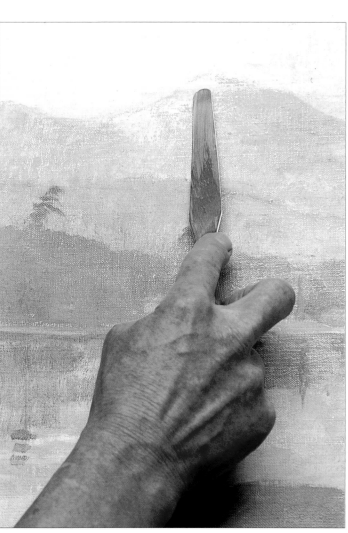

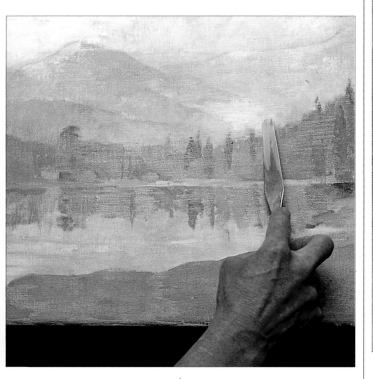

5 The trees on the far shore of the lake are now scraped again to enhance the misty effect. The horizontal streaking caused by this treatment mimics the way patches of mist tend to lie in motionless veils above still water.

6 The pale paint added earlier to the mountainsides is now partly removed with the palette knife so that the thin covering of paint merges almost imperceptibly into the sky.

Scumbling involves applying an uneven layer of paint over a dry, thin, relatively oil-free underpainting so that the first colour shows through to some extent. In skilful hands scumbling can create some of the most magical effects in a painting, giving a veil-like impression rather like a filmy fabric placed over a matt one. It is an excellent way of modifying colour without sacrificing liveliness, and indeed the scumbled layer itself can be modified by the underpainting so long as this had been planned in advance. For example, you might use a flat, dark red underpainting as a basis for scumbling in lighter red, pink or even a contrasting colour. In addition, the surface texture of the paint is more evocative than flat colour, and may well carry the illusion of its subject more effectively.

Dark colours can be scumbled over light ones, but the method is usually more successful with light used over dark. One way to apply a scumble is to load a wide, flat bristle brush with diluted paint, squeeze it to expel as much moisture as possible and then lightly drag it over the surface to produce a very thin film of paint. Thick, undiluted paint is often applied in a circular motion with a well-loaded round bristle brush held perpendicularly. Alternatively a fairly wide flat hog carrying thick paint can be dragged nearly flat to the surface leaving a flecked, broken layer of paint. A round hog or fan dabbed over the surface will create a stippled effect.

Scumbles can also be applied with the fingers, the side of the palm, a rag, a sponge (see DABBING) or a palette knife. The coarser the texture of the canvas the more effective is the scumble because the paint is deposited mainly on the top of the weave. Experimenting with different thicknesses of paint, different surfaces and different implements held in a variety of ways will give you an idea of the many effects that can be achieved.

▲ Pale blue sky has been painted previously and allowed to dry. Clouds are now being built up by scumbling with a rag, using a gentle rocking motion of the finger.

▲ Scumbling with a brush leaves bristle marks between which the underlying layer is visible. The method allows soft merging of colour, with imperceptible gradations.

▲ The artist has begun with a flat underpainting in acrylic, which dries very quickly. The dull greys will be modified and enriched in the following stages.

▲ The brushstrokes are made short and decisive so that over-blending does not spoil the effect.

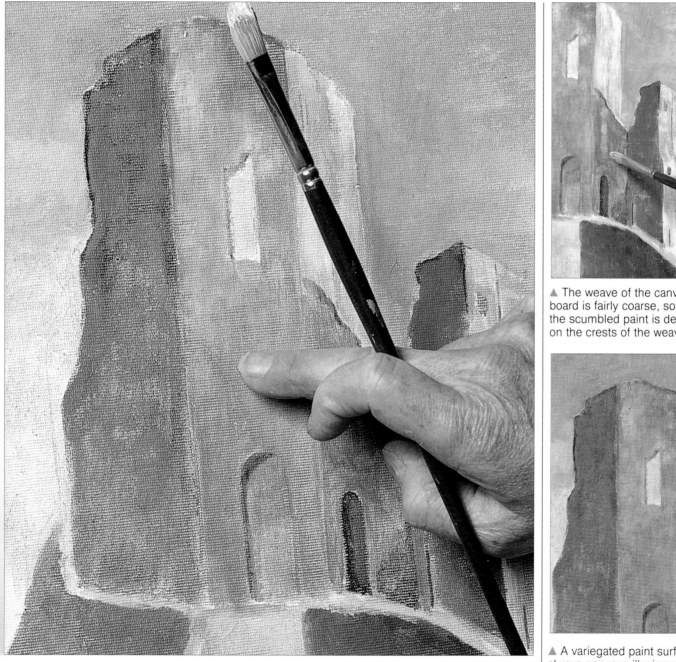

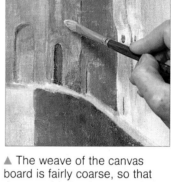

▲ The weave of the canvas board is fairly coarse, so that the scumbled paint is deposited on the crests of the weave.

▲ A variegated paint surface always conveys illusion more successfully than a uniform one. Scumbling is one way to create BROKEN COLOUR effects.

▲ Generally a light scumble over a dark colour gives the best results. The paint should be fairly dry and applied thinly in gradual stages. Here paint is scumbled gently with the finger.

This technique, whose name comes from the Italian *graffiare* – to scratch, involves scoring into the paint after it has been applied to the support. Using any rigid instrument such as a paintbrush handle, a knife, fork or even a comb, the surface layer of wet paint is scratched into to reveal either the ground colour or a layer of dry colour beneath. Lines of any thickness can be drawn into the paint, and the separate layers of colour chosen to contrast or complement each other. Dark brown paint, for example, could be scored to reveal a pale blue, or a dark green to reveal a brighter, lighter one beneath.

Scoring is often used as an accurate way to depict hair, creases in skin and marks on flat surfaces such as walls or pavements. Rembrandt (1606-69) used the technique extensively, scribbling into thick, wet paint with a brush handle to pick out individual hairs in a sitter's moustache or the pattern of lace on a collar. Shaded areas can be developed by hatching with the scorer to reveal dark underpainting. Wavelets on the sea, patches of light sky within foliage or flashes and sparks in fire can all be suggested in this way.

The quality of line depends on the thickness of the paint and to what extent it has dried. Even when thoroughly dry, paint can be scratched into as long as a really sharp point is used. In this case the scored lines will be white, as all the layers of paint will be removed, but this can be effective for some subjects. It is best to restrict scratching into dry paint to rigid boards, however, as it might damage canvas.

▲ The background colour of the wooden tabletop is applied in fairly thick paint. The pattern of the wood grain will be scraped into this paint at a later stage.

The ground colour is dark brown, and it is this that will appear as the paint is scratched off.

▲ The artist uses a painting knife to "draw" in the pattern of the wood grain.

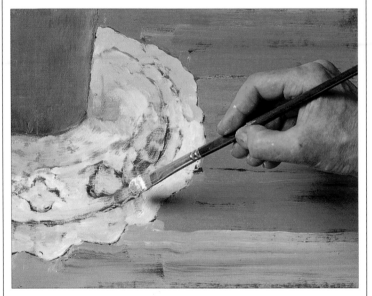

▲ In this photograph the doily is being painted white prior to sgraffito.

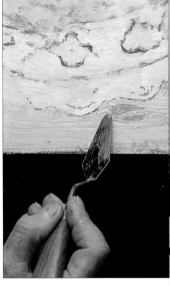

▲ Knots in the wood can be described admirably by this technique.

▶ It is also an excellent method for obtaining thin lines in thick paint which would become unmanageable if yet more paint were added. Here lines are inscribed with the "wrong" end of a paintbrush.

▶ The complex pattern of the doily is drawn into the still-wet paint with a pencil. Like the paintbrush handle used earlier, this scrapes the paint aside, but it also leaves its own mark, the brown ground only showing in the regions where it was left unpainted.

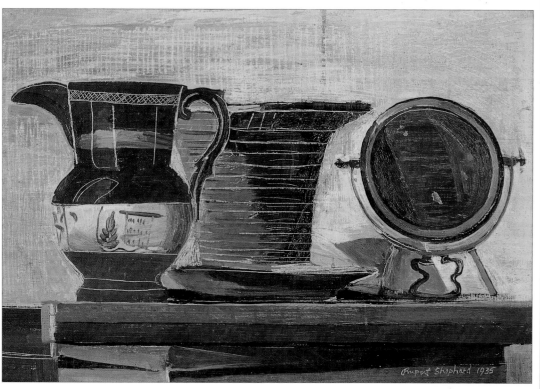

▲ RUPERT SHEPHARD
"The Lustre Jug"
The overall effect of the picture relies heavily on the sgraffito technique, which has been used very skilfully to define contours and describe pattern on both the objects and background. The latter is basically flat, but is enlivened by fine cross-hatching. In this case the paint has been scratched back to the white ground, which is best done when the paint is dry or semi-dry.

The word support simply means the surface on which you paint, whether canvas, prepared board, paper or cardboard. The choice of surface is very important, as it affects the way the paint behaves. In general, textured surfaces are pleasanter to work on as they hold the paint to some extent, whereas on a shiny, non absorbent one like hardboard it tends to slide about and takes a long time to dry. It is not possible, however, to recommend an "ideal" support; the choice must necessarily involve some trial and error, and will depend on your style of painting, the size of the picture, whether you are painting indoors or outdoors and, ultimately, what you feel comfortable with.

Canvas and canvas board

Canvas is the most widely used support for oil paintings. It provides a sympathetic working surface, is light and easy to carry, and can be removed from the stretchers and stored without taking up much space.

Some of the unique properties of oil paint can only be brought out by the texture of canvas. In areas where paint is applied thinly, the grain is always visible, to become an integral part of the picture and contrast with any IMPASTO work which hides the grain. When DRY BRUSH or SCUMBLING techniques are used, the paint will deposit on the top of the weave only, which results in a characteristic grainy paint surface through which the underlying paint layer still shows. The rough texture provides "tooth" to help the paint adhere during application, and the springy

flexibility of stretched canvas enables a range of brushstrokes which reflect both the shape of the brush and the way it is handled.

Canvases are available ready stretched and primed, but you can also buy stretchers and "raw" canvas and prepare your own, as shown here. Several different types of canvas are available from the larger art suppliers, but the cheapest, and ideal for the beginner to experiment on, is cotton duck. Linen is superior in that it is less abrasive, keeps its shape better and tends to have less unpleasant knots in it. For a very coarse grain you can even use sacking or hessian, favoured by both Gauguin (1848-1903) and Van Gogh (1853-90).

Canvas does not have to be stretched; it can simply be glued to a plywood or hardboard panel (with rabbit-skin glue if possible), but this does sacrifice its flexibility. Before painting it must be sealed by priming with acrylic primer, or with a coat of size followed by an oil primer (see GROUNDS).

A popular alternative to canvas is prepared painting board. This is made in a variety of surface textures, the less expensive being a rather unconvincing imitation canvas texture. This usually has a slightly greasy feel and does not hold the paint well, but some manufacturers produce a canvas board which is actually fabric stuck onto board.

Boards and plywood

Plywood or the smooth side of hardboard is often used for small paintings, while some artists like to work exclusively on hardboard even for large-

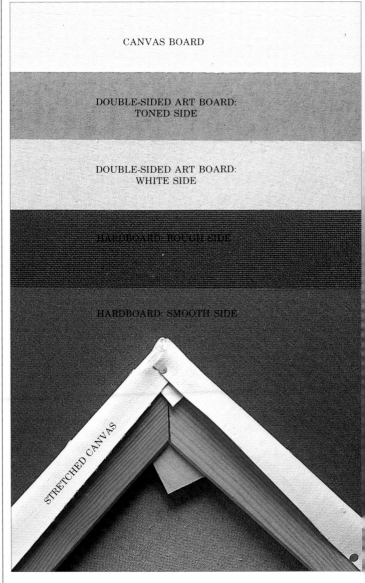

CANVAS BOARD

DOUBLE-SIDED ART BOARD: TONED SIDE

DOUBLE-SIDED ART BOARD: WHITE SIDE

HARDBOARD: ROUGH SIDE

HARDBOARD: SMOOTH SIDE

STRETCHED CANVAS

Shown here is a selection of oil painting supports. The one you favour will depend upon the particular surface quality you like, such as "tooth" and springiness, so you will almost certainly have to try out several before deciding which one suits your working method.

scale pictures. It is particularly suitable for those who like to apply paint thinly, with sable brushes, and a practical advantage is that it can be cut easily into any shape, either before or after painting (there are artists who consistently paint on triangular, hexagonal or completely irregular panels).

The paint will grip better if the surface is rubbed down with sandpaper and then primed with acrylic, which is slightly more absorbent than oil primer. Large sheets of hardboard warp easily, and should be strengthened with a frame of wood battens on the underside.

Paper and cardboard

Inexperienced oil painters do not always realize that the choice of painting supports need not be restricted to canvas and painting board. Both paper and cardboard can be used provided they are primed first (see GROUNDS). One of the advantages of painting on paper is its lightness. A selection of stiff papers prepared with different COLOURED GROUNDS can easily be carried for an outdoor work session, and if you also take a knife and steel ruler the paper can be trimmed on the spot to the required size and shape.

If you are merely making sketches as reference for a later painting it does not much matter what paper you use, but if the picture is to last it is best to use rag rather than wood-pulp paper – the heavy, rough watercolour papers are ideal, and will provide a pleasant texture on which to work. It should be sealed with gelatin or casein size, applied to both sides of the paper, or primed with acrylic primer. The final

picture can be mounted on canvas or hardboard for protection.

Cardboard is also convenient for painting on, particularly if you like a smooth texture. Heavy mounting board or pasteboard sized or primed as described for paper makes an inexpensive support and is easily trimmed to size. Natural-coloured (unprimed) cardboard was favoured by both Degas (1834-1917) and Toulouse-Lautrec (1864-1901), both of whom liked the way it absorbed the oil to give a matt, pastel-like effect (see PEINTURE A L'ESSENCE). Unconventional supports like these are always enjoyable to experiment with, and may suggest a new way of working, but if such a painting is to last it must be glazed.

▲ First assemble the stretchers, making sure they are correctly joined at the corners. Lay the frame on the canvas and mark off the amount you need, allowing a 5cm (2½in) overlap on each side.

▲ Fold the canvas over the stretcher and staple or tack it in the centre of first one of the long sides and then the other, pulling the canvas as taut as possible.

▲ Finish the corner by folding it over along the stretcher joint and then staple or tack. Take care not to staple into the joint itself.

▲ Cut the fabric with sharp scissors, taking care not to pull it out of shape; the weave must be parallel. Cut along the weave, using a metal edge as a guide if necessary.

▲ Continue in the same way, working outwards to each corner, and then fold in the corner flap neatly. The corner must not be too bulky or the canvas will not fit into a frame.

▲ Insert the wooden (or sometimes plastic) wedges into the corner slots and hammer them in gently. This pushes the corners apart slightly and enlarges the frame, thus tautening the canvas.

TEXTURING

Unless very thinly applied, the very nature of oil paint provides texture in a painting. A number of other techniques can be used to provide specific textures, among them IMPRINTING and KNIFE PAINTING, which are dealt with separately. Here the word refers only to the addition of other ingredients to the paint both to increase its bulk and to enhance or alter its character.

One way of doing this is to mix the paint with one of the special IMPASTO mediums, which enables much thicker applications than normal and reduces the danger of shrinkage and cracking. Once on the support the heavy paint mix can be sculpted and modelled using any implement suitable for the job. Other favourite additives are clean sand, sawdust and wood shavings. Sand gives the paint surface a granular texture, while paint containing sawdust can be cut with a knife once partly dried. Wood shavings give a very obvious texture, which is best restricted to certain areas of a painting, where it could contrast with smoother ones.

The building up of relief in this manner, which verges on sculpture, stresses the importance of the picture as an object in its own right rather than merely a two-dimensional "translation" of a particular subject.

▲ The addition of sand to unthinned paint gives it a grainy, glittering texture.

▲ Plaster or decorator's filler also increases the paint's bulk and gives a fine-grained, cement-like texture when the paint is dry.

▲ Wood chips give a very pleasing flaky texture to paint, especially good for use in large paintings.

▲ Sawdust increases the paint's bulk, enabling the application of very thick impasto. The resulting texture is slightly granular.

▲ Here the paint is mixed with impasto medium (see MEDIUMS), which bulks it out without altering its colour or texture.

TONKING

A painting will often reach a stage when it becomes unworkable because there is too much paint on the surface. Any new colour simply mixes with that below, creating unpleasant muddy mixtures as well as disturbing previous BRUSHWORK. When this happens, the excess can be removed by "tonking", a method named after Henry Tonks, a former professor of painting at the Slade School of Art in London. A sheet of absorbent paper such as newspaper or kitchen paper is placed over the overloaded area – or the whole painting – gently rubbed with the palm of the hand and then carefully peeled off. This carries off the top layer of paint, leaving a thinned-out version of the original, with softer outlines, which serves as an ideal UNDERPAINTING over which to continue.

Tonking is particularly useful in portraiture because it eliminates details while leaving the main structure of the head firmly established. It is usually details, particularly within the eyes and mouth which, even if only slightly misplaced, will destroy the likeness in a portrait. These also tend to become heavily loaded with paint, as there is a tendency to put on layer after layer in the attempt to get them right. Sometimes the action of tonking produces a passage which needs little or no further painting.

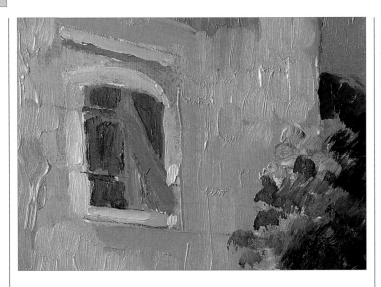

◀ A common mistake is to build up the paint too thickly in the early stages. It is virtually impossible to continue working over this thick a layer of IMPASTO.

◀ Newspaper or any other absorbent paper is carefully laid over the part of the painting to be tonked, and is rubbed firmly with the palm of the hand to ensure that the upper layers of paint adhere to it. The paper is slowly peeled off the painting, bringing the paint with it.

◀ After tonking only a thin layer of paint remains, with brushmarks smoothed away and details eliminated. This is an ideal surface for further working. Tonking can be performed as often as you like during the course of a painting.

TRANSFERRING DRAWINGS

Before embarking on a large painting or a complex subject it is often best to start by making a preliminary drawing on paper and then transferring it to the canvas. This usually involves enlarging it, which can be done in two ways.

The traditional method is squaring up, in which a grid of equal-sized squares is ruled over the drawing and a similar one, but with larger squares, on the painting surface. The size of the squares will depend on the degree of enlargement required; a grid of 2.5 cm (1 inch) on the drawing and 5 cm (2 inches) on the support will obviously give an underdrawing of twice the size, and so on. Each square is numbered identically on both canvas and drawing, and the information is transferred from one to the other, taking care to note the exact position of each drawn feature in relation to its square.

The alternative method is to photograph the drawing on slide film and project the image directly onto the canvas. This is an easier process for those with some photographic know-how, and many artists prefer it to the slow squaring-up process. The projected image can be adjusted for size simply by altering the distance between canvas and projector, and the outlines quickly traced over in pencil or charcoal.

▲ ▶ When photographing a drawing the camera should be mounted on a tripod and the drawing held vertically, either pinned on the wall or held on an easel. If the alignment is wrong, even very slightly, the image will be crooked.

▲ Squaring up is a somewhat laborious process, but well worth the effort, particularly if the subject is a complex one. The more time you take at this stage the less you will have to spend making CORRECTIONS.

UNDERDRAWING

It is by no means essential to make a preliminary drawing on the canvas. However, if the subject is a "difficult" one such as a portrait, figure painting or elaborate still life, it does help to have the various elements in their correct places. It allows you to paint with more confidence, and reduces the risk of having to make drastic corrections.

Underdrawing can be done in several ways. A very direct method is to use a narrow brush, such as a round bristle, and paint well thinned with turpentine or white spirit, which will dry quickly. Choose a colour which is likely to appear in the painting, or the lines may be distracting when you come to paint. Good choices – depending on the subject, of course – are cobalt blue, terre verte (green) and raw umber, all of which are fast-drying.

Some painters like to use charcoal, either just to draw out the contours of their subject or to establish the picture's tonal values (light and dark) by smudging the charcoal around with the fingers. The excess dust should be lightly brushed off and the drawing fixed to prevent it from soiling the paint. A modern synthetic fixative blown through a spray diffuser is quite adequate.

For a detailed drawing a pencil can be more satisfactory, but if working on stretched canvas with a hard pencil avoid pressing too hard or you may pierce the ground layer. Drawings in very soft pencil should be fixed, as for charcoal. On a coloured or dark ground underdrawing can be made with white chalk, which will also need to be fixed.

▲ It is unlikely that you will paint a successful portrait unless you construct it on a sound foundation. Here the artist has carefully laid the "landmarks" of the sitter's face in charcoal, an expressive medium allowing both accurate, fluid lines and broad areas of tone. It is also easy to rub off, so that errors can be rectified before you begin to paint. Once the drawing is established the artist can direct all his concentration on the application of paint (above right) without having to worry about the exact positioning of features.

▶ The drawing should act as no more than a guide, so keep the brushwork as free and lively as possible. Attempting to "fill in" the outlines too precisely can result in a dull, mechanical-looking painting.

Not all artists begin their work with an underpainting, as this depends very much on individual ways of working. In the ALLA PRIMA method, for example, there is usually no underpainting, and perhaps only a very sketchy UNDERDRAWING to serve as a guide for areas of colour. In the more deliberate and considered type of painting, however, underpainting can play an important part, as the idea is to leave parts of it visible in the final painting. In this respect it serves the same function as a COLOURED GROUND, but whereas the latter helps to unify the whole picture, an underpainting establishes the main dark and light areas, and the colours of these are chosen to act as a foil to the final layers.

Usually only a few fairly neutral colours are used, thinly diluted with turpentine or white spirit. Little or no oil should be added at this stage; the thicker and oilier layers are built up later (see BUILDING UP).

Underpainting is not an alternative to underdrawing, but usually a second stage. It is generally applied quickly and can be easily removed if unsatisfactory. In this way the tonal balance of the painting can be controlled from the very beginning.

The colours to choose depend upon those to be applied later, but in general, cool colours will complement warmer final layers. The early Italian and Renaissance artists painted warm skin tones over green, blue or even purple underpainting. Creamy pink or yellowish flesh colours painted as glazes or thin scumbles over such colours (see GLAZING and SCUMBLING) acquire a rich, glowing appearance, while the cool greens of foliage are often more forceful if small touches of a warm brown or reddish underpainting are allowed to show through.

As in underdrawing done with a brush, it is most convenient to use the faster-drying colours such as cobalt blue, raw umber or terre verte, as the underpainting must be dry before further colours are laid. (It is worth mentioning that flake white is much faster-drying than either zinc or titanium white.) You will have a wider choice of colours if you use acrylic paints (thinned with water), which are very useful in this context, as they will dry within half an hour.

1 Fast-drying cobalt blue diluted with a large quantity of white spirit was used for this preliminary underpainting. In this case it was not intended to play an important part in the finished painting; its main aim was to act as a guide by segregating the dark and light passages within the intricate pattern of leaves, stalks and reflections.

2 The dark background at left is blocked in with thin, lean paint. This is essentially a continuation of the underpainting, and it will still be visible through several glazed layers in the finished picture.

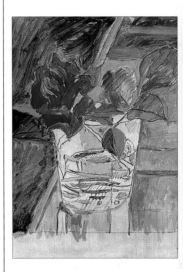

3 Further broad blocking in is done with rather less diluted paint. The picture is now ready to receive some of the final colours.

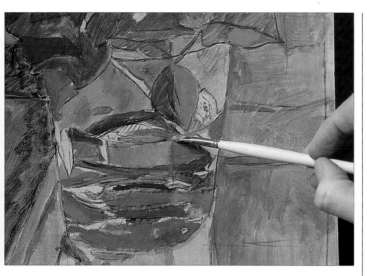

4 The underpainting has been very loosely handled, although care has been taken not to lose sight of the carefully measured-out drawing, particularly that of the glass – a difficult subject. Some of the final colours are now being applied. They are more easily judged against the underpainting.

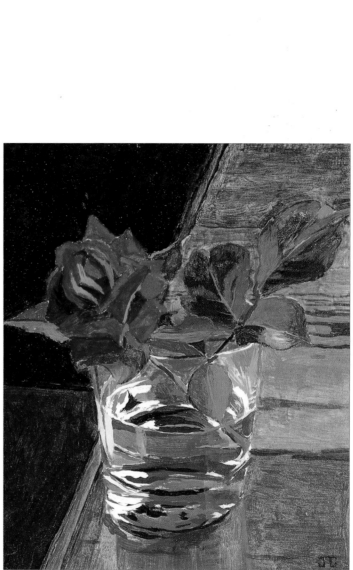

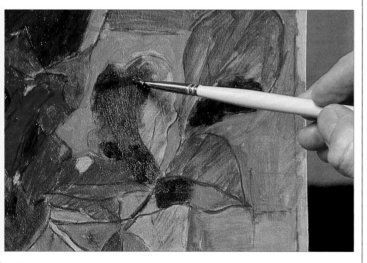

5 Some artists like to underpaint in a monochrome grey, but in this case the blue has been chosen for its relationship to the dominant colours in the subject.

6 In the finished picture very little of the underpainting is visible since great care has been taken to "tidy up" the painting. The main benefit was to allow fluid brushstrokes, which help to keep the picture alive. Small, intricate subjects like this can very easily become overworked and tired-looking.

WET INTO WET

This involves applying colours over and into one another while still wet, and it gives a quite different impression to working WET ON DRY. Because each new brushstroke mixes to some extent with those below or adjacent to it, the results are softer, with forms and colours merging into one another without hard boundaries. Monet (1840-1926) exploited such effects in his rapidly executed outdoor landscapes, often deliberately mixing his colours on the canvas surface by streaking one over another.

Wet into wet is the essence of the ALLA PRIMA approach, because the entire painting is done in one session, but the technique can be used for a small part of a painting also. Sky, water, parts of the clothing or face in a portrait, indeed any area where a soft, blended effect is needed, could be painted in this way, while the remainder is built-up wet on dry.

Painting wet into wet requires a sure hand and no hesitation; too much reworking will destroy your BRUSHWORK, and may result in overmixed, and hence muddy, colours. If the painting begins to look messy and lose its clarity the best course is to scrape it down and start again (see CORRECTIONS).

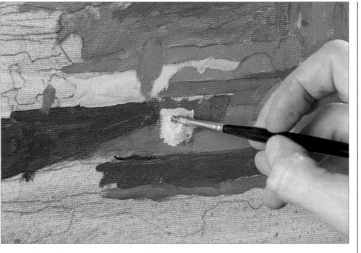

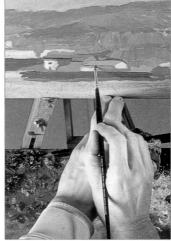

▲ All the colours used to paint this small area of farmhouse are being applied rapidly, one after the other. The white patch of wall has been painted into wet, brown paint and some mixing has occurred. The photograph (above left) shows the grey-blue windows being added carefully with a flat sable brush. Accuracy is essential when painting wet into wet since mistakes cannot be removed without destroying earlier good work. The artist steadies his hand (above) by resting it on the other hand which in turn has a secure hold on the easel.

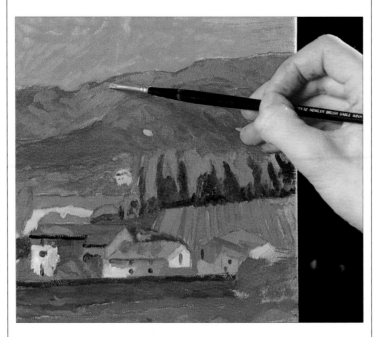

▲ The pink roof is modified by the addition of grey, applied deliberately freely so that the wet colours will mix slightly. The degree of mixing depends on the thickness of the paint and the way it is laid on. The same medium should be used for each colour; in this case the paint is diluted with two-thirds turpentine to one-third linseed oil.

WET ON DRY

If you are completing a painting over a series of sessions you will probably find that you are painting wet on dry whether you planned it or not. Some artists, however, take a more methodical approach and deliberately allow each layer to dry before adding the next, perhaps in order to build up by means of GLAZING or SCUMBLING.

In pre-Impressionist days, virtually all oil paintings were built up in layers in this way, beginning with an UNDERPAINTING which established the drawing and tonal structure. It is not a technique for recording quick impressions, but is highly suitable for more complex compositions where there are many different elements, as it gives a higher degree of control over the paint than WET INTO WET.

It is important to think of each layer as the prelude to the next, and to build up gradually to achieve the contrasts between light and dark areas that will give depth to the painting. The usual method of working – but not the only one – is from dark to light, keeping the paint thin in the initial stages and reserving the thicker highlights until last (see BUILDING UP).

▲ STEPHEN CROWTHER
"Survivors"
Sharp, clear edges like these would be difficult if not impossible to achieve by working wet into wet.

▲ Considerable precision is possible with the wet on dry method, as the paint does not mix with the layer below as it does when working wet into wet. It is thus ideal for the crisp detail added in the final stages of a painting. The slightly blurred effect seen on the shirt and face here is due to earlier TONKING, a method often used for portraits.

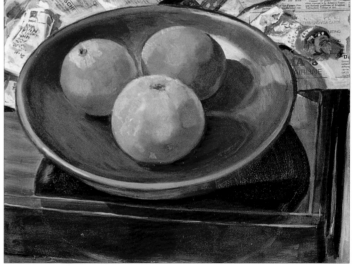

▲ JULIETE KAC
"Oranges"
Here there is a combination of both methods, with the table top and inside of the bowl worked wet into wet and the crisp edges wet on dry. There is an element of COLLAGE in this picture: the newspaper is not painted but real.

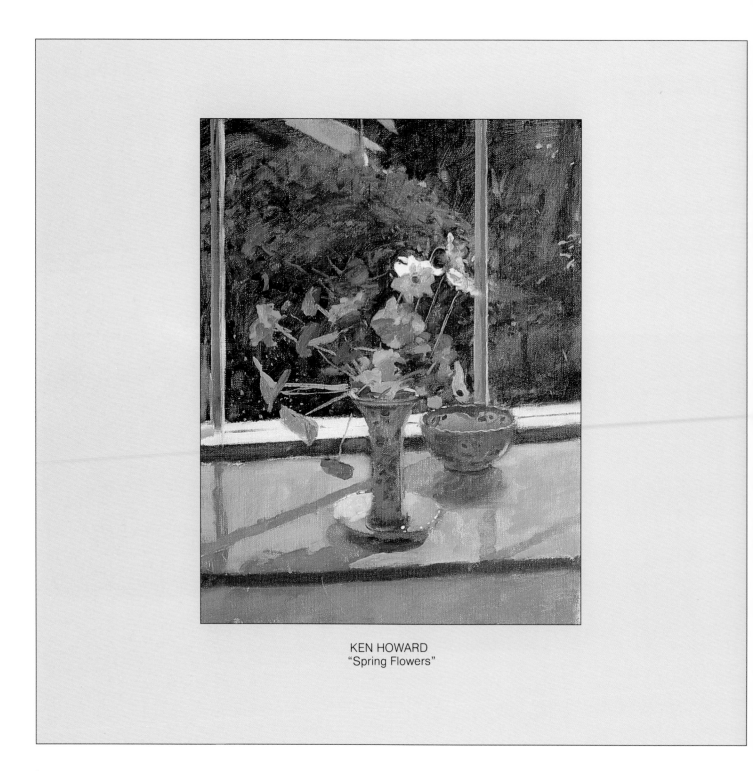

KEN HOWARD
"Spring Flowers"

PART TWO
THEMES

The first part of the book may have encouraged you to try out some techniques you had perhaps been nervous of in the past – or possibly had never heard of. The aim of this section is to show how the "craft" of painting is used by other artists. I have chosen six main themes – architecture, the human figure, landscapes, skies, still life and water – and a wide variety of different approaches is shown in each of these subject areas. Wherever relevant, the captions cross-refer to techniques mentioned in the A-Z section, so that you can see how each artist has used them as a vehicle for the expression of ideas. I hope also that looking at the paintings may suggest new subjects – someone who has only painted landscape, for instance, may be inspired by the portraits or still lifes.

Each of the themes is accompanied by a step-by step demonstration in which you can follow an individual artist's progress from the conception of an idea to the completion of a painting. You will probably find some more sympathetic to your own ideas than others, but this is all to the good, as making a choice of "teachers" is part of the learning process. It is always interesting and instructive to study the work of other painters, even if in the end you decide to go your own way. You will notice that all the artists have highly individual styles – their own "handwriting", so to speak. Never feel inferior if you cannot paint exactly like them – instead, concentrate on your own personal style.

Inexperienced painters often avoid architectural subjects because they feel unable to cope with the complexities of perspective, but this is a pity as buildings play such a large part in the 20th-century landscape. It is certainly helpful to have some understanding of the basic rules of perspective, but they are not really very difficult to grasp.

Perspective is no more than a convention which allows you to represent a solid, three-dimensional object on a two-dimensional surface, and the only really important rule is that all objects appear to become smaller the further away they are. This creates the illusion that parallel lines receding from you meet each other at a "vanishing point" at your eye level. If you are looking down on a scene from a hilltop the lines will slope upwards to your eye level, but if you are positioned below a building on rising ground they will slope downwards, sometimes quite sharply.

Often this vanishing point is outside the picture area, but bearing the rule in mind helps you to check your own on-the-spot observations. If you rely on your eye alone you may find yourself painting what you think you see instead of what is actually there – it is often difficult to believe the sharpness of the angle made by receding parallels. When making an UNDERDRAWING for a painting it is sound practice to mark in the horizon line (your eye level), as here the receding lines will be horizontal, and they will provide a key for all the others.

Mechanical aids

When you are painting a single building perspective is easy enough, but for a complex cityscape it can present problems, and always has. Canaletto (1697-1768) is known to have used a device called a camera obscura, which projected the image onto paper through a system of lenses so that an accurate outline drawing could be made with the minimum of effort. Many of the topographical artists of the 18th and early 19th centuries carried similar unwieldy objects around with them, but today we are more fortunate as we have the benefit of the camera.

Photographs are not always the ideal starting point for paintings, as they tend to fudge detail and often fail to catch the subtleties of colour, but they certainly have their uses. You might, for example, make an underdrawing from a photograph and then go out to complete the painting on location. Or you can use photographs in combination with on-the-spot sketches and colour notes as a basis for a studio painting.

Outdoors or in

Working directly from your subject is very appealing, but it does present certain problems, particularly for urban subjects. It can be difficult to find a place to paint where you have an interesting view of the subject and are relatively safe from the comments of passersby. It is wise to explore various locations before setting out with your easel and paints. You can often find a quiet corner, or you could ask permission to sit on the roof of a building to paint an aerial view; Oscar Kokoschka (1886-1980) did this in several European cities.

The other major problem is coping with changing light. On a fine day the colours of both the sunstruck and shaded areas will change dramatically as the sun moves higher (or lower) in the sky, and shadows will also change shape quite rapidly. Never try to finish a whole painting in one day, as you will find yourself making alterations to keep up with the changing light, and this is a recipe for failure. Either set aside about two hours at the same time each day and work in a series of sessions, or make quick sketches which you can then work up into a composition indoors.

Many painters of architectural subjects take the latter course, and their pictures are none the worse for it. However, the way you choose to work depends very much on individual interests, and if your main concern is light and atmosphere rather than structure and precise detail there is no substitute for working ALLA PRIMA directly from your subject.

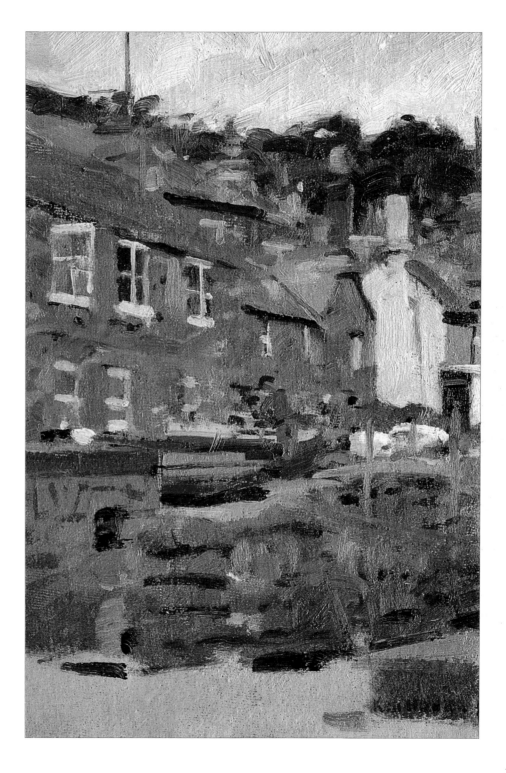

▶ KEN HOWARD
"Mousehole, Cornwall"
The geometric and linear shapes of buildings, and their colours, textures and architectural details offer endless possibilities to the artist, but it is always wise to begin with a sound drawing. The kind of broad, impressionistic approach seen in this painting looks delightfully spontaneous, but such effects cannot be achieved without some pre-planning.

VIEWPOINT

Your choice of viewpoint should depend on three main factors. Firstly, you must consider exactly what aspect of your chosen subject you wish to portray, and perhaps emphasize. Is it a specific building or the relationship of buildings in a street that interests you? Perhaps it may be the overall colour or character of the street itself you want to capture, or the way the buildings throw a strong pattern of shadows across the ground and walls.

The second consideration is composition. Even slight changes in your own position can cause dramatic ones in the view in front of you, so be careful to explore all available possibilities. A good composition is a well-balanced one, and if you have chosen a viewpoint which shows you a large, dark house at the left with nothing to balance it your painting will look wrong. This does not have to be another house; it could be a suitably shaped shadow, a tree, clouds or even a small shape such as a figure as long as it makes up for lack of size by being a strong tone or colour.

The third consideration is purely practical. For example, you cannot station yourself in the middle of a road (where, unfortunately, the best viewpoints are often found). The view from a window is sometimes ideal, and has the added advantage of peace and seclusion.

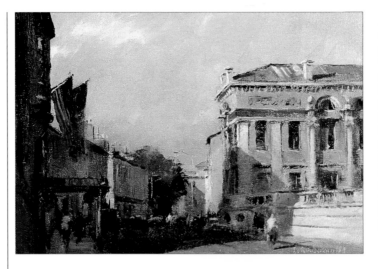

◄ TREVOR CHAMBERLAIN
"Morning, Ashmolean Museum"
This viewpoint on the pavement provides a combination of verticals and horizontals which has enabled the artist to convey the solidity of the structure. He has strengthened the composition by choosing a time of day when the road and the buildings on the left are in deep shadow, the dark shapes providing a perfect balance for the strongly illuminated museum building.

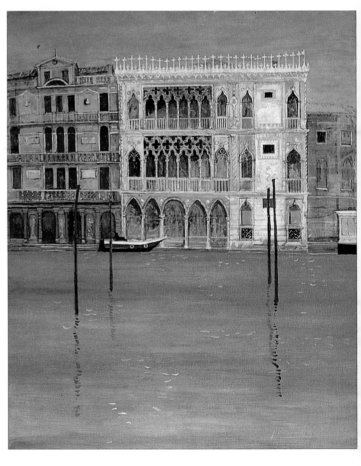

► RICHARD BEER
"Ca d'Oro, Venice"
Painting buildings from directly in front has a tendency to make them look flat, but in this case the viewpoint has been well-chosen, as the artist wanted to emphasize their decorative quality. Depth is given to the picture almost solely by the perspective created by the blue posts. The expanse of water, occupying over half the picture area, provides a counterfoil for the lovely intricate arches and balconies.

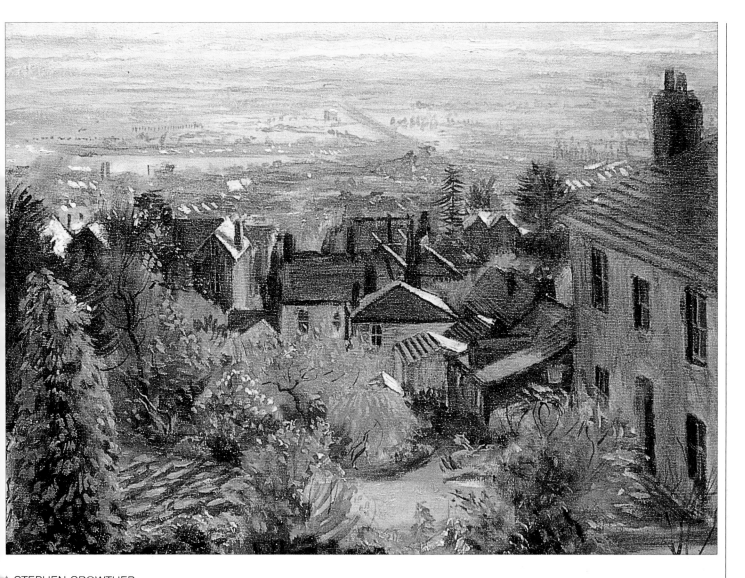

▲ STEPHEN CROWTHER
"The Severn Valley from Malvern"
The elevated viewpoint taken here enabled the artist to make the most of the foreground garden and the roofs, which would otherwise have been hidden. A great expanse of landscape in the background was also visible, sweeping away to the distant strip of sky.

COMPOSITION

Because architectural subjects are among the more difficult, there is a tendency to forget about the purely pictorial values in the effort to get the proportion and perspective right and all the doors and windows in the correct place. But composition is important whatever you are painting, so if you are working on location take a critical look at what is in front of you and try to decide how you can place the various elements to the best advantage.

There are no absolute rules about composition, but in general you should aim for a good balance of shapes, colours and dark and light areas, and enough variety to encourage the viewer's eye to look from one part of the picture to another.

It is not usually a good idea to divide a picture in half or to place the main subject – such as a house – right in the middle of the picture area. Symmetrical arrangements are usually static and dull.

To some extent your composition will have already been determined by the place you have chosen to paint from (see VIEWPOINT). However, it is highly likely that you will have to do some fine-tuning, and you will also need to decide how much of the subject to include.

A viewfinder is a great help here. Some artists like to take an empty picture frame out with them so that they can hold it up and explore various possibilities, but you can make your own viewfinder simply by cutting a rectangular window in a piece of card.

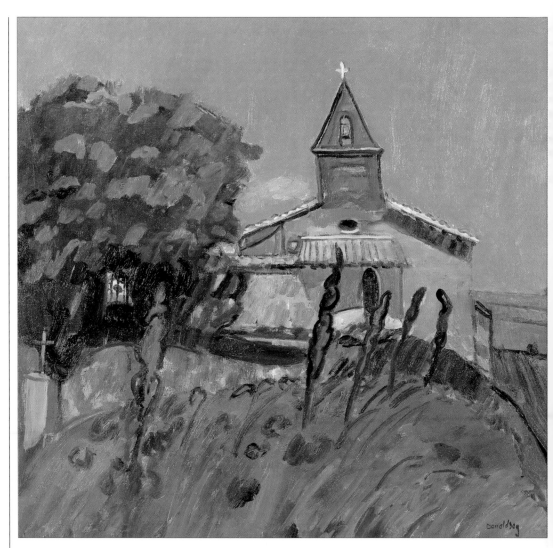

▲ DAVID DONALDSON
"Village Church, Provence"
The obvious centre of interest here is the church, with its striking geometric tower, but the artist has taken care to place it off-centre and to balance it with the contrasting round mass of the tree on the left. The extreme foreground has been painted loosely in order not to steal interest from the church, but the bold, linear treatment of the plants and grasses leads our eye towards it, as does the directional BRUSHWORK on the tree.

▼ RAYMOND LEECH
"The Tea Stall, Southwold"
The high angle chosen here
(see VIEWPOINT) has allowed the
artist to make an unusual and
dynamic composition with a
pleasing balance of diagonals
and verticals. When planning a
painting it is always worth
exploring different possibilities
– the most obvious view is not
always the best.

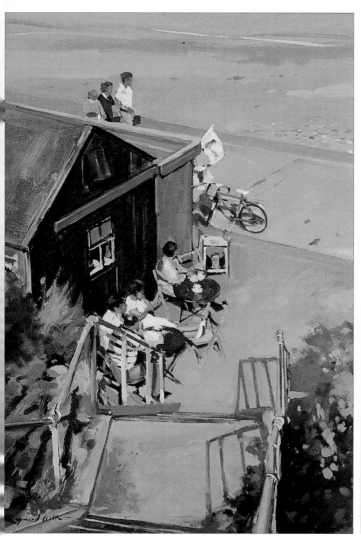

▲ JEREMY GALTON
"The Empty Street, Lacoste"
Here shadows have been
skilfully used as a dominant
force in the composition, with
the dark walls in the foreground
framing the sunlit street and
cool blue landscape beyond.
The picture relies on the
contrast between light and dark
shapes, and these have been
observed and painted with
great care to create a lively but
harmonious effect.

URBAN SCENES

City- or townscapes can be marvellous painting subjects, but they are somewhat daunting to novices for a number of reasons. One is the thought of coping with so much detail – brickwork, balconies, doors and windows, roofs and chimneys – in one painting. And another is the complexity of the perspective when buildings are set at angles to one another, or on different levels. And, of course, there is the added problem of finding a suitable location in which to set up your easel.

It is probably wise to avoid very ambitious projects at first, as it is easy to become discouraged. Choose a small section of the scene, such as the corner of a street, which has fairly simple perspective, and remember to ignore all details until the later stages, when you can see how many of them are really necessary to the painting.

The recurring verticals, horizontals, the squares and rectangles created by walls, windows and doorways are powerful compositional tools. They can give a sense of stability or harmony to a picture and also guide the eye around its surface according to how they are placed. Diagonals, caused by receding horizontals, are excellent for leading the eye in to a focal point, but be careful as they can become over-dominant. All these angles and shapes, of course, alter as you change your position, so choose your viewpoint carefully (see VIEWPOINT).

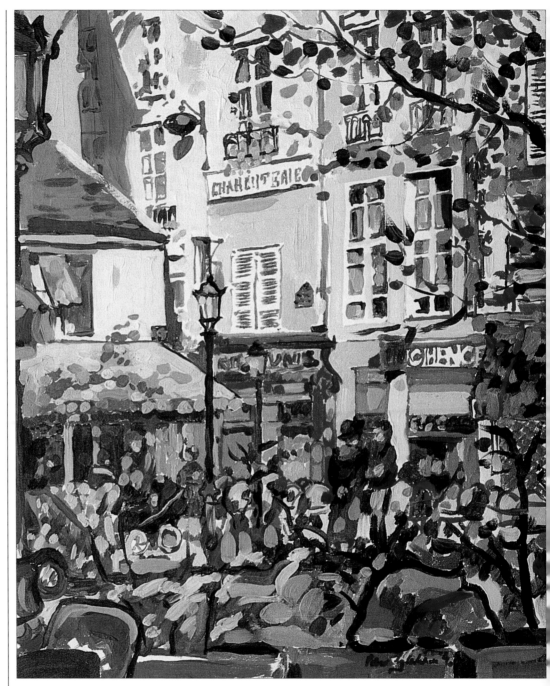

◄ PETER GRAHAM
"Rue Saint-André des Arts"
The artist's flamboyant style has transformed an ordinary corner of Parisian life into an exciting and colourful composition.

► RAYMOND LEECH
"Feeding the Pigeons, Venice"
Within an urban environment there are always quiet locations where the architecture is not the main centre of interest. Here the buildings are no more than a backdrop for the birds and humans in their dappled shade.

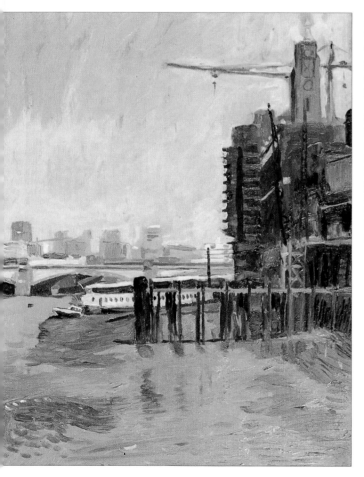

◄ JEREMY GALTON
"The Oxo Tower"
The picture was painted on the spot. Before painting, the exact shape of the bridge and the piers of the jetty were measured and drawn in pencil, as mistakes would lead to an unconvincing portrayal of their construction. The main shapes were then rapidly outlined in thinned paint, and the mudbank and right-hand buildings blocked in with umbers and ochres. Thicker paint was used to add details in the later stages.

▲ RAYMOND LEECH
"The Market on a Foggy Morning"
This misty, atmospheric scene is brought to life by touches of brilliant colour, and the variety of shapes makes the composition lively and exciting.

DETAIL

Once you begin to focus in on a building to see what it is that gives it its special character you will see a wealth of detail, such as balconies, cornices, window frames and sills, patterns of brickwork and drainpipes twisting down a wall, and you will have to decide how much to include.

There is no reason why you should not put in everything you see, but equally there is no reason why you should.

Remember that the painting is the important thing, and if the composition needs an accent of colour in the form of a brightly painted door or a curtained window then make the most of such things.

You might also consider taking a close-up approach and homing in on one small part of a building, such as an open door or a single window. Such subjects can make very exciting compositions, but you will have to plan the composition with care to avoid an over symmetrical effect – symmetry is static and thus does not hold the viewer's interest.

Think about placing a window off-centre or painting it at an angle so that you have diagonal as well as vertical and horizontal lines. You might also stress texture and pattern, such as that of the brick- or stonework surrounding a window or door.

▼ RAYMOND LEECH
"Girl in a Red Dress"
The vital ingredient of this unusual composition is the steps, whose form and repetitive shape lead the eye into the picture to the central lamp standard and eye-catching red dress. They have been very carefully painted, as has the area of wall behind with its pattern of large slabs. This also plays an important part in the picture.

▲ JEREMY GALTON
"Venetian Square"
This painting is unfinished, but the overall composition has been stated along with the main details to be included. All these, including the details on the bollard and the human interest, are indispensable to the composition.

▲ GLENN SCOULLER
"Garden Topiary"
Very few precise architectural details have been included here. The artist's interest lay in the overall pattern created by the repeating shapes of the shutters with their slanting shadows and the two parallel gateposts with their triangular red tops. The latter have been echoed by the stylized conical bushes to the right, which are obviously contrived for the sake of the painting, as are the palm trees whose semi-circular fronds provide curves to balance the more angular shapes. The paint surface is equally exciting. Rich texture has been built up on the white wall by a combination of brush IMPASTO and KNIFE PAINTING, while the SGRAFFITO method has been used on the right-hand bush to make linear marks which reveal an earlier layer of vivid colour.

INTERIORS

Painting interiors involves a mixture of different artistic disciplines. Because there are elements both of architecture and of still life, you will have to cope with the problems of perspective as well as with complex lighting conditions.

The rules of perspective are exactly the same for interiors as for exteriors. The parallel tops and bottoms of walls recede toward the same vanishing point, as do floorboards, the sides of tables and so on. However, there is a built-in danger when drawing or painting interiors. Because you are so much closer to your subject, indeed virtually within it, there is a tendency to "pan" around with your eyes, which gives too wide a field of vision. What happens in such a case is that you are effectively using more than one viewpoint, and this makes it very difficult to assess the main vanishing points. It is wise to begin with one part of a room, and try to remain in exactly the same position when you make your UNDERDRAWING, as the perspective will alter dramatically even if you change from a sitting to a standing position.

Among the most exciting aspects of interiors are the many different ways in which they can be lit. Bright sunlight streaming through a window can illuminate one area, leaving strongly contrasting shadows, and window bars may cast regular or distorted patterns across the floor. It can be an interesting exercise to paint the same room at different times of the day to see how the variations in lighting affect the composition and color key.

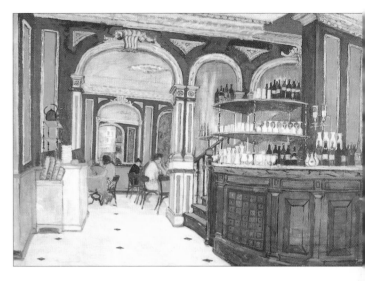

▶ RICHARD BEER
"Restaurant des Beaux Arts, Paris"
The complex pattern of panels and arches makes a decorative composition, and contrasting bare floorspace emphasizes the spaciousness of the room.

▼ JAMES HORTON
"Interior at Les Planes"
Light enters the room not only through the balcony doors but also from an unseen window on the left of the picture, conveying an attractive feeling of space and airiness enhanced by the high-key colour scheme.

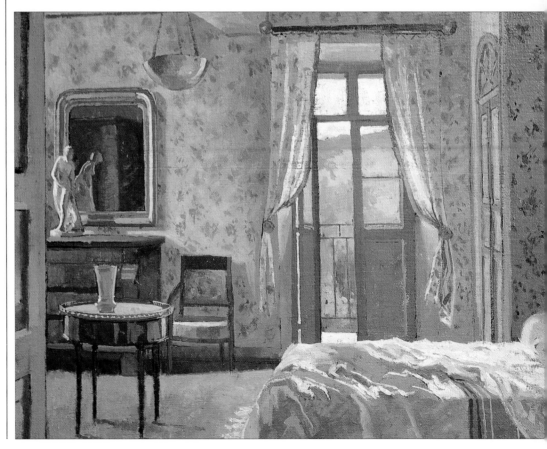

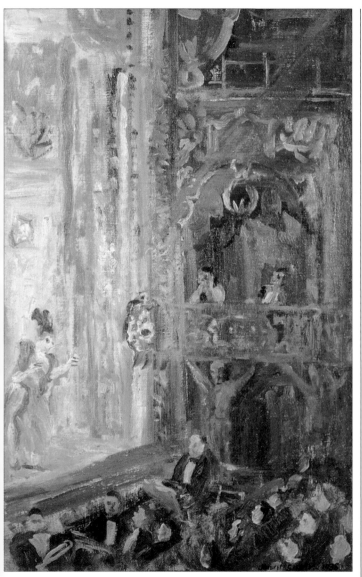

▲ RUPERT SHEPHARD
'Max Miller at the Music Hall"
The warm glow of artificial light from the stage illuminates this small portion of the theater, and the painting is richly decorated throughout with architectural ornament, drapery and the pattern made by the faces of the audience. Theaters have always been popular subjects for artists, but it is, of course, usually necessary to work from small on-the-spot sketches.

▼ RAYMOND LEECH
"Tea on a Wet Afternoon"
Perspective can be a powerful composition tool, as here, where the roof makes a lively pattern of diagonals. Perspective lines also lead our eye to the garden, a portion of which is seen through the arched window. This in effect serves as a frame within the frame of the main picture.

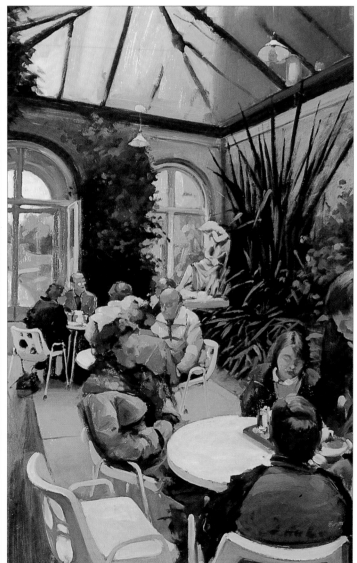

BUILDINGS
DEMONSTRATION
GORDON BENNETT

Bennett rarely paints on location, but he sketches extensively, and uses his first-hand observations as a basis for finished paintings. This picture was based on a series of sketches and colour studies made during a prolonged stay in the Greek Islands. It was painted on hardboard with a white gesso priming, and was completed in one working session.

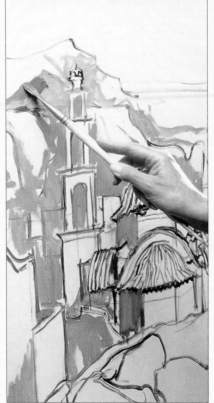

◄ **1** One of the original sketches done on the spot is supported on a second easel for easy reference.

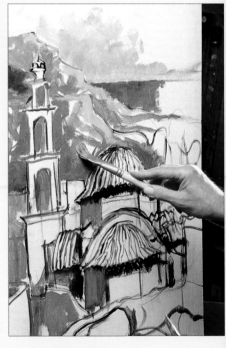

▲ **3** The background colours – yellow ochre and raw sienna mixed with varying amounts of white – are now applied in oils over the acrylic UNDERPAINTING.

▶ **2** The foundations of the painting are laid in charcoal and then sprayed with fixative to prevent smudging. Some of the lines are reinforced with thinned black paint, which Bennett often allows to show through in the finished work to give a linear emphasis in some areas. He now begins to block in broad areas with acrylic, which dries very rapidly.

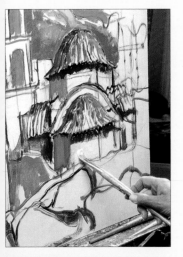

◀ **4** With the general colour of the background established the artist is now able to judge the colour relationships of the buildings. As nothing can be lighter than pure white, the painting of these whitewashed walls sets a tonal extreme against which other tones can be related.

▲ **5** A pale ochre and white mixture is used for the bell tower. Large flat bristle brushes are ideal for straight-edged areas like this.

▲ **6** White paint, slightly thinned with a linseed oil and white spirit mixture, is applied with deliberately uneven brushstrokes over the grey underpainting. This provides an interesting surface texture as well as suggesting the actual texture of the walls.

▲ **7** The shadows under the eaves are now sharpened up with a small sable brush and black paint. For these linear touches the artist uses somewhat thinner paint than the thick creamy IMPASTO of the walls.

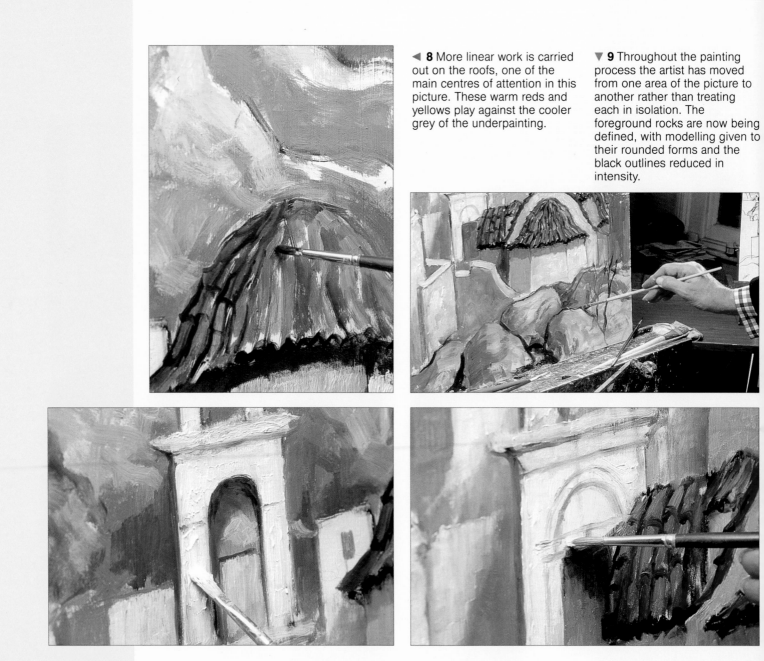

◄ **8** More linear work is carried out on the roofs, one of the main centres of attention in this picture. These warm reds and yellows play against the cooler grey of the underpainting.

▼ **9** Throughout the painting process the artist has moved from one area of the picture to another rather than treating each in isolation. The foreground rocks are now being defined, with modelling given to their rounded forms and the black outlines reduced in intensity.

▲ **10** With the painting almost complete, Bennett was able to assess what changes or additions should be made. The bell tower was insufficiently prominent, so he applied a further layer of thick white impasto, which was slightly modified by the still-wet layer of paint below.

▲ **11** Small details like this arch, although vital to the painting, should be left until last. If you attempt to put them in too early they are likely to become spoiled by subsequent paint applications.

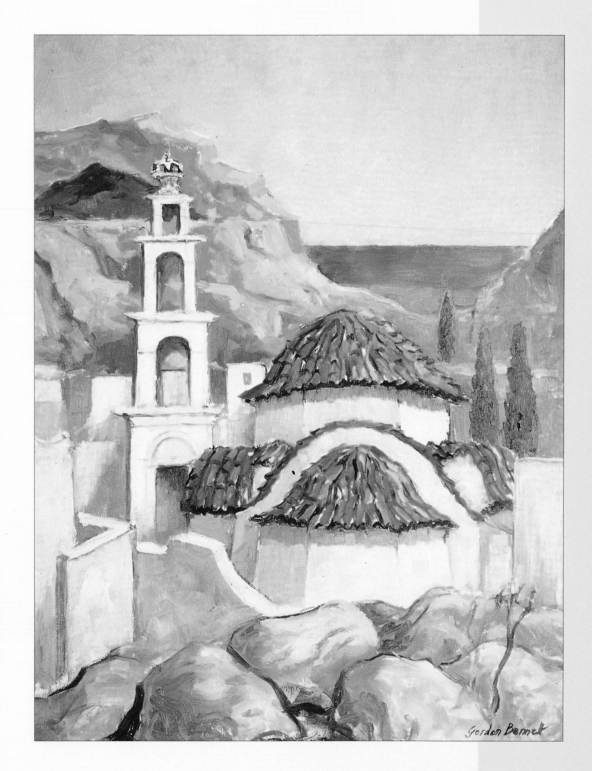

GORDON BENNETT
'Greek Island Village"

Painting people – whether portraits, full-length figures or groups – is one of the most challenging and satisfying of all branches of art. It is also the one most often associated with oil painting. This is partly because most of the portraits and figure studies of the past have been in oils, but there is a more practical reason too. Drawing and painting people is not easy, and using oils, which can be scraped down, overpainted and corrected in a number of ways, allows you to make false starts without being bound by them.

Changing styles

The ways in which figures have been portrayed over the centuries has varied enormously, partly because of a shifting emphasis in patronage. The pre-Renaissance artists, dependant on the Church for their commissions, were limited to exclusively religious subject matter, and their depictions of the Holy Family and various saints were idealized versions of humanity – the physical imperfections of actual human beings would not have been acceptable. These, however, began to appear in the works of such artists as Masaccio (1401-12), Leonardo da Vinci (1452-1519) – who always insisted on drawing from life – Michelangelo (1475-1564) and Raphael (1483-1520).

During the time of the last three, it was believed that figure painting had reached its peak and could not be bettered. In a way it certainly had, and Renaissance art still has much to teach us today, but in terms of style we have moved on. The figures in Michelangelo's Sistine ceiling have tremendous power and drama, but these are no longer major concerns. Most people would now find a portrait by Whistler (1834-1902) more immediately appealing and lifelike, though his pictures were scorned by contemporaries as sketchy and unfinished looking.

One of the most famous of all nude studies, *Olympia* by Edouard Manet (1832-83), caused an outcry when it was exhibited at the Salon. The nude had previously been acceptable only when placed in a historical or mythological setting, but Manet's model was an ordinary Parisian girl, and the picture exudes sexuality.

In those not very far-off days there were rules, not only about subject matter, but also about how to paint. Manet was much criticized for his technique, in particular his lack of tonal modelling. We are fortunate in having no such standards imposed upon us. Looking round any major art gallery demonstrates the way each new generation has brought its own theories and interests to bear on the subject of the human figure, and it is now obvious that there is no "best" way to paint figures or portraits – it depends on what the individual artist wants to say.

The importance of drawing

But however free and spontaneous a portrait or figure study may look, it has to be based on sound knowledge and observation, so get into the habit of drawing and sketching people whenever you can, and when you start on a painting, try to see the figure as a set of simple forms that join together, not as a collection of small details. In a portrait, look for the main planes of the head created by the forehead and temples, the bridge and sides of the nose, eye sockets, cheekbones and chin. One way to observe these while excluding details is blur your vision by half closing your eyes. This will also enable you to assess the main shape of a face and its overall colour, the two most important basics.

Be careful about proportions, as these are the downfall of many inexperienced painters. Legs and arms, for example, are longer than you would think, and feet and hands larger. Proportions can be measured by holding up a pencil or ruler and sliding your thumb up and down it, a time-honoured method used by most artists – some even use a pair of dividers for very precise measurements.

Once you have worked out the composition, make careful UNDERDRAWING on the support before you start to apply colour. You may find it helpful to do an UNDERPAINTING as well, as this will help you to establish the main masses of colour and tone. The golden rule is not to rush; the more care you take in the early stages the freer you can be in the later ones.

SUSAN WILSON
"Kim Looks at Bonnard"
Although the vigorous
BRUSHWORK in this portrait
appears loose and free, it is
highly descriptive: we gain a
very definite impression of the
sitter's attitude and personality,
although there is the minimum
of detail in the features. The
composition of the portrait has
been carefully planned, with the
edge of the chest-of-drawers
on one side and the curtain on
the other framing the figure
without being obtrusive.

COMPOSING A PORTRAIT

A portrait is first and foremost a painting, and should be treated with as much regard for composition, colour and so on as any other subject. To fulfil its function as a portrait it must also portray a specific personality, so you will need to consider how the composition can bring this out.

Decisions must be made about the position of the head, the clothing, how much of the person's body to show (you could stop at the shoulders or continue down to the hands), the background and any other objects you may want to include.

Study your sitter to ascertain what to you are his or her most distinctive qualities. It is usually easier to begin with someone you know well, as you will have made some of these observations already. Most people have characteristic ways of holding their heads and hands, and tend to sit in particular positions. They cannot assume these to order, but will gradually fall into them if allowed to relax and become used to being stared at.

Choose a colour scheme for the picture, but remember that it is usually best to keep the clothing and background fairly muted so that they do not compete with the face, which is always the focal point in a portrait. Experiment with the lighting, making sure that the shadows are cast in a way that defines the form of the features and any important creases or dimples. In general it is best to avoid very harsh lighting as this can make the sitter look gaunt and old, and robs the shadows of colour.

▼ STEPHEN CROWTHER
"The New Baby"
The window bars provide a background frame for the delicate treatment of the sitter's head, and the green foliage in the garden beyond stresses the theme of new life. The pose, with the tilting head and the hand resting on the baby's body, expresses quiet devotion, but the composition is full of movement.

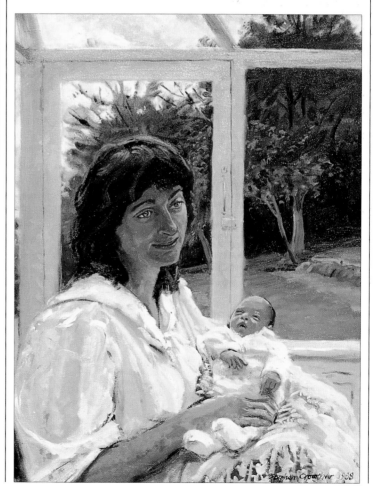

◄ NAOMI ALEXANDER
"My Daughter, Georgia Rosengarten"
This portrait illustrates the importance of BRUSHWORK in a composition. Here the sweeping brush marks follow the contours of the hair, blouse, arm and chair back, continuing up and around the background wall. A necessary anchor for all this swirling movement is the strong vertical of the window frame, whose dark tone echoes the bold black outlines of the chair.

▲ OLWEN TARRANT
"Sydney from Stepney"
This simple, classic composition ensures that attention is focused on the sitter's character, and the sombre mood is enhanced by the very limited colour range. When planning a head and shoulders composition care must be taken to leave sufficient space at the top and sides of the head or it may look cramped and uncomfortable.

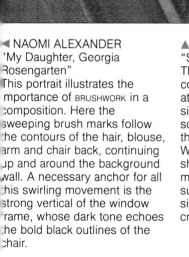

ACHIEVING A LIKENESS

The general shapes of faces vary much more widely than most people realize. You do not have to go right up to people to identify them; even at a distance a face can be distinguished as that of a specific person. You can also usually recognize a blurred photograph without any trouble.

It thus follows that the first thing to do in a portrait is to establish the shape of the face and the underlying structure: the planes of the forehead and temples and of the bridge and sides of the nose; the positions of the eye sockets, cheekbones and chin.

The next step is to take careful measurements to establish these planes and their relationship to one another on canvas. Details, such as eyebrows and the precise line of lips, should always be built up to slowly; if you begin with these you are less likely to produce a good portrait. You may even find that you can stop working on the picture far sooner than you had originally envisaged and with fewer details than you would have thought necessary. If this is the case, resist the temptation to continue, as you could ruin the painting.

If you do overwork a portrait, and it is all too easy to do so, it can sometimes be saved by TONKING if the paint is still wet. This removes excess paint and leaves a soft, undefined image which is an ideal base for further work.

◀ RUPERT SHEPHARD
"Professor Michael Shepherd"
This formal portrait has been
built up gradually in layers over
an UNDERPAINTING. The face has
been described in considerable
detail, but there are very few
hard edges, the only relatively
sharp contours being those of
the nostril and the lips.

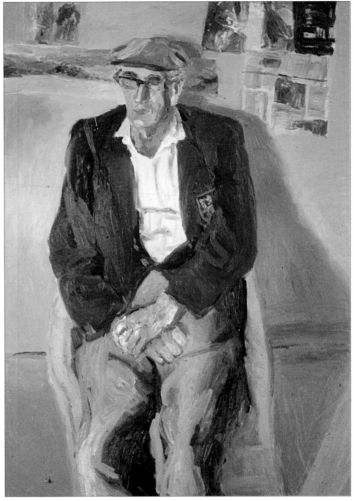

◀ SUSAN WILSON
"Farrell Cleary"
This powerful portrait, with its
loose, bold BRUSHWORK, makes
an interesting contrast with
Rupert Shephard's opposite.
The posture and face are
beautifully observed, and the
composition is given additional
strength by the firm black lines
against the flat neutral
background.

▲ SUSAN WILSON
"My Father"
Here the sitter's pose
contributes as much to the
likeness as the face itself.
Always try to recognize
particular ways of sitting and
standing before you embark on
a portrait, as people's "body
language" varies widely and
can be very expressive.

SKIN TONES

Although skin appears predominantly pinkish or brownish, it is in fact made up of a great many different hues and tints, some very far removed from the tubes of colour sold by paint manufacturers as "flesh tint". Even when you discount variations arising from light and shade on a form, the colour and texture of skin is markedly different from one person to another, and it also varies according to the part of the body.

The presence of pigment darkens the skin, the extent according to racial origins and degree of exposure to the sun. All skin, however, is to some extent translucent, and much of its colour comes from the blood in the capillaries below. This is responsible for the warm pink or red glow particularly noticeable on the face and hands. Sometimes, particularly with very pale-skinned people, you will also see tinges of blue from underlying veins.

Skin tends to appear as a collection of warm and cool colours, which can help to describe form, since the cool colours tend to recede and the warm ones to advance. The PALETTE should therefore comprise a selection of both types. A suggestion for the cool primaries is cobalt blue, alizarin crimson and lemon yellow, while the warm ones might be French ultramarine, cadmium red and cadmium yellow. Other useful colours are yellow ochre, Naples yellow, burnt and raw sienna and raw umber.

It is important to be decisive about the colours you apply to

the painting. Keep mixtures clean and pure by limiting the number of colours in them to three or four, and take time over mixing or you will end with a collection of random, unrelated hues.

The techniques you use depend entirely on individual preferences, but certain skin qualities can be brought out by particular techniques, notably GLAZING over an UNDERPAINTING. The translucency can be emphasized by glazing dark over light as in the portraits of REMBRANDT (1606-69). A method widely used by the Renaissance painters was to apply warmer skin colours thinly over a cool green, grey or purple underpainting.

▲ OLWEN TARRANT
"Tides of Silence"
Flesh is seldom if ever a uniform colour. The variations in tone and hue have been played down here so that the body harmonizes with the other basically flat shapes which make up the picture, but it is still very three-dimensional, owing to the subtle modelling of form with relatively muted colours. The overall impression is of pink, but the highlights are in fact a creamy colour, while mauvish mid-tones lead to shadows of light green, blue and red.

▼ SUSAN WILSON
"The Spinal Injuries Nurse"
The overall colour of this sitter's
skin appears as a brownish
pink, but on close inspection
you can see that this is made
up of a variety of hues, from
creams to browns and reds.
Painting skin demands careful
COLOUR MIXING, as these colours
are all closely related to one
another, and a too-bright or
over-dark patch of paint could
have a disastrous effect.

▲ ARTHUR MADERSON
"Looking for Skimmers"
Painted rapidly in thick IMPASTO,
the skin tones are composed of
bold chunks of colour
interweaving and overlapping
one another. The actual colours
range over a wide spectrum,
but because they have been
applied WET INTO WET they merge
and streak into each other,
creating a soft effect.

THE CLOTHED FIGURE

When drawing and painting the clothed figure it is important to remember that it is only a cover for the body, and that all the folds and creases are dictated by the shapes beneath. The beginner tends to treat garments as though they had lives of their own, with the result that the uncovered head, hands and feet bear little relation to the amorphous mass in between.

Very careful observation and drawing of the clothing is needed to bring out these underlying forms. It is helpful, particularly if the clothing is thin, as in the case of a summer dress, to try to visualize the person's body and limbs. You can even make a loose skin-toned UNDERPAINTING of the body first, leave it to dry and then glaze or scumble the clothing over it (see GLAZING and SCUMBLING).

Another potential problem is that of rendering specific textures. Different textiles owe their particular appearances to the ways in which they reflect light. For example, velvet differs markedly from linen or cotton owing to the fact that the highlights occur at different positions on the folds. A shiny fabric like satin has much more distinct tonal variations than a matt one such as wool.

In a portrait it is usually best for the sitter to wear garments in which he or she feels most at ease, as people unconsciously express their characters through their clothing. The colours should not dominate the painting, indeed clothing can often be treated quite broadly and sketchily in order not to steal interest from the face.

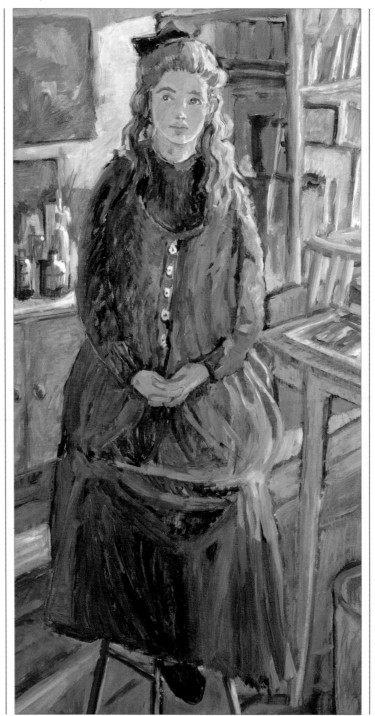

◀ NAOMI ALEXANDER
"My Daughter Georgia"
The clothing is treated first and foremost as a simple, rather elongated shape leading the eye up to the sitter's face, and yet there is quite enough detail to make it interesting in itself. The contours and folds of the dress suggest the way it flows comfortably over the body, and also define the waist, hips and knees. The artist favours a smooth surface on which to work (see SUPPORTS), and this painting was done on a wood panel.

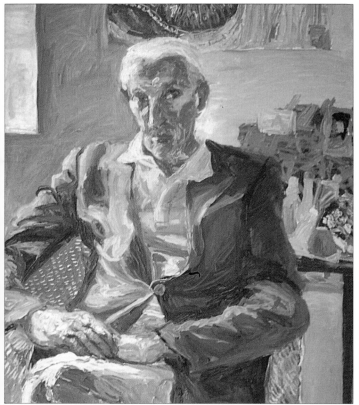

▲ SUSAN WILSON
"Lewis"
This artist's BRUSHWORK is always both exciting and descriptive, and here she has almost "drawn" the jacket and trousers in thick IMPASTO. The shirt is similarly treated in the same bold and angular style, which suits the sitter very well. A portrait such as this gives us an insight not only into the person portrayed but also into the artist's perception of him.

▶ STEPHEN CROWTHER
"The French Visitor"
The black and white stripes covering about a quarter of the picture surface give the painting a very individual character. The face has also been treated basically in terms of black and white, so that it harmonizes with the sweater instead of being dominated by it. The BRUSHWORK is fairly loose, particularly of the black stripes, which in fact are painted in a dark blue. Notice also that the colours used for the white stripes are far from pure white.

CHILDREN

Painting children, particularly those related to you, is extremely rewarding, as each picture becomes a personal record of the child's growth.

A difficulty is, of course, the child's notorious inability to keep still. Some artists solve this problem by bribery, while others try to catch their "sitter" when he or she is fully absorbed in some activity, such as drawing, reading, playing with trains or dolls, or even watching television. The latter course has a dual advantage; firstly the child will appear relaxed and will unconsciously adopt some typical pose or gesture, and secondly the activity will tell a story about the child's particular interests at the time.

Children tend to look stiff and embarrassed if asked to pose for any length of time, which does not make for a good portrait. Thus if you do intend completing a whole painting in front of the sitter you will have to be prepared to work quickly in short sessions. If you normally make an UNDERPAINTING, it is helpful in such cases to use acrylic for this, as it dries in a matter of minutes.

One of the commonest mistakes is making the child look too old, which can happen if you even slightly overwork any dimples or shadows. It is best to keep the lighting soft, and avoid too much contrast of light and dark. The contours of the face are much gentler in children than in adults, so you may want to avoid obvious brushstrokes – the FINGER PAINTING method could be useful, at least in some areas of the picture.

▲ JEREMY GALTON
"Timmy"
Painted in exactly two hours, the intention of this ALLA PRIMA portrait was to capture a pose and expression characteristic of this child, the artist's son. Some very thin UNDERPAINTING established the main framework of the face, and this was followed by just one layer of thicker paint. The painting was done on hardboard stained an ochre colour, and this COLOURED GROUND, visible over much of the face, contributes to the finished effect.

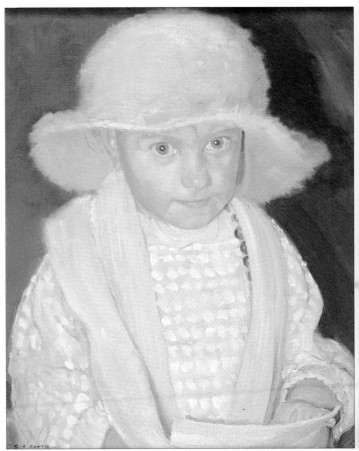

▲ DAVID CURTIS
"Portrait of Emma"
The proportions of the face and body of a child are quite different to those of an adult, and the contours of the face are smoother. These big blue eyes set in a smooth pink face, and the narrow shoulders and short arms, could only belong to a child. The soft hat and muted colours enhance the impression of youthful innocence.

◄ ARTHUR MADERSON
"Boy and Girl on Beach"
The placing of the children high
in the picture enhances their
slightness of build and also
excludes the spectator from
their private, whispering world
by placing the water between
them and us. Most of the
painting is constructed of fat,
slurred strokes of IMPASTO over
lean UNDERPAINTING. A bright red
COLOURED GROUND left uncovered
in many places is particularly
noticeable in the foreground
and the children's reflections.

SETTINGS

In a portrait, or a picture which is primarily a portrait, the surroundings must complement the figure without competing with or detracting from it. However, even if they are treated in less detail than the figure, they need just as much thought. A setting can back up the portrait by offering a visual description of the interests or occupation of the sitter. For example, you might paint a child reading or drawing, or an artist standing at his easel – where you can be sure he will remain engrossed for hours. Similarly, a shopkeeper could be portrayed in his shop or a tennis player out of doors holding his racquet.

In purely pictorial terms the setting you choose can provide a useful set of compositional "tools" with which to construct the picture. Linear features such as corners of walls, window frames or the edges of floor and ceiling provide verticals and horizontals which give solidity to the setting. The diagonals made by horizontal lines at an angle give depth to a picture by indicating three-dimensional space, and are also useful as lead-ins to the focal point. Windows, pictures on walls, vases of flowers and other eye-catching items can be used to balance the composition provided they play a subsidiary role and you ensure that the eye is ultimately led back to the figure.

Sometimes a figure painting is not so much an individual portrait as a portrayal of a person performing a particular task – the face may not even be visible. You might be

interested in painting a tennis player in action, for example, or someone windsurfing or dancing (Degas' ballet dancers are the most famous portrayals of such subjects). It is the action itself that must be conveyed, so look for the positions and attitudes that best suggest movement, and try to make your technique express it also. A rapid WET INTO WET approach is well suited to moving subjects, as it provides a degree of blurring and avoids over-precise definition.

In contrast, a figure may be no more than one element in a landscape or interior. While relatively unimportant in itself, it can act as a focal point or provide a standard for scale. A tiny figure in the foreground of a mountain landscape, for instance, can emphasize the feeling of space and grandeur.

◀ TREVOR CHAMBERLAIN
"Working on Site, Bugsby's
Reach"
A favourite subject for the
painter is a fellow artist
engaged in the same activity.
The "model" is likely to remain
more or less immobile as long
as you are there, and can be
shown in a setting which is
wholly compatible with his or
her occupation. Here the figure
is the obvious centre of
interest, but our eyes are drawn
from the foreground area to the
delicate depiction of the distant
river bank.

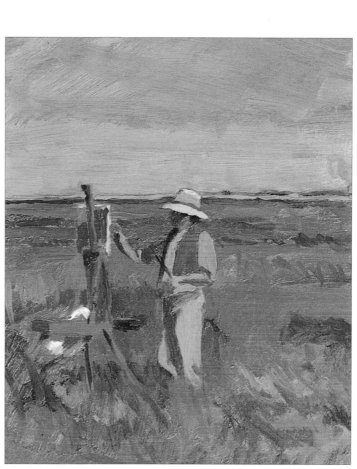

◀ DAVID CURTIS
"Study of Sian"
This painting is both a fine
portrait, in which the
surroundings say something
about the sitter, and a painting
of a specific interior with the
figure as the main subject. The
composition is carefully
planned: the cupboard doors at
bottom right balance the
window, and the diagonal of the
chair back links the foreground
and background.

▲ JEREMY GALTON
"James Horton at Work,
Morston Marshes"
This small oil sketch again
shows a fellow artist at work,
with the figure and his painting
paraphernalia contrasting nicely
with the desolate landscape
and gloomy sky.

▼ ANDREW MACARA
"Home from School, India"
Although the setting is colourful
and full of interest, the
composition would have been
incomplete and dull without the
striking forms of the four
children. These are used to
introduce a pattern element into
the foreground, while the fifth
figure entering the scene from
the left introduces movement to
an otherwise static arrangement

▲ OLWEN TARRANT
"A Lady of Beguiling Ways"
The figure is again the focal
point because of the sharp
tonal contrasts provided by the
dress. However, this is just one
part of the intricate mosaic of
shapes and colours which
make up the composition. The
overall pattern is the real
subject of the picture.

◀ ARTHUR MADERSON
"Birthday Treat"
In any painting of a figure in an
interior care must be taken to
treat the whole picture as one,
as the artist has done here. The
girl, with her angular black-clad
limbs, nevertheless remains the
centre of attention.

GROUPS

Figure groups are an exciting and challenging subject, but beginners are understandably wary of such seemingly ambitious projects – one figure is difficult enough. But in fact, unless you are painting something like a group portrait of a family, where likeness is important, you can usually treat a collection of figures in broad terms – it is the way you arrange them that is important, and the "story" that they tell.

A group will almost always have something in common, a reason for being together. They may be strangers to one another but drawn by the same interest, for example watching a performance or buying fruit in a market. Or they may be together because they are friends or members of the same family.

Whatever they are doing, people seldom stay in the same positions or formations for long, and for this reason many figure groups are painted from sketches. You will need to make your studies as informative as possible or you will find it difficult to combine them into a painting, so make sure you give an indication of scale and the direction of the light. Also look for characteristic shapes and gestures: although you are not painting portraits the "storyline" will suffer if you fail to make the figures look believable in human terms.

◀ RAYMOND LEECH
"Searching for the Ice-cream Money"
Even without knowing the picture's title it would be obvious from the unoccupied mats and sunbeds that the people have got up specially to participate in some communal activity. Paintings of figures and groups of figures often contain a degree of narrative content, as people are nearly always engaged in some activity, and this "story-telling" element can play an important part in a picture.

◄ NAOMI ALEXANDER
'Fabia and Children"
Even though there are no facial
details, the postures and
shapes of the figures are so
carefully stated that they are
immediately recognizable as a
mother and her children. A
feeling of intimacy is created by
the cool, gentle colours and the
pool of light that unites the
small group.

▲ ARTHUR MADERSON
"Lismore Fête"
All eyes are turned towards a
source of entertainment beyond
the edge of the frame, yet such
is the richness of the
BRUSHWORK, colour and texture
on the picture surface that our
eyes remain held by it. Indeed,
although the figures are
beautifully observed and stated,
the painting has a powerful

physical presence of its own
which has less to do with the
subject than the way it is
treated.

PORTRAIT

DEMONSTRATION

TOM COATES

Coates enjoys painting portraits of people he knows and likes, but seldom accepts commissions, as he prefers retaining the freedom to explore new subjects and media – he also works in watercolour and pastel. He describes himself as a tonal painter, who perceives the subtle harmonies of colours but has never been able to exploit brilliant hues. This preoccupation with light and dark is very apparent in this portrait, which is extremely tightly organized in terms of tone. It was completed in one session; Coates is a rapid worker who likes to explore his subject and make decisions as he works.

▲ 1 Working with heavily diluted paint, the artist establishes the overall composition and pose with broad strokes. The thickness of the lines avoids any precise definition of outlines at this stage.

▼ 2 He then begins to indicate the main planes of the face, delineating the cheekbone with a slash of lighter colour.

▲ 3 Working on all the areas of the picture together, the important relationships of colour and tone are mapped out. The BRUSHWORK is still loose and free, and there is no attempt at detail.

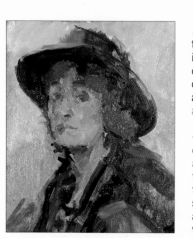

◄ 4 A few deft brushstrokes of cool and warm pinks, browns and yellows, and an individual face begins to emerge. Notice that the paint, thin in the early stages, is now quite juicy, in accordance with the principle of working FAT OVER LEAN.

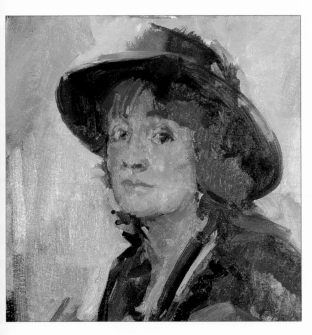

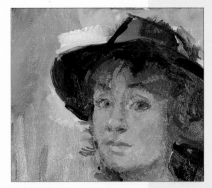

▶ **6** A little BLENDING has smoothed out the contours of the face. Final touches such as the feather in the hat, the highlight on the earring and the stripes on the scarf impart a lively sparkle to the picture (below). The clothing, particularly the area at bottom right, has been left vague so that it does not compete with the centre of attention – the face.

▲ **5** The steady build-up of paint gives form to the features and shape of the face. The artist now turns his attention to the background. Having tried out various combinations of pale and darker grey, he finally decides on the warm, mid-toned greenish-grey seen in the finished picture (right).

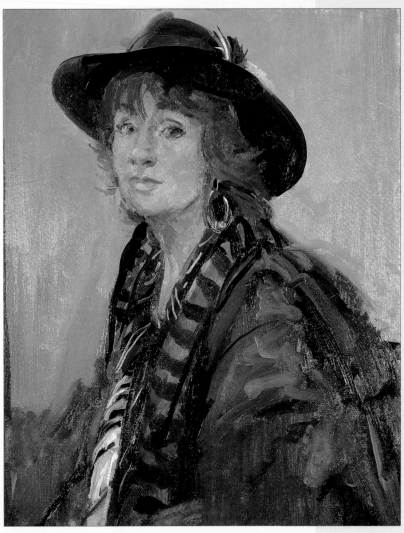

TOM COATES
"Portrait of Patti"

Although beautifully observed details of hills, fields and flowers began to appear in religious paintings even before the Renaissance, landscape only became accepted as a subject in its own right in the 17th century. Two of the greatest proponents of the genre were Claude Lorraine (1600-82) in France, and Jacob von Ruisdael (1628-82) in Holland, both of whom had a considerable influence on later painters. Neither, however, painted nature as it really was: Claude's scenes were idealized and peopled with classical nymphs and heroes, while Ruisdael's had an emotional and subjective content which was to be taken further over a century later by the great J.M.W. Turner (1775-1851).

It was left to Turner's contemporary John Constable (1776-1837) and later, the French Impressionists, to explore nature objectively, recording such things as the play of light on leaves and grass and the movement of sky and water. Today landscape is the most popular of all painting subjects, and although we may admire the beautifully organized compositions of Claude, most of us respond more positively to the Impressionists' more spontaneous ALLA PRIMA works.

Working on location

There is still nothing to beat working in this way. In the unstable weather of temperate climates it is not always possible to complete a whole painting on the spot, but it does not take long to make colour sketches which you can use as the basis for a studio painting. Direct experience, with the landscape and the weather surrounding you rather than held at a safe distance, will make you better able to convey the flavour of a particular place in particular weather conditions, which is what landscape painting is all about.

Oil paints are the ideal medium for outdoor work, and if you restrict the size you can cover a canvas or board very quickly. The tiny oil sketches Constable made as reference for his large finished works were often done on paper or cardboard (see SUPPORTS), both of which are surprisingly sympathetic to work on. You can also buy pads of special oil sketching paper, which are

inexpensive. Some artists dislike it because it has rather a greasy surface, but others find it useful.

It has to be admitted that there are problems in outdoor work; most artists have stories to tell about sunburn, insect bites, easels blown away by sudden gusts of wind, and paintings abandoned because of rain. There is little you can do about rain, but in hot climates is wise to take tubes of sun filter and insect repellent and a hat to ward off the sun, while in cold ones extra pair of thick socks and even a hotwater bottle are sometime needed. There is nothing fussy about this – extrem physical discomfort lessens your ability to paint well.

Building the foundation

To some extent the popularity of landscape springs from the idea that it is easier than painting portraits of buildings. But although you don't have to achieve specific likeness – it may not matter too much if the contour of a hill is not exactly right – careful observation and good drawing are still important. It is perfectly permissible to move a feature such as a tree from one place to another if it helps the composition, but if you change its shape you will also lose its character, and the will result in dull, meaningless work.

So unless you are very confident about what you are doing, always begin with an UNDERDRAWING in which you establish the main elements and their relationship to each other. And don't forget that perspective comes into it also; the accurate placing and correct proportioning of features such as rivers, hedges, fields and so on crucial.

In a flat landscape this is particularly vital. It often comes as a surprise to find that what you know is a large lake in the middle distance actually takes up only a very narrow strip of space on the picture surface. It is seldom safe to trust to the eye alone. Take measurements by holding up a pencil or brush with your thumb positioned so that its distance from the tip coincides with that between the features you are measuring. If you are working "sight size" you can transfer such measurements direct to the working surface.

► CHRISTOPHER BAKER
"A Turn in the Woods"
Weak sunlight is beautifully captured in this painting, filtering through the spring foliage down to the carpet of flowers. The converging shadows lead the eye through to the clearing and beyond to the pale, distant trees. The more prominent foliage and foreground vegetation has been stippled, scumbled and dry brushed in thick paint (see SCUMBLING and DRY BRUSH). Thin UNDERPAINTING is visible in places over much of the canvas.

◄ TREVOR CHAMBERLAIN
"Suffolk Lane, June"
This small ALLA PRIMA painting was completed quickly, and derives much of its character from the way the relatively large WET INTO WET brushstrokes criss-cross into each other in a lively and energetic manner. The red barn doors form an eye-catching focal point, their colour accentuated by the dark richness of the surrounding hues.

SUMMER

The most noticeable thing about summer landscapes in temperate climates is their lush greenness. But while lovely to look at, this very quality can become monotonous in a painting unless the colours and tones are carefully controlled.

Greens vary very widely; some are almost yellow, some have a distinct bluish cast, while others, such as the dark olive greens, can seem nearer to brown than green. There are also many other colours among the greens, from pale yellow highlights to blue, violet or brown shadows, so always try to make the most of these rather than painting everything in darker or lighter versions of the same colour.

There are many excellent tube colours in the green range, but try not to rely too much on these, at least until you have learned to identify the different greens and mix them for yourself. The best way to do this is to work out of doors directly from nature – another of the great bonuses of summer.

An excellent way of matching a colour to the subject is to make a mixture on the palette, as close as you can to the particular part of the landscape you are painting, and then load a brush with it and hold it up in front of the tree or patch of grass. This allows you to see immediately whether you have mixed a shade which is too blue, too dark or too light, and you can then amend it accordingly.

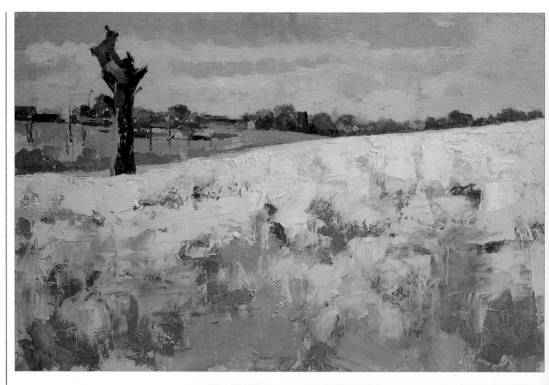

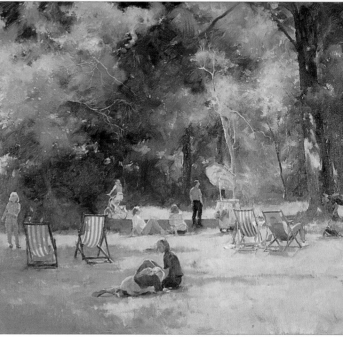

▲ JAMES HORTON
"Rape Field"
The bright yellow flowering rape and the fully foliaged distant trees instantly suggest early summer, albeit on a dull and overcast day. Although the rape field covers two-thirds of the picture surface, the artist has prevented the yellow from becoming overbearing by balancing it with strong green areas in the foreground. The richly textured picture surface has been achieved by KNIFE PAINTING.

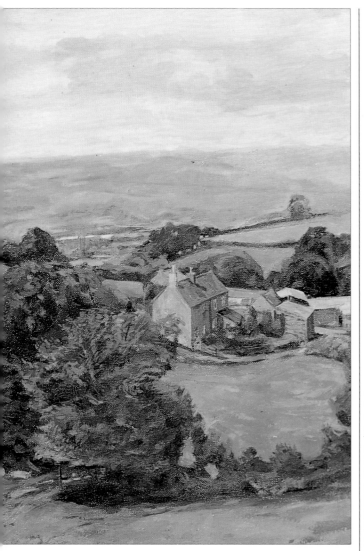

◄ CHRISTOPHER BAKER
"Moreton Hampstead"
The greens of summer foliage
become increasingly blue with
distance, an effect which has
been well-observed here. All
the different greens in this
painting could be obtained by
mixing varying amounts of
ultramarine and phthalocyanine
blues with cadmium and lemon
yellows or ochre.

▲ ARTHUR MADERSON
"Picnic Evening"
Here the technique of optical
mixing (see POINTILLISM) has
been used to give the colours
extra brilliance. The foreground
vegetation has been dabbed
and stippled in mainly blues,
greens and yellows, so that the
whole painting shimmers with
light.

◄ DAVID CURTIS
"The Ice Cream Seller"
The relaxed and happy
atmosphere of a summer day is
beautifully recreated by the lush
greens and dense foliage. The
painting is almost entirely
composed in vivid greens and
muted blues, with the one
touch of orange-yellow drawing
the eye into the centre.

WINTER

Many of the sensations typical of winter are felt rather than seen, for example we do not actually see the cold, the damp or the biting wind. A good painting, however, can evoke these physical sensations by sight alone. This can often be done by providing visual clues, such as a pale, weak sun, low-level clouds, stark bare trees or figures leaning into the wind with their clothing clutched around them.

You can also suggest cold by means of colour. The colours of winter are in general more subdued than those of summer, and less warm. One of the dangers is that a painting in which cool greys and blues predominate can become dull, so it may be necessary to include accents of bright, warm colour for contrast. The whiteness of snow, for instance, can be pointed up by the inclusion of a red roof or a figure in bright clothing. In fact snow, although appearing white at first glance, often contains a host of blues, violets and greys, or it reflects colour from the sky.

One way of avoiding monotony of colour is to paint snow scenes over a warm ground of ochre, sienna or dull red (see COLOURED GROUNDS). If the surface is left only partially covered the brushstrokes of cool colour are enhanced by the warm patches of ground showing through in the finished painting.

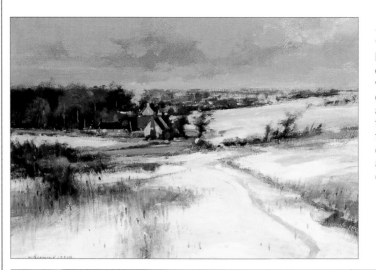

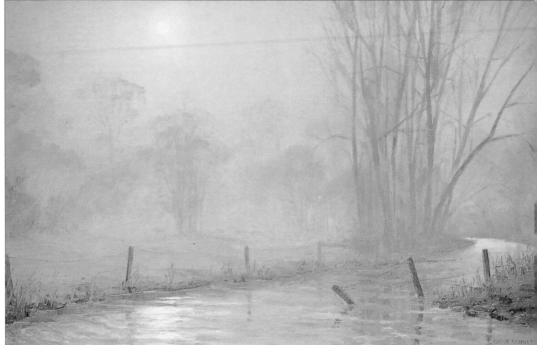

◄ RAYMOND LEECH
"The Edge of the Village"
In spite of the large expanses of snow and sky this picture is well-balanced in terms of both cool and warm tones and light and dark areas. The ochres of the hay and the red-browns of the trees and houses counterpoint the cool whites and blues of the snow and distant hills.

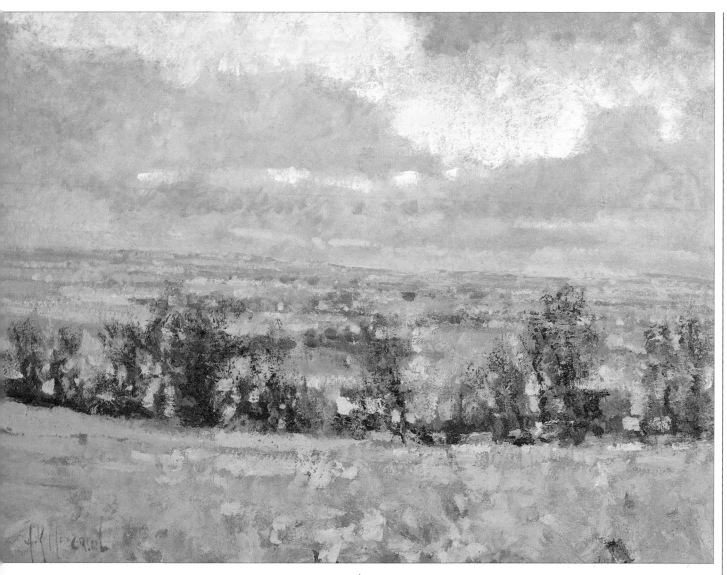

◄ BRIAN BENNET
"Peover Eye, Christmas Morning"
Damp, frost, mist and a low sun are the ingredients of this convincingly wintry scene. The overall pale blue has been slightly yellowed in the foreground and middle distance to suggest the green grass, and the linear foreground trees and fence posts provide an anchor for the diffuse distant forms of the trees.

▲ ARTHUR MADERSON
"Approaching Dawn, Mendips"
The cold, icy blues are tempered by accents of warm reds, yellows and ochres scattered through the painting. The picture has been built up in stages, with the final layers applied WET ON DRY, with considerable use of SCUMBLING. You can see clearly how the thick, relatively dry paint has deposited on the crests of the canvas weave, allowing the UNDERPAINTING to show through and contribute to the final effect.

WEATHER

The appearance of the landscape on any particular day – or even minute – is governed by the weather, indeed the weather in many cases *is* the landscape, and can form a subject for painting in its own right. For instance, everyone has seen a sunny, tranquil view becoming dark and brooding as a storm brews up, or watched a dull landscape being transformed into a place of magic by a gleam of sunlight emerging through mist or rain.

Such effects, however, are fleeting, so get into the habit of making small on-the-spot sketches which you can use as a basis for studio paintings (you can also use photographs, but try not to rely on them too heavily).

Both Constable (1776-1837) and Turner (1775-1851) were fascinated by weather effects, and made countless small colour notes of this kind. Constable was particularly interested in rainbows, which offer a marvellous opportunity to contrast bright colours with a mass of dark greys.

Pouring rain seldom makes an interesting subject, but light rain sometimes does, particularly when gleams of light are visible. Mist creates lovely atmospheric effects, softening the contours of shapes and reducing the intensity of colours. You might find either the FINGER PAINTING or the SCRAPING BACK techniques useful here. For stormy skies, try to make your BRUSHWORK as lively and descriptive as possible; that in Constable's small oil sketches of skies is tremendously vigorous – sometimes almost wild.

◄ JEREMY GALTON
"Norfolk Wheatfields"
Fine, sunny days tempt one out to paint more readily than the dull, overcast ones, but this kind of weather can be equally interesting in terms of colour, as Galton's painting shows. The very absence of direct sunlight make the dark shapes such as hedges and trees appear heavier and more solid, while fields can appear strikingly green, or golden, by contrast.

▲ RAYMOND LEECH
"The Flooded Woods"
The sharpness of a cold winter's day is suggested by the jagged forms and spiky BRUSHWORK. Clever use of the DRY BRUSH method defines both the thin, delicate winter branches and vegetation and their reflections in the water.

► TREVOR CHAMBERLAIN
"Welsh Mountain Sheep"
Heavy cloud or mist on mountains is a perennially popular painting subject. Here the cloud plays as vital a role in the composition as the dark mountain, but the artist has stressed the different qualities of air and rock by painting the sky WET INTO WET to create a soft blurring. The sharper edges of the mountain are strengthened by contrast.

► TREVOR CHAMBERLAIN
"September, Waterford Marsh"
The pastel shades of this misty scene have been achieved by using highly unsaturated colours – that is those mixed with a substantial amount of white. Very careful control of tones is needed for scenes like this, and it is wise to mix several colours side by side on the palette before putting them onto the canvas. Alternatively, stronger colours can be applied and then given a misty veil of white or grey using either the DRY BRUSH or the GLAZING techniques. In this case the underlayer of paint must be completely dry.

TREES

Trees, particularly when in the foreground of a painting, are a tricky subject to paint, mainly because of the difficulty of deciding just how much to include. Distant trees are easier to tackle, since you can see much less variation of colour, and the contours are quite obvious.

It is always necessary to simplify to some extent, whether you are painting bare winter trees or foliage-clad summer ones. Far-off trees are less confusing simply because distance has done the simplification for you. Foliage and clusters of twigs appear as large masses, while closer up they divide into a bewildering number of smaller components, including individual leaves.

It is thus a good idea to make an initial assessment of the subject by half closing your eyes to blur your vision. This throws the details out of focus and helps you to establish the main shapes and colours.

Begin by blocking these in loosely with well-thinned paint. This will dry fast, and act as the UNDERPAINTING over which you can begin to develop the smaller branches or clumps of foliage. Leave the fine detail until last, and make sure your BRUSHWORK is consistent with that of the rest of the painting. Do not attempt to paint every leaf even if you are close enough to see each one clearly; picking out a few around the edges of sprays can often suffice.

Notice the way the light falls on the tree as a whole and on the separate clumps of foliage, as this gives it form and solidity – amateurs often produce flat cardboard cutouts. Another common error is to paint a hard outline where the top of foliage meets the sky. The leafage is thinner at the ends of branches, and the light shines through it strongly, so the colours at the edges appear quite pale. Working WET INTO WET is an excellent method for this kind of soft blending, and indeed for all areas of foliage.

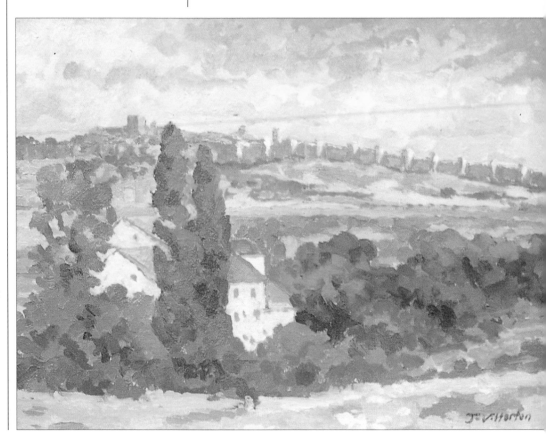

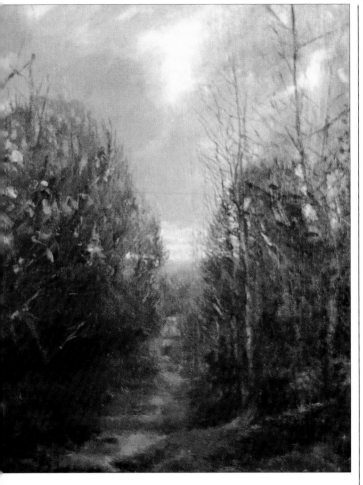

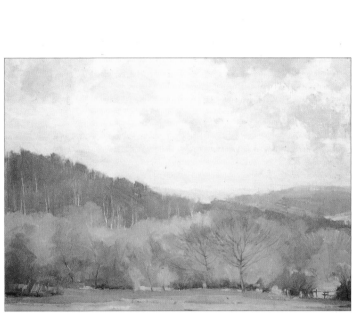

◀ JAMES HORTON
"Avila"
The types of trees that can tolerate hot climates are often distinctly blue in colour, and the artist has exaggerated this to produce a composition with an overall blue bias. The use of patches of BROKEN COLOUR combined with bold BRUSHWORK gives a strong feeling of life and movement as well as stressing the importance of the picture surface. Notice how the shapes of the clumps of foliage are echoed in sky.

▲ CHRISTOPHER BAKER
"Path Through the Wood"
Winter trees can be a problem, as it is often difficult to decide how much of the intricate network of branches to include. In this case the branches of the birches against the sky on the right have been meticulously painted, while the others are mainly treated as blocks of colour, with background sky added in patches later on.

▲ DAVID CURTIS
"Early Spring, Cordwell Valley"
The great variety of colours to be seen in winter trees is shown beautifully here, with pinks, browns and purples neatly juxtaposed. Just a few trunks and branches have been picked out in detail, leaving the rest as suggestions.

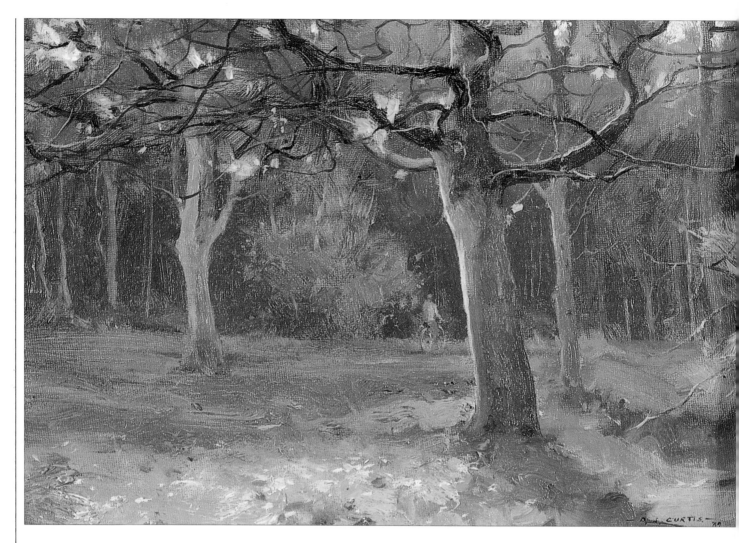

▲ DAVID CURTIS
"Late Autumn, Clumber Park"
Fairly thin paint has been used for much of the picture, but the fallen leaves and the few golden leaves remaining on the trees are applied in thick IMPASTO to great effect. Notice how all the branches of the nearest trees have been depicted in great detail, in contrast to the broader treatment of the distant forest. To achieve the effect of tiny lines of daylight in this area, the artist has scratched through the dark paint (see SGRAFFITO) to reveal the white ground below.

◄ ARTHUR MADERSON
"The Orchard"
Trees in blossom are wonderful subjects to paint, though not exempt from the perennial problem — how much detail to include. Maderson's near-Pointillist style (see POINTILLISM) is ideally suited to the subject, and by skillful handling of color and tone, he has enabled us to distinguish between the dabs of pale paint which represent blossom and those which represent sky.

► ROBERT BERLIND
"Sycamores at Night"
Berlind is fascinated by night scenes as well as by trees, and here has used almost black sky as an effectively dramatic background. It has been added after and around the lamp-lit branches in such a way as to leave considerable areas of COLORED GROUND showing. In addition, some of the branches and the gray window (center left) have been scraped down to the bare ground (see SGRAFFITO). The branches of the left-hand tree appear almost to be wrestling with those of the right, producing a powerful, dancing image.

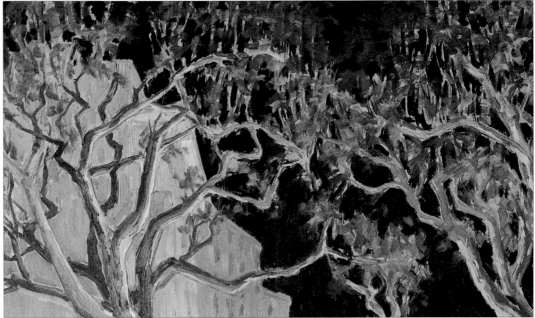

SHADOWS

Because shadows change in colour, depth and shape according to the season and time of day they can provide valuable clues about the place being painted. But more important is their role in composition; a well-placed shadow can be used to balance other shapes, indeed shadows are often more exciting visually than the object that casts the shadow.

The colours of shadows are often misunderstood by beginners. They tend to be bluish or violet, and the reason for this is quite simple. A shadow is caused by an obstacle which prevents sunlight from striking the area, but a shadow is not an absence of light; it is still illuminated by the sky. Since the sun is shining the latter will be blue, and the shadow will reflect this colour to some extent.

Another factor involved in our perception of shadows is vision itself. If you look at something yellow and then shut your eyes you will "see" an after-image of the complementary colour (in this case violet). Thus when you look from a light-struck area to a shadowed one the after-image becomes apparent in the same way.

◄ DAVID CURTIS
"Last of the Apples – Troway"
Sloping ground in shadow from
the late autumnal sun divides
the composition diagonally into
contrasting dark and light
masses.

◄ TREVOR CHAMBERLAIN
"Spring Day, Chapmore End"
Little sky is visible, but the
strong shadows across the road
leave the viewer in no doubt
that this was painted on a
sunny day. Their deep blues,
browns and purples contrast
strikingly with the pinkish
browns, and their horizontal
arrangement, at right angles to
the vertical figure, fence posts
and distant trees, establishes a
firm geometric foundation for
the picture.

► JAMES HORTON
"Landscape near Perpignan"
Here the striking blue shadows
echo the colour of the distant
mountains, tying foreground
and background together. The
striped pattern they make plays
an important part in the
composition as well as allowing
the viewer to visualize the
arrangement of the hidden
trees to the left.

FOCAL POINTS

Most paintings, whatever their subject, have a focal point, or centre of interest. It is often the main feature of the picture, such as the sitter's face in a portrait, or a figure in an interior, but it does not have to be as obvious as this.

Most landscapes need a focal point because without one the viewer is not drawn into the picture and it consequently looks dull and meaningless. It is not always easy to establish, one, however. Even in the most beautiful of countrysides there often seems to be no perfect spot to paint from, and this is usually because nature has not provided a centre of interest. You may in this case have to invent one, which can often be done simply by making more of something already there. Perhaps a small building or clump of trees can be moved to a more advantageous position or stressed by means of colour or tonal contrast.

Even in a stark, apparently featureless landscape you may find a feature such as a fence, broken gate or small shrub, and there is no reason why you should not put in a figure in the middle distance even if there is no one in the actual scene.

The focal point does not have to be of intrinsic interest; it is a pictorial device to carry the rest of the landscape into the picture, and the next task is to find a way of directing the viewer's eye towards it. Linear features such as the lines of a wall or ploughed field can act as lead-in lines, while carefully placed highlights and accents of colour in the focal point itself will act as eye-catchers. A figure in a landscape, while not in itself the focal point, could lead to it by a directional gaze or even a pointing hand.

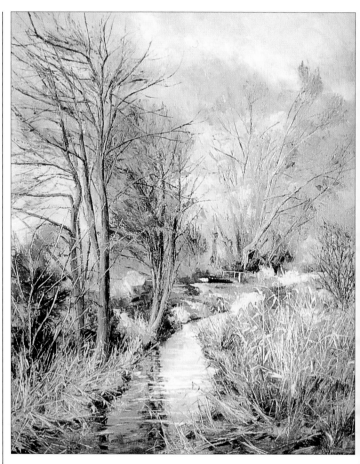

◄ CHRISTOPHER BAKER
"View from Goodwood"
Our eye is drawn immediately to the opening in the wood, the lightest part of this majestic landscape, standing out clearly against the dark woodland. The streaks and stripes of paint, sweeping down through the grassland, all converge at this point, and the foreground also leads the eye inwards, albeit less obviously. The diagonal formed by the golden field might have led out of the frame on the left, but the dark trees form a block to prevent this.

▲ BRIAN BENNETT
"Near the Lock, Spring"
Curving lines, such as those made by paths or rivers, are a favourite device for "signposting" the focal point of a picture. Here the eye is led along the stream to the small but eye-catching white railings, and thence to the central trees, their pale delicacy enhanced by the blue-grey sky behind.

► DAVID CURTIS
"A Morning Walk, Stone Mill"
Figures naturally become the
focal point in a landscape,
simply because we identify with
them, and here they are placed
unequivocally centre-stage.
There are other, minor focal
points in the picture, however,
such as the distant house at the
top right, the small tree at lower
right, and the green field on the
left disappearing into the
distance, all of which hold our
interest by inviting us to move
from one part of the
composition to another.

◄ ROY HERRICK
"Gathering Clouds"
The path swerves round to the
right, leading out of the picture,
but the eye is brought back by
the house and the powerful zig-
zag effect of the roof. The
brightly lit yellow field plays an
important part in linking the
foreground to both the house
and the dramatic sky.

FOREGROUNDS

It is often difficult to decide how to treat foregrounds, and consequently many beginners ignore this area of the picture until they are some way through a painting. This is unfortunate, since one of the tasks of the landscape artist is to create a sense of space, and you cannot do this unless the picture has a foreground and middle ground as well as a background, or distance.

The foreground also serves another even more important purpose, that of leading the eye into the picture, so obviously it must be planned with care. A common mistake is to treat it in much greater detail than any other part of the picture, which is quite natural as you are so much nearer to it. This can destroy the composition, as all the interest is effectively concentrated in one place.

If your foreground is a field or a beach, you may need to exclude details, and simply pick out one or two blades of grass, flower heads or pebbles. It may, on the other hand, be a dull and featureless expanse, in which case you might have to invent something to make it more interesting, such as a twig on the ground, a fence post, or a shadow.

▲ DAVID CURTIS
"The Fishermen's Huts, Port Mulgrave"
The clump of long grass in the foreground plays a key role in the colour scheme of this picture as well as acting as a lead-in to the focal point, the boat and huts. It has been painted very loosely, though, so as not to detract from the main subject, but the pink flowers of rosebay willowherb have been entered carefully, as have a few long grass stalks. The dark iron fender emerging from both sides of the grass patch echoes the dark tones of the huts, thus linking the foreground to the middleground.

▶ JEREMY GALTON
"Provençal Meadow"
The overall colour of the foreground area needs to be established before adding detail. In this painting the average grey-brown of the meadow was determined by half-closing the eyes, and was then scrubbed in place with thinned paint. The more prominent and closest flowers were painted in some detail, while the further ones are merely small patches of pale paint.

▲ BRIAN BENNETT
"Grasses near Coombe Hill"
In this unusual painting the
artist has chosen a low
viewpoint so that the
foreground effectively becomes
the whole picture. The flowers
and grasses have been painted
with a knife, which can give
fine, linear effects when used
on its side (see KNIFE PAINTING).

PERSPECTIVE

Linear perspective is usually thought of in connection with buildings, but it is equally important in landscape, as it enables you to create an impression of space and depth. Any parallel straight lines or rows – the sides of a road or a canal, an avenue of trees, rows of vines in a vineyard – will appear to converge at a "vanishing point" on the horizon as they recede into the distance.

The accurate placing of the horizontal features such as hedges, fields, rivers and so on is crucial, and very careful observation is needed. In a flat landscape, for example, it always comes as a surprise to discover how little of the picture surface is taken up by what you know are large fields or lakes in the distance. It is always wise to take measurements by holding up a pencil at arm's length and sliding your thumb up and down it.

The size of a human figure in a landscape must also be determined accurately. It is helpful to remember that if you are standing at an easel the head of another standing figure, however far away, always coincides with the horizon because the latter is at your own eye level.

Just as important as linear perspective in landscape painting is aerial, or atmospheric perspective. As a view recedes into the distance details and edges become less clearly defined owing to atmospheric haze. Colours become paler and cooler, and tonal contrasts very indistinct. Depth can be accurately described even if there are no linear features such as paths and walls, simply by controlling the tones and colours carefully and making sure those in the foreground are strongest.

▶ CHRISTOPHER BAKER
"Sussex by the Sea"
The colours and tones are very carefully controlled in this painting, with the amount of detail and tonal contrast steadily decreasing towards the distant blue hills.

▶ JEREMY GALTON
"Landscape near Apt"
The apparent sizes of similar features decrease and appear to become flattened with distance, as shown by the fields in this picture. In addition, the distant mountains appear blue. In most landscapes you will find a similar combination of linear and aerial perspective.

◀ CHRISTOPHER BAKER
"Haymakers' Field"
Here linear perspective — the converging rows of cut hay — pushes the background firmly away, but aerial perspective is also used, with the warm colours of the foreground coming forward and the pale blues of the hills receding.

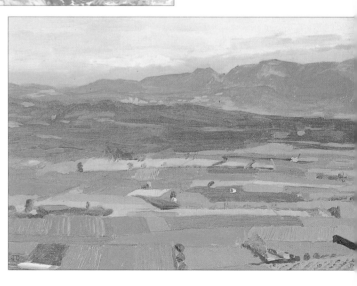

▲ COLIN HAYES
"Olive Groves near Limni,
Euboea"
The emphasis in this painting is
on pattern and colour, but the
use of the blue intermingled
with the greens in the
background provides enough
recession to make the picture
work on a three-dimensional
level as well. The rich blues
have been repeated in smaller
quantities in the foreground and
middle distance, thus uniting
the parts of the picture.

LANDSCAPE
DEMONSTRATION
JAMES HORTON

James Horton is an artist who devotes considerable time to painting landscapes on location, in oil and other media. He will walk for miles with his travelling easel-cum-paintbox and stool, mentally noting possible viewpoints until settling upon his final choice for that session. In this studio demonstration he reconstructs a painting he did in the French Pyrenees, adopting as far as possible the same procedure followed in the original.

◀ **1** Horton usually works on a COLOURED GROUND, leaving small areas uncovered in the completed picture. The composition has been marked out in diluted paint.

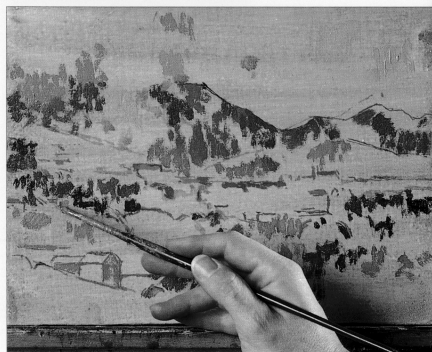

▲ **2** The first stages of painting involve an exploration of the chosen landscape in terms of colour and tone. The artist places dabs of colour all over the canvas so that he establishes a relationship between each area. He is concerned at this stage with the composition as a whole, and little attention is given to detail.

3 The relationship between the sky and mountains is established early on, since mistakes may be difficult to rectify later. The painting is to be completed in one session, and the paintmarks now being laid are likely to remain visible to the end. Horton mixes his colours with a medium made up of damar varnish, linseed oil and turpentine.

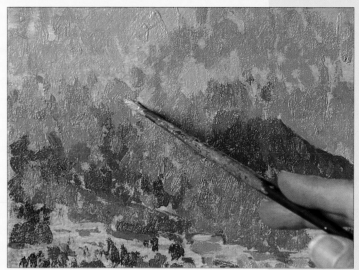

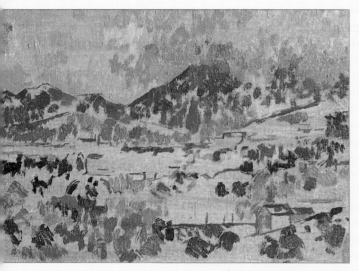

▲ **4** In this detail we see how the individual brushmarks are either pushed into one another by working WET INTO WET or do not quite touch their neighbours, thus leaving patches of bare ground showing. Notice how even the essentially flat areas are built up of BROKEN COLOUR.

▶ **5** When working on location the sky has to be recorded early on, as weather conditions are liable to alter rapidly. The cloud around the mountain top was a feature the artist particularly wanted to capture, and here is adding pale clouds WET INTO WET over darker regions of sky. Horton generally uses a palette of six or seven colours together with black and white. For small pictures such as this he tends to use only round brushes.

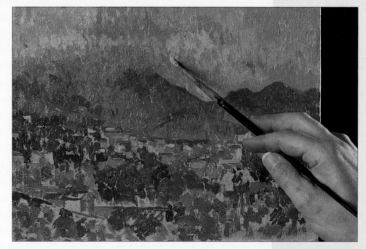

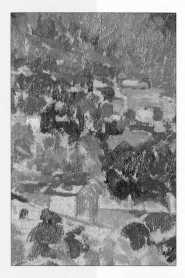

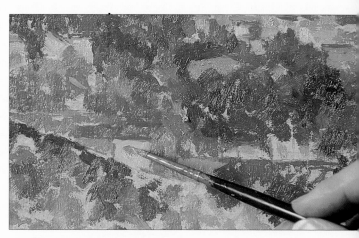

◀ ▶ **6, 7** The detail (**6**) shows the large amount of ground left bare in the early stages so that later additions or modifications of colour can be slipped into the gaps. This avoids the danger of overworking the area with paint. Details are added (**7**), with particular care being taken with the placing of roofs, windows and other architectural features.

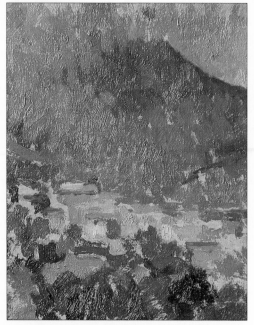

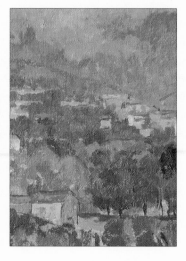

◀ **9** Although nothing is treated in great detail, small highlights and accents such as houses, a church spire and tree trunks encourage the eye to rove over the picture surface.

▲ **8** The whole composition is based on the interplay of warm and cool colours. In this detail we see the richly coloured red and ochre rooftops, which provide a focal point of warm tints to which our eye is immediately attracted.

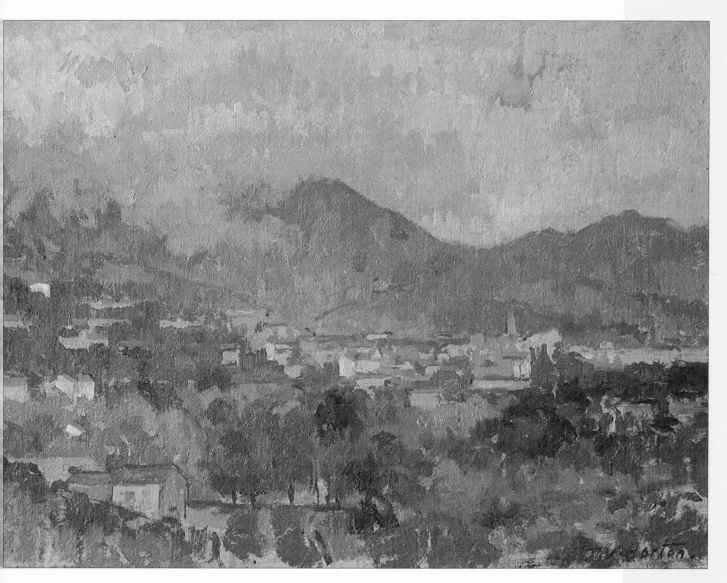

JAMES HORTON
"St Laurent de Cerdans,
Pyrenees"

Sky is nearly always an element in landscape and townscape, and sometimes it can be the main subject of the painting, occupying some three-quarters of the picture area. It is also the primary light source, without which the colours of the land below could not exist, so it follows that it should always be observed and painted with as much care as any other part of the picture, not treated as a mere backdrop.

Perspective in skies

Because of the tendency to regard the sky as a backdrop, many people do not realize that it is subject to the laws of perspective just as the land is. It helps to think of it as an inverted soup bowl over your head; the "rim" is further away than the centre, so when you are painting clouds, they appear larger overhead than at the horizon, where they bunch together rather like faces in a distant crowd.

They also become less distinct in colour and tonal contrast the further away they are. This is an effect of the phenomenon called aerial perspective (see LANDSCAPE: PERSPECTIVE on page 130), which affects both clear and cloudy skies. Beginners often make the mistake of painting blue skies the same colour all over, but in fact a sky that looks quite dark above your head will become paler and paler as it recedes from you. You are seeing through successive "veils" of atmosphere containing the tiny droplet or particles of dust or moisture that constitute haze.

A clear sky is blue because the atmosphere scatters the blue component of sunlight. The components of haze, which is always present to some extent, scatter the red end of the spectrum also so that the sky appears whiter, and sometimes yellowish or pinkish at the horizon depending on the nature of the haze.

Painting skies

It is not always easy to know how to treat skies in terms of paint. A common mistake is to put on the paint for the sky much more flatly than elsewhere in the painting, with much use of BLENDING methods, which seems to be the most logical means of expressing the insubstanti

CHRISTOPHER BAKER
"Watergate Beach"
The sweeping sky forms virtually the entire composition, but the stripes of land and sea below are necessary as anchors for the movement and drama above. The muted yellow of the beach also provides a touch of warm colour to balance the cool grey-blues.

ARTHUR MADERSON
"Hazy Dawn near Rotherhithe"
An initial monochrome
UNDERPAINTING was done in
shades of grey, (this is known
as grisaille). The artist then
reinforced the basic tonal
structure by building up both
warm and cool colours
throughout, using the GLAZING
technique for certain areas of
the sky.

nature of air. However, it is essential to think as much about the painting as you do about the subject, and it will not hang together properly unless the brushwork is consistent throughout.

If you want a subtly blended sky with no visible brushmarks – and there is nothing wrong with this – you must make sure to treat the land in the same way. On the other hand, if you are making a feature of brushwork you must carry it through the whole picture. When Van Gogh (1853-90) depicted a clear blue sky he did so in swirling strokes of thick paint similar to those he used for the land, and in the landscapes of Cézanne (1839-1906) the bold brushstrokes are as evident in the sky as anywhere else.

Recording skies

Dramatic skies and interesting cloud formations can be used in a compositional way to add extra interest to a landscape. Their shapes and colours can echo or complement features on the ground, such as hills or clumps of trees. However, clouds do present problems when you are working on location, as they are constantly forming, re-forming, moving around the sky and sometimes disappearing altogether. It is hard to resist the temptation to make changes – each new formation seems better than the one before – which inevitably destroys the brushwork and overworks the paint. The best course is to work out your composition rapidly and then stick to it, putting small patches of colour down all over the painting to relate the cloud colours to those of the land below.

In one way the changeability of cloud formations can be seen as an advantage, since if you watch them for a while you can choose the shapes best suited to your composition. It is not a bad idea to build up a "reference library" of cloud studies, as Constable did. Small oil sketches on paper can be made in a matter of minutes, and will teach you a great deal about the shapes, colours and general behaviour of clouds as well as providing material for later paintings.

CLOUD COLOURS

The colours of clouds are often quite unexpected, as is their tonal range, so careful observation is needed. There are, however, some general guidelines which are useful to know if you find you have to re-create a sky from memory.

The colour of a cloud depends primarily on the illumination it receives. At midday, when the sun is high, there will be little variety in the colour, and the tops will be almost pure white. A low sun, for instance in the evening or on a winter day, casts a yellowish light, and the illuminated side of a cloud is distinctly yellow also. The other side, which is in shadow, can be bluish if it is reflecting clear sky or brownish if not.

The other factor which determines cloud colour is distance. If you think of the sky as a wide, flat soup bowl inverted over your head you will realize that the clouds overhead are much further away from you than those on the horizon, and are thus affected by the laws of aerial perspective (see LANDSCAPE: PERSPECTIVE).

Colours become paler, often veering towards brown, pink or violet, and the tonal contrasts become far less marked.

The contrasts of tone seen in overhead clouds in changeable weather are very marked indeed, ranging from pure whites tinged with yellow to really deep blue-greys, violets and browns. At sunset all the colours of the spectrum appear, giving you the chance of painting with brilliant reds and yellows for areas close to the sun and blues, violets and even greens away from it.

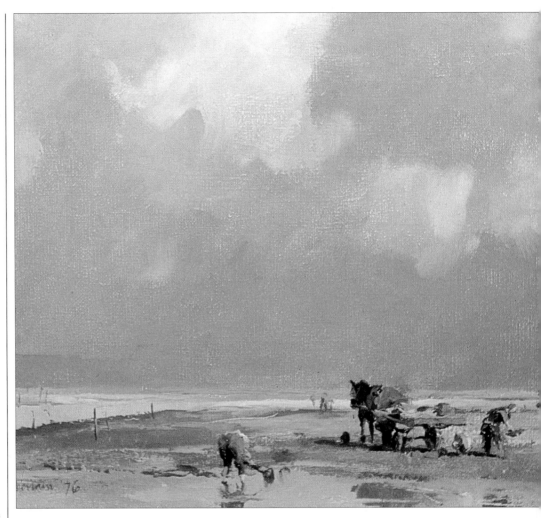

▲ TREVOR CHAMBERLAIN
"Welsh Cockle Gatherers"
Deep blue-grey storm clouds and falling rain obliterate the horizon, while to the left a deep pinkish glow penetrates the gloom. The unseen sun is high, so the upper clouds are receiving the strongest light, also reflected in the sea. In a painting like this, where the sky is the main subject, taking up three-quarters of the picture surface, it is important to give equal care to the land area, which acts as an anchor. Here the solidity of the figures on the beach contrasts effectively with the ethereal sky, painted WET INTO WET to ensure soft blending of colours and tones.

▲ JAMES HORTON
"Beach Huts, Walberswick"
As sunlight filters down through layers of cloud it sometimes becomes scattered in such a way as to give the clouds a yellow or brown colour which often relates closely to the land below. Here this tendency has been just slightly exaggerated to link the warm cloud colours to the equally warm ochres of the land.

CLOUDS IN COMPOSITION

When you are painting a landscape on location you will often find that the "found" composition, that is, what you actually see in front of you, is less exciting than you originally thought, necessitating some slight adjustments of the foreground or focal point (see LANDSCAPE: FOCAL POINTS). Since in most landscapes the sky occupies a significant proportion of the picture area, it follows that its contribution to the composition is considerable, so always think of it as part of the painting, not just as a backdrop.

It is often both easier and more satisfactory to enliven a picture by adding some dramatic cloud formations than to invent foreground features such as walls or clumps of trees. You can also use both the shapes and colours of clouds to echo those of features in the land below, thus creating a series of pictorial links. Cloud contours can lead the eye to the focal point of a picture, and coloured masses of clouds can provide a balance for similar large, dark shapes below. One of the common faults in beginners' paintings is failure to exploit this kind of opportunity, resulting in weak, disjointed compositions in which the sky is not properly related to the land.

If you are painting on the spot you can turn the changeability of the sky to advantage and choose cloud shapes to suit your composition as you see them.

If you usually paint indoors from sketches you will find it useful to build up a reference library of drawings, colour notes or even photographs which you can refer to when planning a picture. These should be labelled with the time of day and season, as otherwise you could find yourself creating an impossible situation such as painting a midday landscape with an obviously evening sky. The colours of the sky always relate to those of the land simply because the former is the source of light.

▲ WILLIAM GARFIT
"River Test at Leckford"
The clouds, together with their reflections in the river, make up most of this picture's surface, and the artist has cleverly used these two sets of opposing diagonals to create a beautifully balanced composition with a strong feeling of movement. Our eye is drawn towards the little bridge at the centre by the sweep of the river, and then follows the sloping tree upwards and to the right, where the patch of blue sky continues the diagonal.

▼ JEREMY GALTON
"Norfolk Landscape"
The approaching storm appeared quickly as the artist was working on location, so rapid decisions about how much blue sky to retain had to be made. While painting he became aware of the clouds as a compositional element: their small horizontal shapes echoed the distant landscape as well as the brushwork in the foreground.

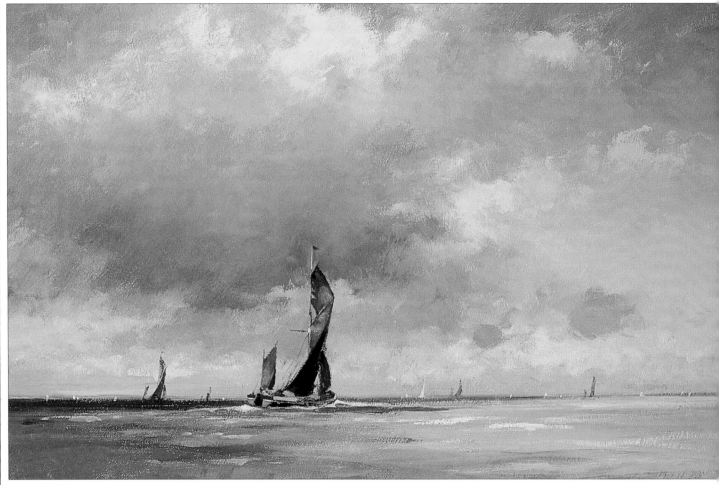

▲ RAYMOND LEECH
"An Easterly Breeze"
Here the dramatic cloud formation has been used to reinforce the focal point, the central boat with its brown sail, placed a little left of centre. It is no coincidence that the darkest part of the cloud is directly behind the white mast, picking this out and dramatizing the picture very much in the manner of the Dutch seascape painters. The cloud's shadow has been skilfully used to darken the water on the left, throwing the illuminated central area into prominence.

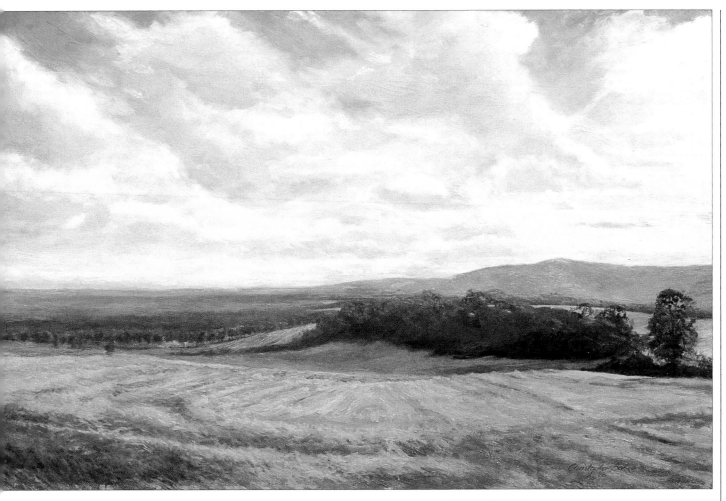

▲ CHRISTOPHER BAKER
"Up on the Downs"
Scattered fair-weather cumulus dominate this sky, and the artist has ensured that they are an integral part of the composition. The sizes of the clouds, diminishing with distance, echo the perspective of the fields, woods and hills, and some of the shapes in the sky almost exactly repeat the sweeps in the contours of the land, giving the effect of an overall diagonal striping.

◄ JEREMY GALTON
"Cley Beach"
The regular, repeating pattern made by the little processions of white-capped cumulus drifting over the headland is so eye-catching that it might have completely dominated the picture. However, balance is provided by the near-central white figures and the touches of crisp IMPASTO in the foreground.

UNIFYING THE PICTURE

Since the sky may occupy a considerable part of the picture area, or even the greater part of it, it is vital to treat it as an integral part of the composition and to find some way of tying it to the land in pictorial terms.

This is not always easy, as sky and land could not be more different in quality, but as in all painting your first consideration should be the picture, and this often involves taking some small liberties with reality.

If you are painting a cloudless or evenly overcast sky, the first step is to look at it as though it were an abstract shape intersected at various points by rooftops, hills, the branches of trees and so on. One way of stressing the pictorial importance of these "negative" shapes is to paint the sky in after you have completed the "positive" shapes so that both assume equal importance.

It is also vital to treat the whole picture in the same way in terms of BRUSHWORK. A common mistake, and a perfectly understandable one, is to paint the sky much more smoothly than the land, but this destroys the relationship between the two. If you look at Cézanne's landscapes you will see that the same kind of bold brushwork is used for every area, yet the skies look perfectly convincing.

Whether the sky is clear or cloudy, you will have to think carefully about colours. Because the sky is the light source for the land- or seascape there is always a colour relationship between the two, but this may need to be exaggerated a little. A good way of relating a blue sky to the land is to paint on a COLOURED GROUND and leave little patches of base colour, which could be brown, ochre or even pink, showing in the sky as well as areas of the foreground.

Cloudy skies are easier to deal with, as similar colours can be used for the blue, violet or brown undersides of clouds as for shadows and other features on the land. Repeating colours from one area of a picture to another is one of the best ways of creating unity, the other being to make shapes in the sky echo or balance those in the land (see CLOUD COLOURS and CLOUDS IN COMPOSITION).

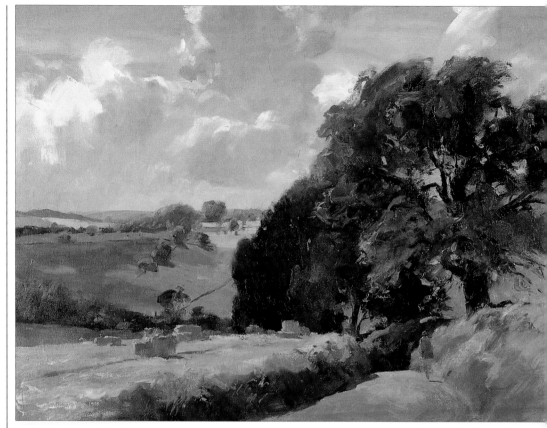

▲ TREVOR CHAMBERLAIN
"August, Overlooking Sacombe"
The small "negative" shapes of sky showing between the branches of the trees have been given as much if not more importance as the branches themselves. Some of these patches have been added as final touches of thick IMPASTO. The bulbous shapes of the trees find their echo in the clouds, while similar colours have been repeated from these to parts of the foreground, and little touches of blue appear in the patches of shaded parts of the fields, road and figure.

▼ ARTHUR MADERSON
"Towards Cwmchwefru"
Layers of dry paint have been
built up over UNDERPAINTING and
loosely dragged over it in a
variation of the DRY BRUSH
technique. The.same method
has been used for the whole
picture, which gives it a
powerful strength and unity.

These qualities are enhanced
by the use of a brilliant but
limited PALETTE, with the same
colours repeated throughout
the picture.

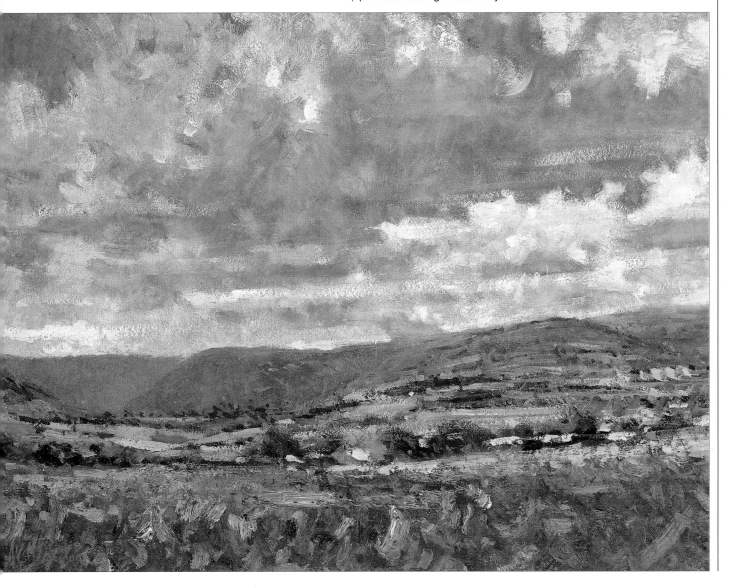

▶ DAVID CURTIS
"Over Port Henderson"
The dark mass of the sky is counterbalanced by that of the land, with the distant white sea and sky sandwiched between them finding its small echo in the white roof. Considerable use has been made of the SCRAPING BACK technique, both in the grey areas of cloud and in the lower half of the picture.

▼ CHRISTOPHER BAKER
"Park Farm, Earlham"
Sweeping curves of cloud are continued in the furrows of the cornfield, ensuring that the viewer's eye is attracted back and forth between the two areas. The long horizontal format of the picture enhances the feeling of movement and suggests the continuation of the landscape beyond the confines of the canvas.

▲ JAMES HORTON
"Etretat"
One painterly technique used in
this picture to help unify the
whole is the artist's trick of
deliberately leaving patches of
COLOURED GROUND uncovered.
Here the pale ochre appearing
among the blues of the sky and
sea as well as on the cliffs and
beach is conspicuous without
being distracting.

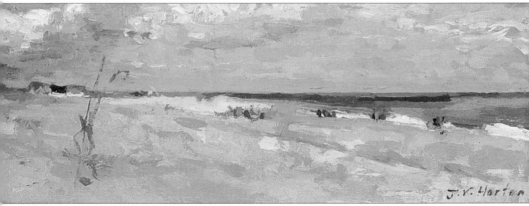

▲ JAMES HORTON
"Walberswick Beach"
This is a small picture painted
with relatively large brushes,
which gives the BRUSHWORK extra
importance. The treatment is
the same for sea and sky, and
colours have also been
repeated from one area to
another. In addition, the general
drift of the cloud masses is
towards the upper right, while
the beach is angled in the
opposite direction, creating a
wedge shape which dominates
the overall composition.

SKIES

DEMONSTRATION

CHRISTOPHER BAKER

The large-scale finished painting shown on the following two pages was executed to commission, and the first steps were the two smaller oil sketches illustrated here. These, which helped the artist to finalize his ideas, were also shown to the client before work on the final version was begun. Unlike many landscape painters, Baker seldom works directly from his subject, but his visual memory is extremely accurate, and he can usually re-create a scene from this alone, sometimes with the aid of a quick sketch or photograph.

◀ 1 The first oil sketch was done on hardboard primed with white acrylic primer, and the paint was mixed with an oil-based but quick-drying impasto medium mixed with turpentine and refined linseed oil. It was applied with broad sweeps of the brush to create the slightly raised ridges visible in the dark paint on the left.

◀ 2 The colours used were titanium white, Indian red, French ultramarine, raw sienna and transparent brown in varying proportions, giving a full range of warm and cool greys. Here the palette has been covered with cling film to keep the colours from hardening between working sessions.

▲ 3 The paint has been used quite thinly, allowing streaks of the white ground to show through the greys.

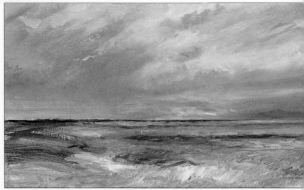

▲ 4 The sweeping, directional brushstrokes create a strong sense of movement. Although so few colours have been used there is considerable variety in the hues of sea and sky.

5 In the second oil sketch the horizon is lower, as it is in the final painting. This has also been painted on acrylic-primed cardboard, and the paint was mixed with an oil paste which contains some wax. This creates an IMPASTO effect while retaining a degree of transparency.

▶ **6** Little or no white was added to the colours, as the artist relied on the light reflected back from the white ground to create a vibrant, transparent effect. This is a technique akin to watercolour painting, at which Baker also excels.

7 In the completed oil sketch the effect of the paint only partially covering the white ground can be seen clearly, particularly on the left side of the foreground, where it suggests some feature such as a row of posts on the beach.

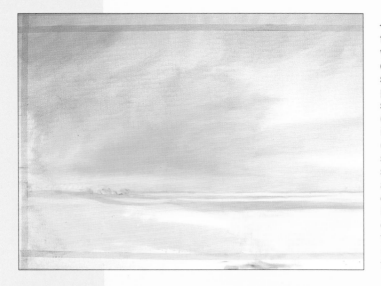

◀ **1** Linen canvas was used for the final painting, again primed with acrylic. Although considerably larger than the sketches, the proportions of the painting are the same: the sketches are 32×54cm (12½×21½in) while the painting is 81.3×137.2cm (32×54in). (The masking tape was used simply because the correct-sized stretchers had failed to arrive in time.) The imprimatura, or UNDERPAINTING, consisted of light red and burnt sienna diluted with turpentine, and these warm golden colours remain an influence in the finished picture.

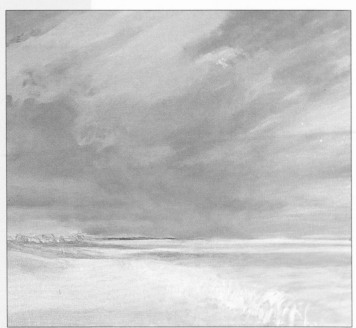

▲ **2** The sky was painted first, loosely and broadly with large bristle brushes (2½in), which prevented any hard edges. The tones were controlled very carefully so that they were not too dark.

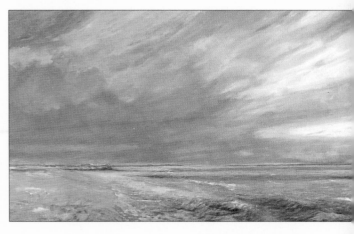

▲ **3** The colours were gradually deepened as the painting progressed, and the relationship of sky and sea was established with the articulation of the light on the water.

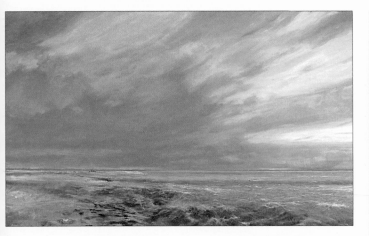

▲ **4** In the final stages some of the diagonals were cancelled, especially on the seashore. The IMPASTO medium (see MEDIUMS) used for the first oil sketch was used again throughout this painting, in increasing quantities as the painting was built up. This is in accordance with the FAT OVER LEAN principle.

▶ **5** Another of the last touches, seen in this detail of the completed painting, was to highlight some focus points in the sky and place small clouds to give an impression of depth.

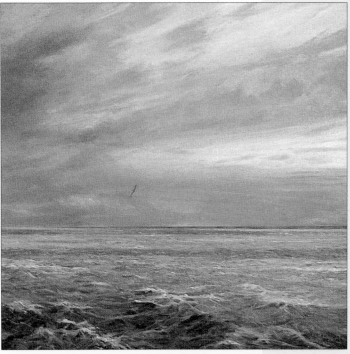

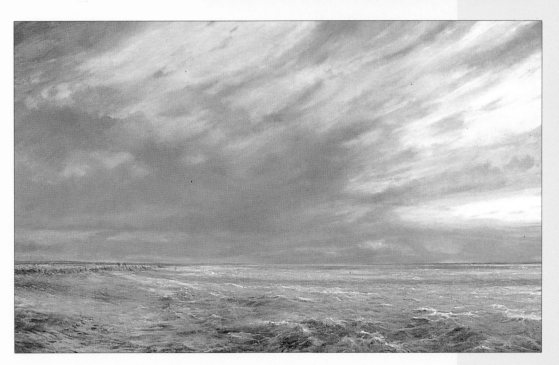

CHRISTOPHER BAKER
"West Sussex Seascape"

One of the most attractive aspects of still-life painting is that it is controllable. With a landscape you take the subject as it is, making only minor improvements on nature, if any. And there is always the worry that the sun will go in or come out; it may suddenly pour with rain before you have finished; the shadows that formed an important part of the composition may change in shape and colour, and so on. But with a still life you can choose the objects you like, decide where and how to arrange them, and take as long as you like over the picture.

At least in theory – in practice it is not quite so simple. If you decide to use natural light for the group (see LIGHTING) you will encounter the same difficulties as the landscape painter – interior light can change very suddenly and dramatically. And, of course, if your subject is flowers, fruit or vegetables they will wilt, shrivel or ripen so that by the end of a week your still life may be very different to the one you first chose.

Cézanne, who painted some of the most marvellous still lifes ever seen, is reputed to have used artificial fruit for this reason – he painted very slowly. This is an idea worth considering; the silk flowers made nowadays, for instance, are both realistic and beautiful, and for a mixed group including one or two blooms they could be the perfect solution.

No branch of painting is problem free, and it is still true to say that still life offers an opportunity to practise your technique and try out your ideas in a highly enjoyable way. You can work quietly by yourself with no one looking over your shoulder, and even if you are not happy with the result the first time you will have learned something for the future.

Choosing the still life

The first thing you have to decide – and perhaps the most difficult – is what to paint. Novices have a tendency to look round the house and seize a random selection of objects, usually far too many, which does not usually make for a good picture.

So think about what your interests are. Perhaps you want to experiment with colour combinations, in which case you might try some blue flowers in a blue jug perhaps with a pink tablecloth for contrast, or a blue bowl full of oranges, which would provide an exciting exercise in complementaries. It is always best to restrict the colours and choose one dominant one; if you have too many they will fight with one another and the picture will be disjointed.

If you are more concerned with textures, on the other hand, a group consisting of fruit, glass, wood and metal and perhaps some fabric would provide an interesting set of contrasts, as well as testing your technique and observational powers.

There is no reason why you should not be able to make an exciting painting out of nothing more elaborate than a few bottles, mugs or jugs if shapes interest you more than either colour or texture. Or you might like to paint something that has personal significance, such as a musical instrument (many are marvellous shapes in any case), a favourite ornament or simply a corner of your kitchen which appeals because of its decorative possibilities. Whatever you choose there should be a definite motive behind it so that a kind of theme runs through the picture. And you must enjoy what you are doing and feel affection for your subject.

Still life past and present

Still life did not become an art form in its own right until the 16th century, but even in earlier portraits and religious paintings beautifully observed groups of objects often appeared as part of the incidental detail. Sometimes these were some valued or typical possessions of the sitter, such as a collection of books or writing implements, which provided a glimpse into the person's life. The first pure still life usually had a symbolic content: paintings of skulls, snuffed-out candles, clocks and butterflies reminded the religious patrons of the transience of life.

In time the emphasis shifted, particularly in the prosperous Netherlands, where patrons were less interested in the inevitability of death than the pleasures of life and the splendour of their own possessions. Large

nd elaborate paintings featuring dead game, exotic owers, cut glass, gold and silver, Turkey carpets, fine ace and silk demonstrated the wealth and interests of nose who commissioned them. Such subjects also gave ne artists a chance to show off their skills, and they vied vith one another to produce ever more perfect and ealistic renderings of the colours and textures of glass, abric, metal and natural objects.

These tour-de-force paintings can be admired for their breathtaking skill, but much more immediately appealing to today's artists are the lovely, unpretentious still lifes of the Impressionists, notably Edouard Manet. These, sometimes consisting of no more than a loaf of bread and some ham (the artist's lunch) or a single bloom in a glass, are a lesson in simplicity, showing how a painting can be made from almost anything.

KAY GALLWEY
"Still Life for Judy"
One advantage in painting a still life is that you have almost total control over everything – the subject, the design, the colour and the lighting. Here, the artist has cleverly combined the naturally decorative nature of the flowers and tangerines with the man-made designs of the vase, tablecloth and figurine.

ARRANGING THE GROUP

A still life should always have some sort of theme running through it. The culinary theme, of fruit, vegetables and kitchen equipment, is a favourite one, as is garden and greenhouse articles. Because the objects are related through association they form the basis of a naturally harmonious picture.

▼ BARBARA WILLIS
"Grandmother's Doll"
A still life often has one main object, which must be placed in a position of prominence with the other elements orchestrated around it. It should not usually be placed right in the middle, and here the doll's face is slightly off-centre, with the circle of the hat proclaiming it as the centre of attention (circles are natural eye-catchers).

Another type of theme is the biographical or narrative one, in which personal belongings such as shoes or a chair are depicted – Van Gogh (1853-90) painted both at different stages of his career.

A theme can also be purely visual, with objects chosen specifically for their shapes or colours. Plates and bowls on a table, for example, provide an arrangement of circles and horizontals (or diagonals), while bottles comprise a series of uprights and curves. A colour theme could take the form of predominantly blue, white or yellow objects. In Van Gogh's famous *Sunflowers* the background, vase and flowers are all shades of yellow.

Arranging a collection of objects so that they make a pleasing composition is one of the hardest aspects of still life painting, so be prepared to take time at this stage. You might begin by depositing the objects at random, perhaps even without looking. Then look at them through a viewing frame and adjust them until you begin to see a satisfactory composition which has both balance and a sense of movement.

You don't want an over-static arrangement; the eye should always be led from one part of the picture to another, and you need to establish a pictorial relationship between the objects. This can sometimes be done by overlapping, allowing one object to cast a shadow on another or by placing some drapery so that it curves between, behind and/or in front of the various elements. The latter is a commonly used device in still life painting, and oddly enough it seldom looks artificial.

Circles (fruit or plates) and other regular geometric shapes are useful as eye-catchers, and often form good focal points. Be careful how you place straight lines, as the eye automatically travels along them. Diagonals and verticals, such as those formed by the front edge and legs of a table placed at an angle, are excellent for leading the eye in to a focal point, but parallel horizontals are best avoided as they have a blocking effect.

▼ ANNE SPALDING
"The Mantelpiece"
Successful arrangements are often based on a simple geometric pattern. In Willis's painting the doll sits within a framework of verticals and horizontals, while here the objects and mantelpiece together form a rough cross shape.

▶ JEREMY GALTON
"Still Life in Pink and Blue"
The objects here were chosen primarily for their colours, as the artist wanted to experiment with a pink and blue colour scheme. A good deal of arranging and rearranging was done until the arrangement looked right, and other objects originally included were removed.

◀ JEREMY GALTON
"A Chair and Copper Pot"
This is essentially a found still life (see FOUND GROUPS) although the whole set-up was moved nearer to the window for more light. The pot was deliberately perched rather awkwardly at the edge of the chair to provide a contrast to the rigid stability of the chair itself.

▶ KAY GALLWEY
"Oriental Afternoon"
This kaleidoscope of colour and visual activity contrasts strikingly with Spalding's controlled composition opposite. It is carefully planned, however, with each shape and colour finding an echo in another part of the picture so that the diverse elements are skilfully knitted together.

LIGHTING

A group of inanimate objects illuminated solely by artificial light will stay the same indefinitely. This is ideal for the painter who wants to practise technique without feeling rushed. Special bulbs can now be bought in most art shops which simulate natural light quite well, but the real thing is usually best as it reflects a greater range of colours and casts stronger shadows.

The most dramatic still lifes are those that are lit directly by the sun so that strong shadows fall across the subject and below the objects, accentuating their forms and colours. If you opt for this kind of painting you will have to work in a series of sessions; never fall prey to the temptation of changing your painting as the sun moves round.

It is a good idea to try out several different natural light effects before making the final decision. You can do this by choosing one or two key objects from your group and turning them around so that the light falls firstly on the front and then on either side. You will probably notice that front lighting is the least interesting; it is usually avoided in both still lifes and portraits because it has a flattening effect.

Back lighting can be extremely effective for some subjects, as it partially silhouettes the forms and haloes their edges. A pot plant or vase of flowers on a windowsill can be transformed by the light behind it, which shines through some leaves and petals and casts dark shadows on others. Again, this would call for a series of short working sessions or a very rapid ALLA PRIMA approach.

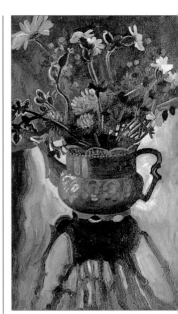

▲ JULIETTE PALMER
"Wild Posy"
Back lighting can be particularly effective for still lifes, as can be seen from this dramatic painting. It has made the petals glow dramatically, with the fine hairs bordering the stems catching the light to create a delicate silhouette. The dark, spiky shadow creates exciting foreground interest and balances the strong shapes above.

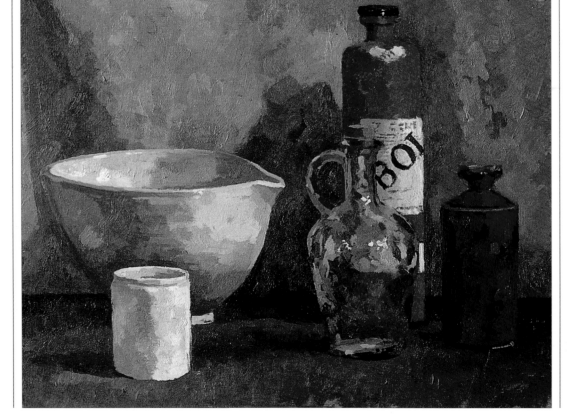

◄ JAMES HORTON
"Pottery and Glass"
A fairly strong light source from the right casts a dark shadow behind the objects and progressively deepening ones around them to the left, thus providing depth and solidity

HAZEL HARRISON
"Still Life with Fruit"
The light source, coming from
the left, casts shadows which
break up the background and
cause reflected highlights on
the glass. Since glass is
transparent it is not illuminated
on one side only, as a solid
object is, and most of what we
see is a distorted image of
whatever is behind the glass.
The fruit and plate in this
picture are the only forms
which are strongly modelled
from light to dark.

BACKGROUNDS

The background is just as important as any other part of a still life, and should never be treated just as an area where nothing is happening. It is akin to the sky in a landscape, and may even comprise a greater proportion of the canvas surface than the objects themselves. With a flat background it can be more satisfactory to block in all the parts of the picture together but complete the final painting of the background after and around the other objects. In this way the shapes between objects are truly observed and stated with conviction.

It also gives you a chance to crispen up and redefine the edges of the objects, and ensures that the brushwork has equal prominence in all areas of the picture.

At the setting-up stage, experiment with a variety of tablecloths, curtains, pieces of furniture or plain walls. It is important that the objects harmonize with the background in terms of colour and are not swamped.

Plain backgrounds can work very well as long as they are not painted too flatly, so try to keep the colours lively, perhaps by painting over a coloured ground or using BROKEN COLOUR, SCUMBLING or GLAZING.

An elaborate or patterned background can act as a foil for plain objects, but another approach is to continue a pattern on a vase, say, across the picture plane by a similar wallpaper or curtain. This decorative treatment was used by Henri Matisse (1869-1954), who was more interested in colour and pattern than in the description of form.

▲ SID WILLIS
"Golden Splendour"
Here the glorious silk fabrics in foreground and background are the dominant features, and were obviously the main reason for painting the picture. Nevertheless, the brass pot, high in the picture, is the focal point, and the dark red cloth behind has been cleverly darkened and muted in colour so that it recedes and creates a sense of space. The execution of the whole work is stunning, with every crease and fold in the cloths lovingly observed and every reflection in the pot faithfully included.

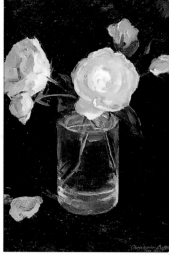

▲ CHRISTOPHER BAKER
"Christmas Roses"
Plain dark backgrounds have traditionally been used for floral groups, and here near-black shows off the delicacy of the roses to perfection. Notice that there is almost no visible division between the dark table top and the background itself, so that nothing competes with the flowers and glass, the latter owing its visibility entirely to a few reflections and highlights.

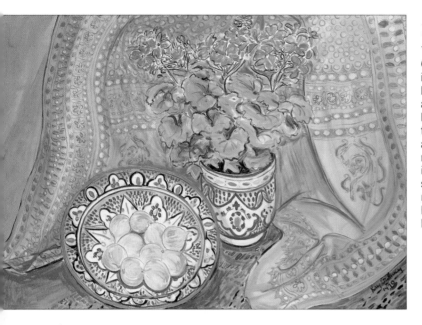

◀ KAY GALLWEY
"Pink Geraniums on a
Turquoise Sari"
Creating depth was not
important here as this is
basically a flat pattern, so the
artist has used the decorative
background cloth to continue
the rich patterns of the vase
and plate. The background
must never be seen as less
important than the main
subject; in this case it is largely
responsible for the movement,
balance and the colour
harmony.

▶ JEREMY GALTON
'Still Life with Mask"
The tablecloth and patterned
sofa fabric were conceived as
vital parts of the composition,
with the latter deliberately
intended to mimic the similar
colours of the cheese dish. A
degree of depth is given by the
stripes of the tablecloth,
converging to a vanishing point,
outside the picture.

FOUND GROUPS

Still lifes are usually (though not always) intended to look natural, but most are in fact very carefully arranged in advance. Cézanne, for instance, is said to have spent days setting up his groups and much longer painting them, though they look wonderfully spontaneous.

But the essence of "found" still life is that it is genuinely not arranged. Sometimes you will just happen to see something, whether inside or out, that has the makings of a painting. This could be virtually anything: pots and pans in a kitchen; some crockery and a loaf of bread left over from a meal; objects on a mantelpiece; a book on the arm of a chair; flowerpots or deckchairs in a garden, or even stones and pebbles on a beach.

Such objects will often be distributed in a more interesting way than you could hope to achieve yourself. Some may have fallen over, others will be half hidden, and their sizes and colour distribution will be random. It is up to you to make the most of the subject by choosing the best vantage point from which to paint.

To find a suitable composition it is a help to hold up a piece of cardboard with a "window" cut in it, or even to form a crude window with your fingers. You may find that you have to move or turn one or two of the objects slightly because they are in ambiguous positions, or to take away some if the effect is over-cluttered. Take care, however, not to spoil the effect by overplanning.

Found still life is a good discipline, as you will usually be painting objects which will not be there for very long, and this forces you to work quickly and decisively. Even if you can leave the "group" where it is for a period of time, a quick ALLA PRIMA approach will help you to convey the temporary nature of the subject.

▲ ANNE SPALDING
"The Black Slippers"
Pictures of this kind are often inspired quite by accident – you suddenly see a potential picture among the visual clutter of your environment. It is often necessary to rearrange things slightly, or to remove a superfluous object, but otherwise your still life is ready to be painted.

▶ ANNE SPALDING
"The Chest of Drawers"
The casual, "found" look is enhanced by a slight untidiness and by a free, spontaneous-looking use of paint. Here the open drawer, the sloping books and the shoes on the floor suggest a fleeting moment before things are cleared up.

▲ JOHN MONKS
"Spanish Archive"
It is surprisingly difficult to
arrange objects randomly so
that your still life arrangement
does not look contrived. This,
although obviously arranged –
with the thin magazine
protruding from the larger
volume – nevertheless looks
convincingly natural, and has
been painted broadly and
economically.

▲ JOHN MONKS
"Learning"
Loose but controlled handling
of thick IMPASTO transforms what
could be a dull subject into an
electrifying composition.
Paintings such as these have a
strong narrative content in that
they hint at the interests of the
objects' owners.

FLORAL GROUPS

Flower pieces, whether living plants in a pot or cut blooms in a vase, are a favourite still life subject. They can be painted on their own or used as part of a mixed group, perhaps including fruit or an attractive bowl or glass.

Flowers are not easy to paint, and one of the commonest causes of failure is overworking the paint in an attempt to get in every tiny detail of petals, leaves and stems. It is essential to simplify to some extent, and to do this you need to be aware of the main characteristics of the flowers. Are they fragile or robust; rounded or trumpet shaped; are there several flower heads on each stem or just one? How thick is the stem in relation to the flower heads? So before starting to paint take a good look and make sure you understand the structures.

Another thing that goes wrong with beginners' flower paintings is that the stems are not properly related to their container, so if your arrangement is in an opaque vase try to imagine the stems below the lip of the vase so that you can get the direction and proportion of those above it right.

The more of this kind of analysis you can do before painting the better are your chances of not having to make endless corrections and thus producing a tired, dead-looking picture. Look carefully at the colours, also, as they are often not at all what you would expect. Some leaves are translucent, and light from behind them may show through, while shadows are often unexpected colours.

The colours of petals are even more surprising. For instance, we all know daffodils are yellow, but once you begin to really look at one you will see that this colour is made up of a collection of greens and browns, and only occasional highlights are genuinely yellow.

It is wise to make an UNDERDRAWING before you begin to paint, and you will probably find it easiest to work from dark to light, leaving the highlights until last. Paint confidently, and try to let bold BRUSHWORK describe the shapes of petals rather than making tentative little dabs with a small sable brush. Keep overpainting to a minimum, and if you find an area is wrong for some reason, scrape it off and start again (see CORRECTIONS).

◀ RUPERT SHEPHARD
"Mixed Flowers in a Jug"
Because a vase or jug is a tall, thin shape you will often need some additional objects to provide a balance. Here the books serve this purpose as well as allowing more colours to be introduced.

▼ JOHN CUNNINGHAM
"Still Life with Silver Tray"
The decorative quality of the composition owes as much to the placing of the objects as to the flowers themselves. The parallel horizontals formed by the frontal view of the table could be dull and static, but the symmetry is broken by diagonals – the side of the tray and the lines on the tablecloth.

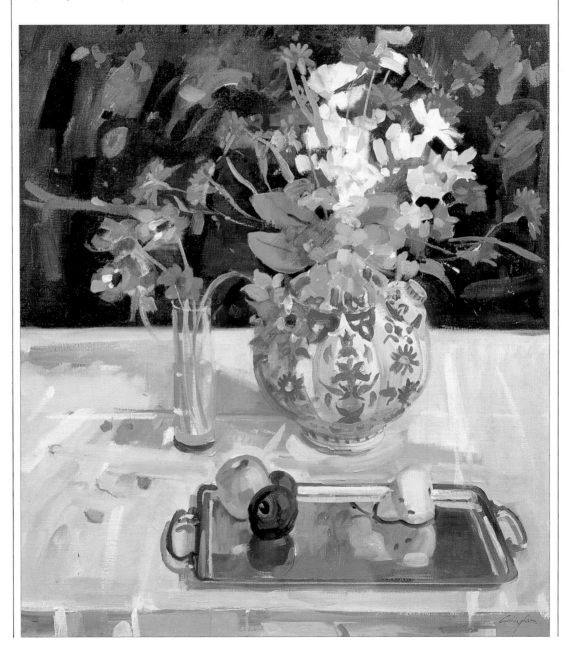

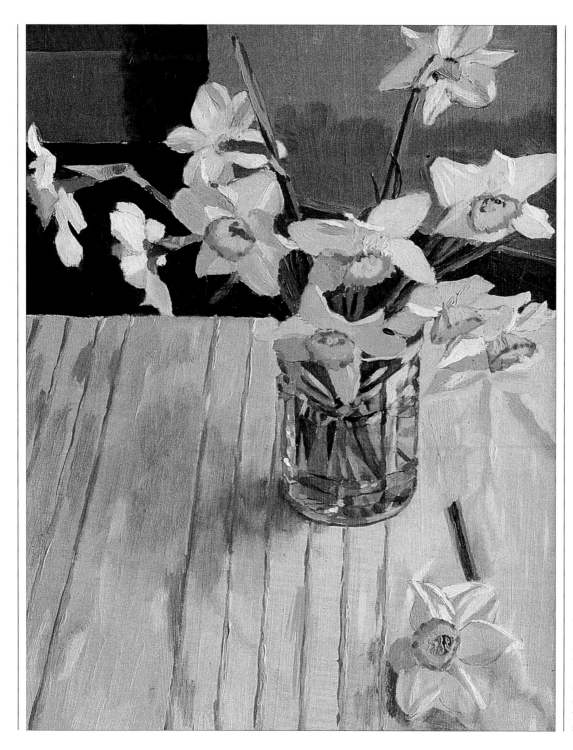

◀ JEREMY GALTON
"Narcissi"
This painting started out as an experiment to discover whether the flowers, all placed high in the picture, could be balanced successfully by the stripes of the tablecloth alone. It became apparent that something more was needed, hence the additional flower at the bottom right. The majority of the flowers, each painted carefully as individuals, were deliberately contrasted against a dark background, while the dark vase, equally important to the picture, is counterpointed by the light tablecloth.

▶ MARY GALLAGHER
"Still Life: Red Tulips"
In this bold composition, strongly coloured forms radiate out from the off-centre jug. The flowers themselves, although an important element, are not the focal point of the still life, and are treated largely in terms of flat pattern. Indeed, the visual impact of this painting, as in much of Gallaher's work, is derived from this two-dimensionality, stressed by the thick, dark outlines around the shapes.

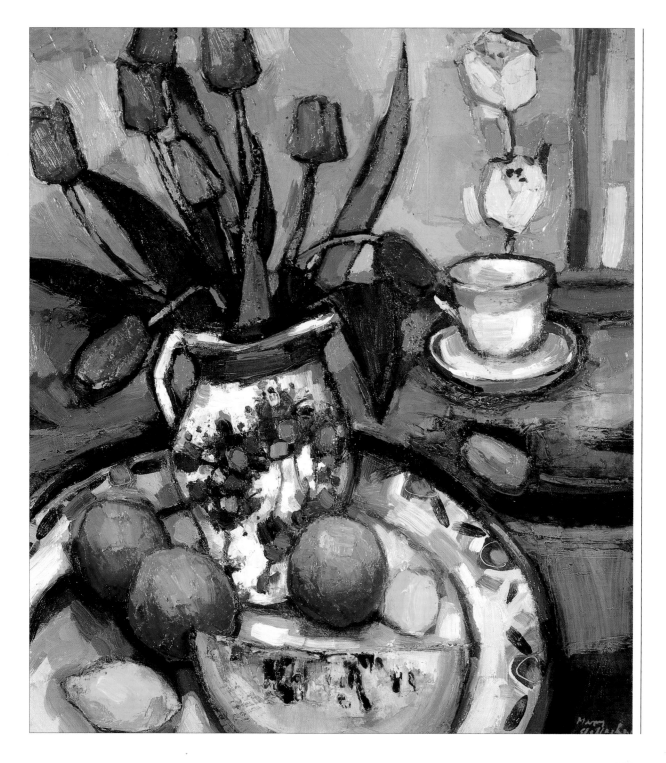

FLORAL STILL LIFE
DEMONSTRATION
JEREMY GALTON

This is a relatively small painting done on primed board and completed in one session, as are most of my still lifes and landscapes. I usually paint "sight size" – that is, so that the edges of the subject coincide with those of the board. This makes it easier to take measurements with the brush handle held up at arm's length, and these are transferred directly to the picture surface.

I am interested both in the precise shapes of the petals, leaves and stalks, and their colours, which can be quite unexpected.

◀ **1** Although the arrangement is a simple one it was given careful consideration before the painting began. The plant was placed on the tablecloth and rotated until it provided the most interesting configuration of flowers.

▶ **2** I dislike painting on a pure white ground, and have toned the board with diluted paint. I begin by making a careful UNDERDRAWING, noting the positions of the flowers in relation to each other.

▶ **3** Because the flowers are basically white I have chosen to block in the dark background first. My left hand resting on the easel acts as a support for my working hand.

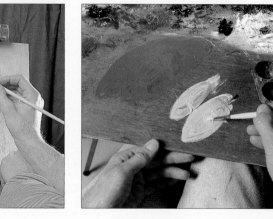

▼ **4** I mix the colours for the petals carefully so that no streaks remain in the paint. The mixture shown here consists of white with a little alizarin crimson and yellow ochre.

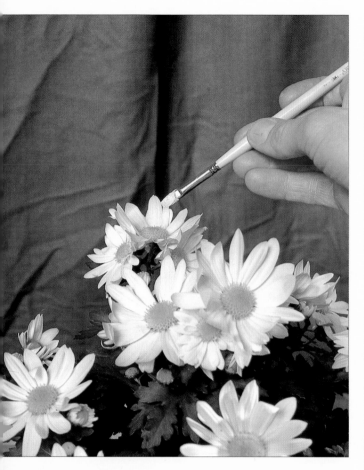

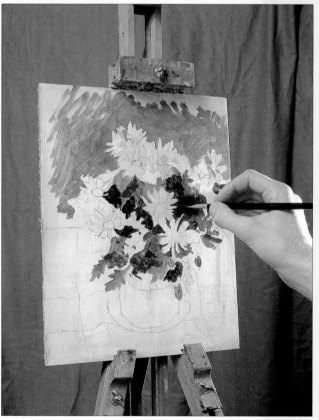

▲ **5** To make sure that the colour is correct I hold the brush up close to the petals and adjust the mixture until I am satisfied with the match. This is a useful way of analysing colours – most people have a tendency to paint what they think should be there rather than what really is. It also enables you to establish a tonal key for the painting.

▲ **6** The first mixed colour is now applied. Since few petals are exactly the same colour repeated alterations of the paint mixture are required as work progresses

▶ **7** Before completing the petals, some of the foliage, especially the darkest areas, are painted.

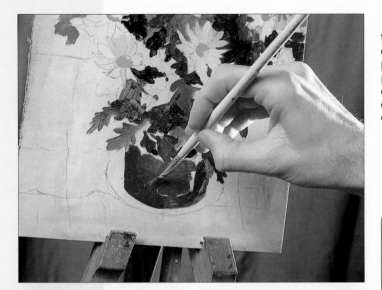

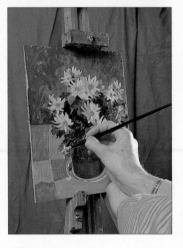

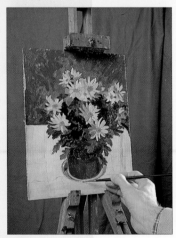

8 The yellow flower centres and the pot provide some warm colours in a predominantly cool picture. Throughout the painting I have mixed the colours with a little medium consisting of one third linseed oil and two thirds turpentine.

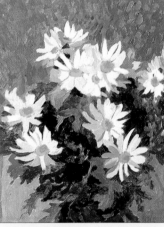

11 This detail shows that the "white" petals range in colour from yellowish whites through pinks to fairly dark purplish greys. Many of these colour variations are caused by the angles at which the petals lie to the light source.

12 The little patches of blues and ochres in the background provide additional interest while also helping it to recede by setting up a "shimmer" effect. These patches were initially too clear cut and bright, so were tonked (see TONKING) with newspaper.

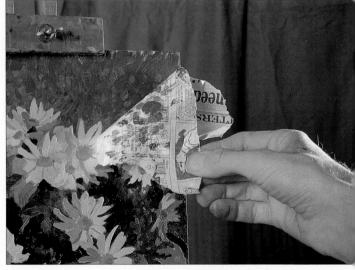

9 I want to make sure that the saucer retains its crisp edge, so am painting the rim, with a pointed sable brush, before the larger area of the tablecloth.

10 With the tablecloth now complete, the shapes of the most important leaves – those that stand out against the background – are defined with a sable brush.

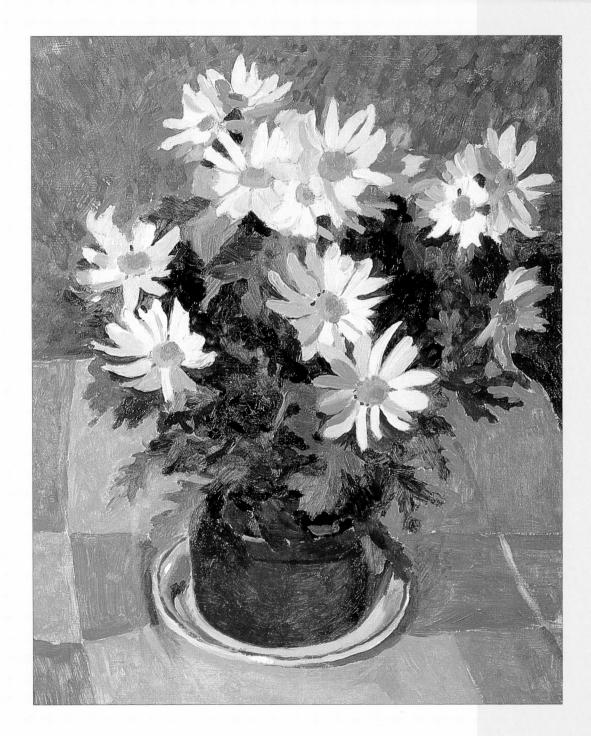

JEREMY GALTON
"White Chrysanthemums"

Water is one of the most attractive of all painting subjects, partly because it is so appealing in itself. There can be few people who do not enjoy gazing at a peaceful expanse of lake or river mirroring the surrounding land, a shallow stream with its complex pattern of ripples or the wild waves and spray of a stormy sea.

Because of its unique qualities, however, water does pose a challenge to the artist. It is transparent and yet has its own physical presence; it seems to reflect light in unpredictable ways; its patterns and colours are hard to analyse. The first thing to realize is that you cannot generalize about water, and the second is that to paint it successfully you will have to observe very closely so that you can learn to simplify.

Water in motion

This applies particularly to moving water. Transparent when you are close to it, a mirror when you are further away, it takes on a very different appearance as it swirls around or tumbles over rocks, or swells to form breakers in the sea. At first, the task of capturing such movements in paint may seem daunting, but if you watch a stream, waterfall or seascape for a time you will see that the movements follow a definite pattern, which is repeated again and again. Once you understand this you will be able to paint with confidence, letting your BRUSHWORK describe the movement.

Still water

On the face of it, painting a flat expanse of water seems easier, but there is a pitfall waiting for the unwary here. In beginner's paintings, water often appears to be flowing uphill, while in fact, of course, it is a flat horizontal plane and must be shown as such. If you paint it the same all over it will look like a wall, so you will have to find a way of suggesting recession. Putting in a few ripples or floating matter in the foreground is one way of doing this, and varying your brushstrokes so that they are smaller in the distance is another.

Colour

Clean water has no colour of its own, allowing us, whe we are close to it, to see through to whatever is below. nature, however, water is seldom completely clean; may contain suspended mud or vegetation which gives a colour of its own. Mountain streams, for instance, a often a lovely sherry-brown colour because of th presence of peat in the water, while the algae in ponds sluggish rivers can make the water distinctly green.

Because the surface of water is reflective, it also take on colour from the sky and surrounding land. If th water is still, it will show almost exactly the same colou as the sky above, but choppy water is a great deal le predictable. Firstly, the movement of the water stirs u any suspended matter, and secondly, waves and rippl cast their own shadows so that parts of the water ma appear surprisingly dark in relation to the sky.

Techniques

There is no one particular technique for rendering wate Although you might think that diluted paint or the w INTO WET method will emulate the qualities of water, th is not always the case. Opaque paint can often be mo successful if the painter takes care to place the colou accurately. In general, however, it is best to keep you brushwork broad and fluid, and avoid trying to descri every detail. Too much niggling with a small brush ten to destroy both the impression of wetness and the sen of movement – most people must have noticed ho photographs can "freeze" water and make it look soli and static.

TREVOR CHAMBERLAIN
"Mellow Autumn, River Beane"
This gently meandering river is beautifully captured with an economic use of paint. The water owes its appearance partly to the reflections – the exact vertical mirroring of the trees ensures that it is read as a horizontal surface – and partly to the occasional ripples which describe its fluidity. The pale water in the foreground reflects only sky, and consequently echoes the latter's colour.

SEASCAPES

Seascapes are an irresistible subject – to paint or simply to sit and look at – but they are not always easy to depict convincingly. One of the difficulties is, of course, their changeable nature: even quite minor alterations in weather conditions will produce a completely new set of the colours, while a calm sea will suddenly be transformed by a rising wind.

If you normally work on a large scale but want to paint on the spot it is wise to restrict yourself to small sketches. You can make several in the course of a day, and these can be used as the basis for a studio painting later on.

The most important decision is deciding on the viewpoint and composition. A beach will present two extremes of choice,

one looking along the shoreline so that the beach and the sea form wedges as they recede into the distance, and the other looking straight out to sea with the shoreline and horizon crossing the picture plane horizontally. In the latter case you will have to decide where to place the horizon. It should not be directly in the middle, as this makes for a dull and static composition. You may also find that you need to break up the horizontals in some way, perhaps by including a figure standing on the beach or the mast of a boat providing a link between sea and sky.

The commonest mistake of all is failure to suggest the sea as a horizontal plane (this applies to all paintings of water). Although you will sometimes observe a great

variety of colours and tones you will have to control them carefully so that you suggest recession (see LANDSCAPE: PERSPECTIVE). Keep the blues and greys cooler towards the horizon and reserve the stronger contrasts of tone for the shoreline.

This is where most of the "action" is, with waves breaking, and advancing water pushing foam over shiny wet sand. The colours to be seen in water close to you are exciting and often quite unexpected – ochres and browns caused by sand mixing with water; violets and blues caused by reflections from the sky. These effects can often be suggested by working WET INTO WET, so that the colours blend softly together, and using large brushstrokes that follow the direction of the water's movement.

▼ CHRISTOPHER BAKER "Westbeach, Littlehampton" A high vantage point, some way back from the sea and with a fairly low horizon, gives an impression of space and distance. The fence posts are vital to the composition, as they contribute to the perspective and provide a sense of scale.

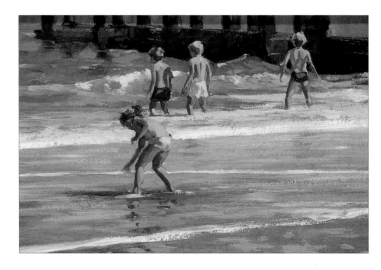

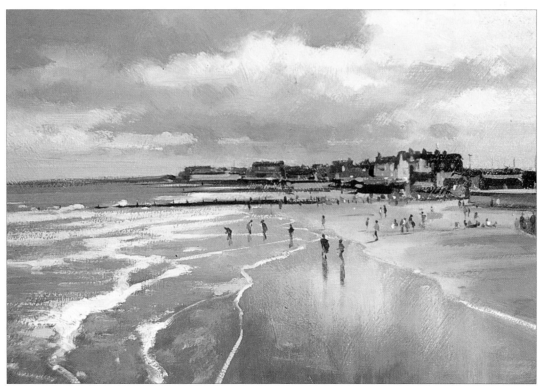

◄ RAYMOND LEECH
"Waiting for a Big Splash"
Here the artist has excluded the
sky entirely, homing in on the
children and the shallow water.
Notice the variety of colours in
the sea, with an ochre brown
used for the rearing wave,
turquoise blues and greens
behind it, and violets, greys and
browns in the foreground.

► RAYMOND LEECH
"After a Shower, Lowestoft"
The medley of shapes and
colours provided by the houses
and figures on the beach give
warmth and movement to the
picture, but the sea is
unequivocally the subject of the
painting. The viewpoint chosen
has allowed the artist to make
the most of the white lines of
foam, which balance the activity
on the beach.

► JEREMY GALTON
"Fisherman and Children, Cley-next-the-Sea"
The green umbrella and red-clad figures provide both atmosphere and foreground interest, enhancing the cold greyness of the sea. Recession is suggested not only by the paler tones of the more distant areas of sea but also by the larger brushstrokes in the foreground. The picture was painted ALLA PRIMA in sparingly diluted paint throughout.

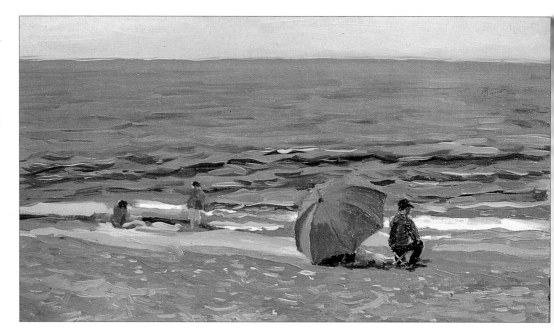

► RAYMOND LEECH
"Anniversary Stroll, Cromer"
The wet sand and its reflections, the turquoise sea and the pale sky provide the perfect backdrop for the colourful figures and the dark shape of the pram. The horizontal striping effect of the shoreline and sea is always a major element in the composition when this type of viewpoint is chosen, and usually needs some counterbalancing verticals or other shapes.

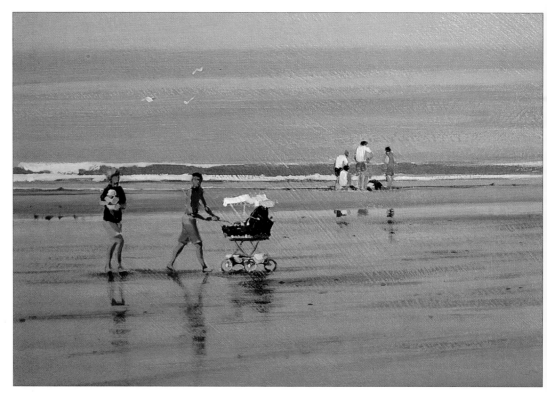

► CHRISTOPHER BAKER
"Viewpoint"
From this dramatic viewpoint the grand spectacle of the cliffs leads our eye down to the distant water and rocks below, where a tiny figure emphasizes the grandeur of the scene. The taut, linear quality of the subject is accentuated by the directional BRUSHWORK used to define the lines of the rock strata, the cracks in the cliffs, the wave crests in the sea and the clouds, creating an intricate veil-like network over the whole canvas.

MOVING WATER

Waves, fast-running streams and waterfalls are less easy to paint than still lakes and calm seas, but this is partly due to a failure to understand the behaviour of water. The shapes made by ripples as they swirl around an obstruction, or waves as they swell, peak and finally curl over into themselves do follow a certain pattern which is repeated over and over again, so it is always worth sitting and watching before you begin the painting.

Another problem is deciding how you are going to catch this feeling of ever-changing movement in solid, static paint. There is a lesson here in the camera. Most people have been disappointed to find that a photograph of a choppy sea or waterfall seems to freeze the subject so that it looks solid and gives no impression of movement. This is because the camera selects one tiny moment in time and includes far too much detail.

Thus the worst thing you can do is to attempt photographic realism in your painting, as this will have the same effect. Initially, ignore details and concentrate on the overall shapes and colours; you can add final touches such as highlights on ripples or spray on the top of waves as final touches if the painting needs them.

No one technique is more suitable than another, but a good general rule is to let your BRUSHWORK describe the flow of water, using directional strokes to follow its sweeps and swirls. GLAZING can help to suggest the transparency of water as it flows smoothly over stones or sand, while WET INTO WET will produce a soft blurring which might be ideal for suggesting the way a river snakes its way among rocks and boulders.

▲ CHRISTOPHER BAKER
"Bridge over the River Dordogne"
This picture conveys a powerful impression of a huge mass of water forging its way downwards, with pale streaks of vegetation carried by the flow. The artist has used thinned, translucent colours, built up in layers WET ON DRY, and the brushstrokes follow the direction of the rushing water.

▲ DAVID CURTIS
"Lamadine"
The shapes made by the waves as they gather, peak and break into spray have been carefully observed and painted with a sure and confident hand and brushstrokes which describe the movement. Both the sails and the white, sunlit patches of cloud echo the breakers, continuing the movement into the sky to create an overall effect of drama.

▲ DAVID CURTIS
"Evening Light, Arisaig"
Patient observation of the colours, patterns and shapes of waves is essential before you can learn to portray them by the most economic use of paint. In this painting each wave is depicted with great clarity, as is the shining expanse of shallow water on the sand, but there is no overworking or tired brushwork, and the colours are fresh and sparkling.

ARTHUR MADERSON
"Boys in the River Wye"
The movement of water
becomes apparent as it meets
an obstacle, when it forms
ripples and waves spreading
out from the source of
obstruction – in this case the
young bathers. Painted in
separate strokes and patches of
rich colour, the ripples have
been defined with a variety of
differently shaped marks: dabs,
lines and curves. Although no
sky is visible at the top of the
picture, its warm violet-blue is a
forceful presence in the
foreground water.

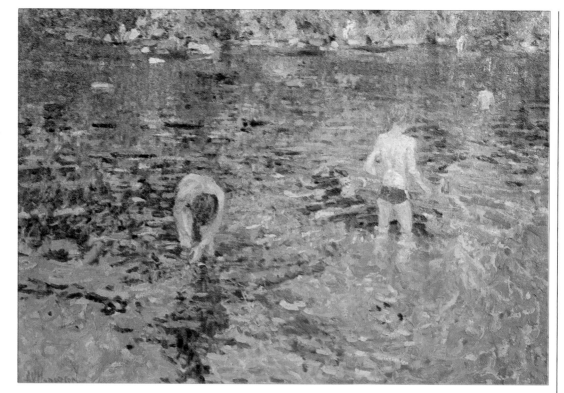

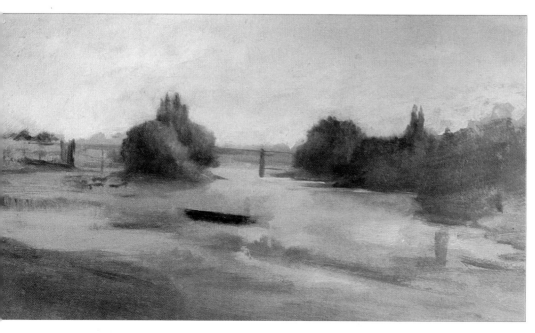

◀ CHRISTOPHER BAKER
"Strand-on-the-Green"
In this oil sketch the paint has
been applied broadly and
freely, with no detail attempted.
The soft, slightly blurred effect
creates a very accurate
impression of the wide, shallow
river.

REFLECTIONS

An important property of water is its ability to reflect light at its surface, thus acting as a mirror of the land or other features above. But it is vital to remember that the mirror in this case is a horizontal surface, and the strength of the reflection increases in proportion to the angle at which you view it. If you are standing at the edge of a lake and looking down at the water at your feet you will see little but the sand, stones or mud below the surface, but if you look at the distant shore you will see a clear reversed image of the landscape behind the lake.

The rules of reflections are often misunderstood, but in fact they are always exactly the same height as the objects that cast them. However near or far from you it is, the reflection of a boat will be the same size as the boat itself, a useful rule to bear in mind when recreating from memory or sketches.

Choppy water, of course, plays tricks with the rules, breaking up reflections and scattering them sideways or downwards. This is because the horizontal surface has been broken up into a number of inclined, or even near-vertical planes. You will need to observe such effects very carefully, as each wave or ripple will be reflecting more than one colour. Always try to simplify when you come to paint, as overworking water subjects is a recipe for failure. Broken reflections are usually adequately represented by interspersing horizontal patches of colour.

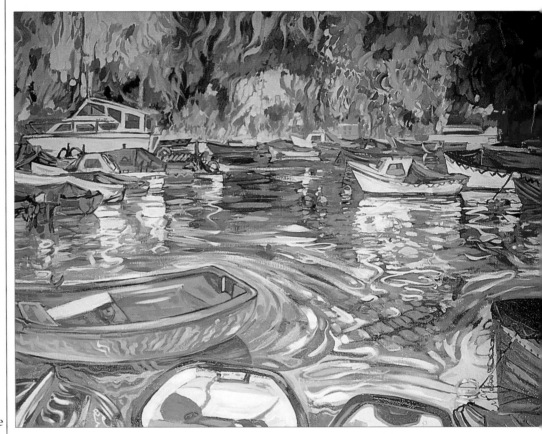

▲ PETER GRAHAM
"Boats at Balmaha"
Built on a colour key of blue, purple and red, this striking painting owes much of its feeling of movement to the swirling reflections. Although Graham seldom translates colour literally, he has ensured that the colours of the reflections are consistent with the features being reflected.

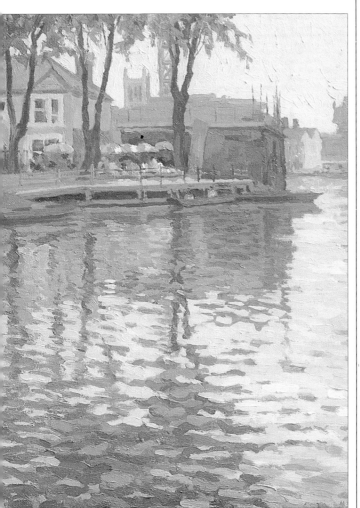

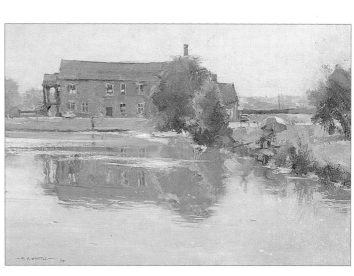

▲ DAVID CURTIS
"Carp Fishing, Shireoaks"
The smooth, still water faithfully mirrors the building, trees and sky, though a few small ripples break the symmetry, and some SCRAPING BACK has reduced the intensity of the reflected images. Air disturbance has ruffled the water surface in places to create horizontal streaks, pale because they reflect more of the sky.

▲ JAMES HORTON
"The Spade and Becket"
It is not always easy to make the ripples in water look natural, but the mistake most often made is that of overworking. Here the choppy water with its broken reflections is beautifully conveyed through a series of separate brushstrokes, each one laid down with precision and then left alone. It is often easier to work WET ON DRY for this kind of effect, as this allows the marks of the brush to remain crisp and clean, without mingling with an earlier layer of paint.

BOATS

Unlike cars, which many people ruthlessly edit out of urban scenes because they "spoil the view", boats are delightful to look at, and seem very much a part of seascapes, lakes and river scenes. However, their swelling curves are not easy to draw, particularly when they are foreshortened or tipped on one side as when on a beach.

During the initial drawing stage you will find it helpful to think of the boat as a shape which can fit into a rectangular box. Begin by drawing the mid-line from bow to stern, as in this way you can ensure that the two sides are precisely equal. Now lightly draw the imaginary box, and fit the rest of the boat into it.

If you are fairly close the rules of perspective will help you with parallel planking, seating, cabin tops and so on. The height of masts and other uprights can be checked by comparison with the overall length of the boat. Hold up a pencil or paintbrush at arm's length and slide your thumb up and down it to assess heights, and hold it horizontally to measure widths.

A boat in the water is also frequently seen at an angle, as it will often be pitching or riding a wave. If the water is still you will not have this problem, but it is important to observe exactly how much of the hull is showing and how much higher it is at one point than another. Reflections are vital here, as they not only make the water look more convincing but indicate the exact position at which the boat enters the water.

◄ KEN HOWARD
"Summer Sky, Penzance"
Verticals are always a dynamic force in composition, and here the tall masts dominate the picture. The flags and the red boat at left provide accents of bright warmth in an otherwise cool colour scheme.

◀ DAVID CURTIS
"Steam and Sail, Southampton"
The sharp curves and diagonals of the foreground hulls and their reflections combine with the verticals and horizontals to produce a geometric framework for this picture. The sensitive treatment of the water, together with small touches such as the puff of smoke from the funnel, contribute to an evocative and poetic image.

▲ DAVID CURTIS
"An Inlet near Morar"
The three-dimensionality of the central boat is conveyed by the accurate drawing of its contours. Its curves are echoed both by the background boat and the remains of the wreck in the foreground. It is these curves in their many permutations that make boats such an exciting subject, with endless pictorial possibilities.

REFLECTIONS
DEMONSTRATION ONE
JEREMY GALTON

This studio demonstration is a "transcription" of another painting done on location. I always prefer to work with my subject directly in front of me so that I can continually choose what information to include in the painting. I usually take with me a small viewing frame to help me select my composition, and a number of pieces of primed card or hardboard of differing shapes and sizes from which to choose.

When I begin to paint I always carefully match the colours and tones of the subject to the paint I am mixing, using the simple method of holding the paint on the brush up to the particular area. If the paint does not match I continue mixing until I am satisfied.

▲ **1** With complex subjects I usually make an UNDERDRAWING, but in this case a thin, quick-drying layer of raw sienna serves as an UNDERPAINTING for the bank of trees. The pale blue areas of water are painted in what will probably be their final colour.

▲ **2** The nearer trees and their reflections are worked in simultaneously using modifications of the same paint mixtures. Note that the reflections are slightly darker than the actual trees.

▲ **3** The more distant trees are now painted together with their reflections, which immediately begin to convey the appearance of water.

▲ **4** Ripples in the water are represented as series of horizontal stripes, here being applied with a sable brush.

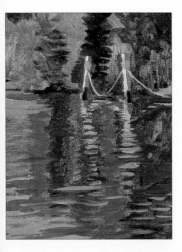

◀ **5** The appearance of water's surface is entirely made up of reflections, whether distorted or not. It is sometimes necessary to simplify, but don't miss important reflections such as those of the white chains seen in this detail.

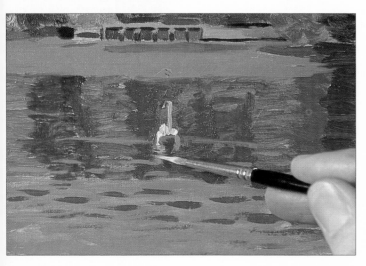

▲ **6** The reflection of the swan is painted with a thin sable. The pale blue area above is caused by the wind blowing the water into tiny ripples which reflect a substantial amount of sky, while the lower blue area is smooth water, also reflecting sky. Larger wavelets, perhaps generated by the swan, are painted as simple strokes.

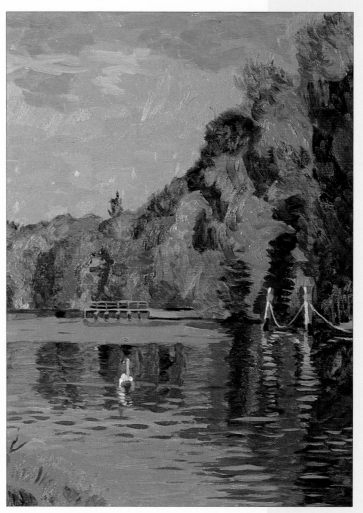

JEREMY GALTON
"The Thames at Henley"

REFLECTIONS
DEMONSTRATION TWO
PETER GRAHAM

Peter Graham likes to work directly
from life, and here has been
photographed painting in a
greenhouse in the botanical
gardens, Glasgow. Although he
derives initial inspiration from his
subject, his use of colour is very
personal, indeed his palette is
somewhat eccentric. He loves blue,
and uses at least ten different tube
blues, together with cobalt
turquoise and various purples and
violets. His one green is emerald
green – used only occasionally –
and cadmium red, alizarin crimson,
lemon yellow, Indian yellow and
titanium white complete his palette.
Browns, ochres and black are
omitted.

He knows the properties of his
colours very precisely, and always
modifies them slightly by mixing so
that the same tint does not appear
more than once in a picture.

▲ **1** Glasshouses are ideal places
in which to paint. You have all
the advantages of natural light
while the less agreeable
aspects of the weather are kept
at bay. It is usually necessary to
ask for permission, as the artist
did in this case.

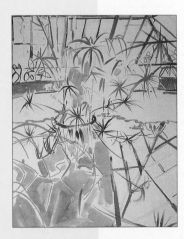

◀ **2** Graham likes to use a white
canvas so that light reflects
back through the paint to give a
luminous quality. From the very
beginning he uses bold, bright
colours, but at this early
blocking-in stage they are
considerably diluted.

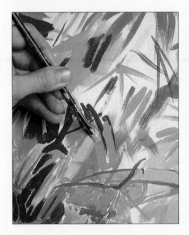

▲ **3** The thin, lancet-shaped
brushstrokes have been made
with Chinese brushes
(generally used for watercolour
and pen-and-wash). Here
Graham begins to lay some of
the "negative" shapes between
the leaves with a bristle flat.

▲ **4** Opaque cobalt turquoise,
which contains some white, is
laid over a transparent layer.
This detail, from the centre right
of the painting, will undergo
major transformations as more
foliage and ripples are built up.

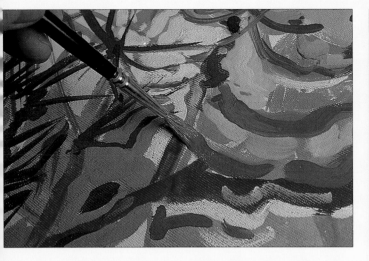

▲ **5** Fluid strokes of manganese blue with an addition of white describe some ripples at the centre right of the picture. Graham tends to paint the cooler areas of his subject in blues, regardless of their actual colours. For the warmer and brightly lit passages, he chooses reds and yellows.

▲ **6** Each colour is mixed thoroughly before it is applied to the canvas, and every brushstroke is placed deftly and decisively and then left alone. Although the painting, completed in one session, is basically worked WET INTO WET, colours are seldom laid one on top of another, so there is little mixing on the picture surface.

◄ **7** The calligraphic treatment of the spiky leaves and their reflections gives the painting an abstract value, so that it can be enjoyed on two levels. A final stage was to emphasize the linear marks by "filling in" between them.

PETER GRAHAM
"The Lily Pond"

INDEX

CREDITS

Quarto would like to thank the following for their help with this publication and for permission to reproduce copyright material.

pp10/11 Jeremy Galton; **pp12/13** Jeremy Galton; **pp14/15** *(left)* Christopher Baker, *(right)* Paul Millichip, *(above right)* James Horton, *(below right)* Juliette Palmer; **p17** *(left)* Peter Graham, *(right)* Naomi Alexander; **pp18/19** Christopher Baker; **p20** Barbara Rae by courtesy of the Scottish Gallery; **p21** *(left)* Juan Gris by courtesy of the Tate Gallery, *(right)* Barbara Rae by courtesy of the Scottish Gallery; **pp22/23** Gordon Bennett; **pp26/27** *(left)* Jeremy Galton, *(right)* Hazel Harrison; **p28** Arthus Maderson; **p29** *(above left)* Raymond Leech, *(above right)* Christopher Baker, *(below)* Olwen Tarrant; **pp30/31** Hazel Harrison; **pp32/33** Jeremy Galton; **pp34/35** Hazel Harrison; **pp36/37, pp38/39, pp40/41** Jeremy Galton; **pp42/43** *(left)* Hazel Harrison, *(below right)* Jeremy Galton; **pp46/47** Ian Sidaway; **pp48/49** *(right)* Gordon Bennett; **pp50/51** Ingunn Harkett; **p54** *(left)* Henri de Toulouse Lautrec, Paris, *(above right)* Edgar Degas, Paris; **p55** Georges Seurat by courtesy of the State Museum Kroller Muller, Otterlo; **p56** *(above left)* James Horton, *(above right)* Peter Graham, *(below)* Arthur Maderson; **p57** Arthur Maderson; **pp58/59, pp60/61, pp62/63** Hazel Harrison; **pp66/67** *(left)* Ian Howes, *(right)* Hazel Harrison; **p68** photography Paul Forrester; **pp70/71** Jeremy Galton; **pp72/73** *(left)* Jeremy Galton, *(above right)* Stephen Crowther, *(below right)* Juliette Kac; **p77** Ken Howard; **pp78/79** *(above left)* Trevor Chamberlain, *(below left)* Richard Beer, *(right)* Stephen Crowther; **p80** David Donaldson; **p81** *(left)* Raymond Leech, *(right)* Jeremy Galton; **p82** Peter Graham; **p83** *(above* and *below right)* Raymond Leech, *(below left)* Jeremy Galton; **p84** Raymond Leech; **p85** *(left)* Jeremy Galton, *(right)* Glenn Scouller; **p86** *(above)* Richard Beer, *(below)* James Horton; **p87** *(left)* Rupert Shephard, *(right)* Raymond Leech; **p93** Susan Wilson; **p94** Naomi Alexander; **p95** *(left)* Olwen Tarrant, *(right)* Stephen Crowther; **pp96/97** *(left)* Rupert Shephard, *(right)* Susan Wilson; **p98** Olwen Tarrant; **p99** *(left)* Susan Wilson, *(right)* Arthur Maderson; **p100** Naomi Alexander; **p101** *(left)* Susan Wilson, *(right)* Stephen Crowther; **p102** *(left)* Jeremy Galton, *(right)* David Curtis; **p103** Arthur Maderson; **p104** Trevor Chamberlain; **p105** *(left)* David Curtis, *(right)* Jeremy Galton; **p106** Andrew Macara; **p107** *(left)* Arthur Maderson, *(right)* Olwen Tarrant; **pp108/109** *(above left)* Raymond Leech, *(below left)* Naomi Alexander, *(right)* Arthur Maderson; **pp110/111** Tom Coates; **p113** *(above)* Christopher Baker, *(below)* Trevor Chamberlain; **p114** *(above)* James Horton, *(below)* David Curtis; **p115** *(left)* Christopher Baker, *(right)* Arthur Maderson; **pp116/117** *(above left)* Raymond Leech, *(below left)* Brian Bennet, *(right)* Arthur Maderson; **pp118/119** *(above left)* Jeremy Galton, *(below left)* Raymond Leech, *(right)* Trevor Chamberlain; **p120** James Horton; **p121** *(left)* Christopher Baker, *(right)* David Curtis; **pp122/123** *(left)* David Curtis, *(above right)* Arthur Maderson, *(below right)* Robert Berlind; **pp124/125** *(left)* Trevor Chamberlain, *(above right)* David Curtis, *(below right)* James Horton; **pp126/127** *(above left)* Brian Bennet, *(below left)* Christopher Baker, *(above right)* David Curtis, *(below right)* Roy Herrick; **pp128/129** *(left)* David Curtis, *(above right)* Brian Bennet, *(below right)* Jeremy Galton; **pp130/131** *(above left)* Christopher Baker, *(below left)* Jeremy Galton, *(right)* Colin Hayes; **pp132/135** James Horton; **pp136/137** *(left)* Christopher Baker, *(right)* Arthur Maderson; **pp138/139** *(left)* Trevor Chamberlain, *(right)* James Horton; **pp140/141** *(left)* William Garfit, *(right)* Jeremy Galton; **pp142/143** *(left)* Raymond Leech, *(above right)* Christopher Baker, *(below right)* Jeremy Galton; **pp144/145** *(left)* Trevor Chamberlain, *(right)* Arthur Maderson; **pp146/147** *(above left)* David Curtis, *(below left)* Christopher Baker, *(right)* James Horton; **pp148/151** Christopher Baker; **p153** Kay Gallwey; **p154** *(left)* Barbara Willis, *(right)* Anne Spalding; **p155** *(above)* Jeremy Galton, *(below)* Kay Gallwey; **pp156/157** *(above left)* Juliette Palmer, *(below left)* James Horton, *(right)* Hazel Harrison; **p158** *(left)* Sid Willis, *(right)* Christopher Baker; **p159** *(above)* Kay Gallwey, *(below)* Jeremy Galton; **pp160/161** *(left)* Anne Spalding, *(right)* John Monks; **pp162/163** *(left)* Rupert Shephard, *(right)* John Cunningham; **p164/165** *(left)* Jeremy Galton, *(right)* Mary Gallagher; **pp166/169** Jeremy Galton; **p171** Trevor Chamberlain; **pp172/173** *(left)* Christopher Baker, *(right)* Raymond Leech; **pp174/175** *(above left)* Jeremy Galton, *(below left)* Raymond Leech, *(right)* Christopher Baker; **pp176/177** *(left)* Christopher Baker, *(right)* David Curtis; **pp178/179** *(left)* David Curtis, *(above right)* Arthur Maderson, *(below right)* Christopher Baker; **p180** Peter Graham; **p181** *(left)* James Horton, *(right)* David Curtis; **pp182/183** *(left)* Ken Howard, *(right)* David Curtis; **pp184/185** Jeremy Galton; **pp186/187** Peter Graham.

Every effort has been made to trace and acknowledge all copyright holders. Quarto would like to apologise if any omissions have been made.